GREEK SCULPTURE AND ROMAN TASTE

JEROME LECTURES TWELFTH SERIES

Cornelius C. Vermeule III

GREEK SCULPTURE AND ROMAN TASTE

The Purpose and Setting of
Graeco-Roman Art in Italy and the Greek Imperial East

THE UNIVERSITY OF MICHIGAN PRESS ANN ARBOR

Library of Congress Cataloging in Publication Data
Vermeule, Cornelius Clarkson, 1925–
 Greek sculpture and Roman taste.

 (Jerome lectures; 12th ser.)
 Bibliography: p.
 Includes index.
 1. Sculpture, Greco-Roman. I. Title. II. Series.
NB115.V47 1977 733 77-5783
ISBN 0-472-08940-4

To
Benjamin Rowland, Jr.
and
Donald E. Strong
Amicis Romae

Preface

This book is the result of an invitation to deliver the Thomas Spencer Jerome Lectures at the University of Michigan and the American Academy in Rome during the academic year 1975 to 1976. Thanks are offered to colleagues old and new at both institutions, notably the former which I attended for two years as a soldier in the Second World War and to which I returned as an instructor then assistant professor in the years 1953 to 1955.

This study originated as a by-product of a research grant from the American Philosophical Society to record the aesthetics of United States coinage in relation to sculpture and painting, 1792 to 1967. Strange as it may seem, the line from the work of Augustus Saint-Gaudens and his collaborators for the World's Columbian Exposition of 1892 and 1893 to the settings of sculpture in the fora of ancient Rome, the suburban imperial villas, or the public buildings in the cities of Asia Minor is very direct and should be apparent to historians of both civilizations. A much briefer, preliminary form of these chapters appeared as two articles in *The Burlington Magazine* 110 (October and November, 1968).

My co-workers in the Department of Classical Art at the Museum of Fine Arts, Boston, have helped in many ways, as have the museum photographer and his staff. Mary B. Comstock has read the book at every stage in its development over the past decade and has done much work of a creative and editorial nature, including compiling the index. Kristin Anderson put the final version in its present order. In Rome during the first days of April, 1976, John and Ariel Herrmann opened my eyes to traces of creative commercialism amid the remains of architectural settings, underground at the Porta Maggiore, throughout Hadrian's Villa at Tivoli, and, most notably, in the quarries between the nearby Alban Hills and the capital.

The dedication is to the memories of two friends, one first encountered as my teacher in Japanese studies at Harvard University just after the Second World War and the second a companion in the British School at Rome at the outset of the 1950s.

Contents

Abbreviations

PERIODICALS AND STANDARD WORKS

AA—Archäologischer Anzeiger.
AB—The Art Bulletin.
ActaA—Acta Archaeologica.
AJA—American Journal of Archaeology.
AnatSt—Anatolian Studies.
AntCl—L'Antiquité classique.
AP—Antike Plastik.
ArchEph—Archaiologike Ephemeris.
AthMitt—Mitteilungen des deutschen archäologischen Instituts, Athenische Abteilung.
BCH—Bulletin de correspondance hellénique.
BSA—British School at Athens, Annual.
BullComm—Bullettino della Commissione Archeologica Comunale di Roma.
CAH—Cambridge Ancient History.
EA—Arndt, P., Amelung, W., and G. Lippold. *Photographische Einzelaufnahmen Antiker Sculpturen.*
Fot—Fototeca Unione presso l'Accademia Americana.
ILN—Illustrated London News.
IstMitt—Mitteilungen des deutschen archäologischen Instituts, Abteilung Istanbul.
JdI—Jahrbuch des deutschen archäologischen Instituts.
JHS—Journal of Hellenic Studies.
JOAI—Jahreshefte des österreichischen archäologischen Instituts.
JRS—Journal of Roman Studies.
MonAnt—Monumenti Antichi.
MonPiot—Monuments et Mémoires publiés par l'Académie des Inscriptions et Belles-Lettres. Fondation Eugène Piot, Paris.

NC—Numismatic Chronicle.

NdS—Notizie degli Scavi di Antichità.

PBSR—Papers of the British School at Rome.

RömMitt—Mitteilungen des deutschen archäologischen Instituts, Römische Abteilung.

BOOKS AND ARTICLES

Brueckner, *Friedhof am Eridanos*—Brueckner, A. *Der Friedhof am Eridanos, bei der Hagia Triada zu Athen.*

Helbig, *Führer*—Helbig, W. *Führer durch die öffentlichen Sammlungen klassischer Altertümer in Rom.*

Lippold, *Handbuch*—Lippold, G. *Handbuch der Archäologie*, vol. 3, no. 1.

Matz-Duhn—Matz, F., and F. von Duhn. *Antike Bildwerke in Rom.*

Morey, *Sardis V*—Morey, C. R. *Sardis V:1 Roman and Christian Sculpture. The Sarcophagus of Claudia Antonia Sabina and the Asiatic Sarcophagi.*

Paribeni, *Sculture greche*—Paribeni, E. *Sculture greche del V secolo. Originali e repliche.*

Pollitt, *Art of Rome*—Pollitt, J. J. *The Art of Rome. c. 753 B.C.–337 A.D. Sources and Documents.*

Poulsen, *Catalogue of Ancient Sculpture*—Poulsen, F. *Catalogue of Ancient Sculpture in the Ny Carlsberg Glyptotek.*

Ruesch, *Guida*—Ruesch, A. *Guida illustrata del Museo Nazionale di Napoli.* (Also published in a shortened, English-language edition, *Excerpt.*)

Smith, *Catalogue of Sculpture*—Smith, A. H. *A Catalogue of Sculpture in the Department of Greek and Roman Antiquities, British Museum.*

Stuart Jones, *Sculptures of the Museo Capitolino*—Stuart Jones, H., et al. *A Catalogue of the Sculptures in the Municipal Collections of Rome. The Sculptures of the Museo Capitolino.*

Stuart Jones, *Sculptures of the Palazzo dei Conservatori*—Stuart Jones, H., et al. *A Catalogue of the Sculptures in the Municipal Collections of Rome. The Sculptures of the Palazzo dei Conservatori.*

I: The Installation of Sculpture in Greek and Roman Times

Copies of Greek statues made in the Roman period have been put to many modern uses. They have been scrutinized to exhaustion for their relationships to lost originals. They have been admired for quality and completeness. In every case their message has revolved around the sculpture and sculptors of the originals and their periods of creation. Few writers have stopped to consider why copies were made, how they were set up, and, most important of all perhaps, how they were installed in relation to each other.[1] With the subject of how Romans and Greeks of the imperial period placed marble (and bronze) copies of Greek originals belongs the problem of mirror reversals among the copies. It has been recognized that such statues sculptured in reverse exist, and their manufacture was relatively simple for a sculptor trained in the milieu of copyism. What has been neglected is why such statues were carved or cast and how they were set in relation to normal copies and to original statues of all periods. In the recognition of mirror reversal and its importance in Graeco-Roman sculpture lies a major key to understanding decorative taste in the Hellenistic period and the Imperial Age which followed.[2]

Classical and Hellenistic Periods

In the sixth and fifth centuries B.C. the relation of sculpture to architectural setting seems straightforward and therefore easy to explain. Cult images were placed on their axes within temples. Architectural sculpture had its well-defined place on the building. Votive statues crowded the sanctuary or temenos area around temple and altar. Grave statues and reliefs enjoyed orderly positions within their cemeteries. The sculpture of grave plots will be taken up again in detail.

After 350 B.C. the relationship between sculpture and architecture seems to grow more complex. The description of the Aphrodite purchased from Praxiteles by the city of Knidos dwells as much on the small circular temple with two entrances in which she stood as on the statue itself. The partly reconstructed tempietto in Hadrian's Villa at Tivoli recreates this relationship between a small Doric structure and a single sculpture of exceptional beauty (fig. 1). The old and new Artemisions at Ephesus seem to have displayed Amazons, their cult images, and other statuary in more or less orthodox fashion, with only the sculptured drums of the columns presenting anything like an unusual sculptural program. Complexity or, at least, novelty of setting appears on a broad scale in the Mausoleum at Halicarnassus, where statues filled the areas between the columns, sculpture of some form topped the pyramid, and lions were placed on and in front of the building.[3]

Grandeur rather than novelty seems to have characterized the setting of works of art in the Hellenistic period. The acropolis of Pergamon was adorned with heroic groups, such as the large Attalid dedication featuring the Gaul and his wife surrounded by dying Gauls and Persians or the regiment of under-life-sized bronzes representing all the combatants in the mythological and real pasts of the Pergamenes. In imperial times the citizens of Pergamon could "update" the statues of their kings, particularly those set amid mythological and heroic groups, by substituting the images of Augustus and his successors. The same process affected the Attalid monuments at the entrance to the Acropolis of Athens and in the Athenian Agora.

The Great Altar of Zeus Soter was an unusual statement of Pergamene artistic organization within a fairly traditional architectural framework. The frieze was magnified in all dimensions and set where the orthostates of the precinct or altar building should have been. Pairs of marine creatures, reversals of each other, adorned the roofs above as akroteria, and the intercolumniations, as well as the path leading to the steps, must have been ornamented with statues. Architects of giant Hellenistic temples, that of Apollo at Didyma or the Olympeion in Athens for instance, paid increased attention not only to the complexities of architectural ornament but to the problems of multiple statues set within the forecourts, around temenos walls, under the porch, or within the building itself.

The outdoor-indoor sculpture garden came to be part of Hellenistic architectural setting. Ptolemaic Egypt has been credited with the adapta-

tion of a Pharaonic rectangular area with temple set at one end to the needs of a large civic-religious complex, often dedicated to the cult of the ruler. The ceremonial gate, often constructed in the Doric architecture of the most famous Propylaea, and the large space enclosed by the outer walls were perfect backgrounds for statues of divinities and divine rulers. The open area of the vast courtyard was lined with trees and set off by fountains.

The Kaisareion at Alexandria, a complex honoring Julius Caesar and later the entire house of Augustus, became a model of this class of structures. Under the first emperor these rectangular enclosures became a feature of the city of Rome.[4] Statues set against their walls and beneath their porticoes must have created the same restful, contemplative, yet noble effect that the sculptures and greenery present in the Great Cloister of the Museo Nazionale in Rome. Porticoes filled with works of art as background for and focus on a central area or edifice became an important Hellenistic contribution to Roman imperial decorative organization. Roman engineering would turn the relatively simple Greek rules of structure into a vocabulary of theatrical complexity, and from the series of Hellenistic stoas around a rectangle would ultimately emerge a building such as Hadrian's Stoa and Library at Athens.[5]

Pre-Imperial Mirror Reversals

The placing of specific works of sculpture and the creation of mirror reversals can be traced quite precisely from 400 to 317 B.C., that is through the late high classical period, in Attic grave monuments. These include not only stelai but also statues of people, such as mourning women, and of animals, notably lions. The notion of related statues in mirror reversal can be first documented with precision in the Caryatids from the Porch of the Maidens on the Erechtheum in Athens (fig. 2). In the Porch of the Maidens, dated about 425 B.C., four statues face outward in the front row, the weight of the building above supported by the right legs of the two on the viewer's left and by the left legs of the two on the right. Each corner figure was matched by the Caryatid directly behind it. Thus, the viewer saw a rhythm of bent left legs covered by taut drapery on the left and bent right legs, outlined in the same way, on the right. The relationship to Graeco-Roman art was a direct one since mechani-

cal copies of these Caryatids adorned buildings in the Forum of Augustus (fig. 3), in the Canopus area of Hadrian's Villa at Tivoli (fig. 4), and on other prominent monuments, to be considered presently. What was a daring and subtle use of the ideal human figure in a closed architectural setting became a decorative commonplace, albeit on a high level of quality, in the copyism of imperial Rome.

On the upper blocks of the hemicycle that formed the Dexileos monument of 393 B.C. in the cemetery beyond the Dipylon Gate stood a pair of Sirens in reversed poses, that is the inside arms of each held the musical instruments, and their bodies were turned so that there was no question which Siren guarded the left front corner and which the right.[6] This notion of balance was developed to a complex sophisticated degree by about 350 B.C. in the arrangement of monuments in a row on top of family plot number II, that of Agathon and Sosikrates of Herakleia, in the same cemetery (fig. 5). A pair of marble lekythoi adorned the corners, with the scenes of farewell on each arranged so the standing figure faced inward and the seated figure of the deceased toward the void beyond. Next to these lekythoi came a pair of small stelai in their architectural frames, each with a single standing figure facing toward the center of the plot. Two large stelai with multifigured scenes followed,[7] and the very center was occupied with one of the traditional tall shafts with rosettes above inscriptions on the principal surface and a floral finial as crowning member. Such essays in balance of objects and the carving on them, of reversed directions to create a total visual unity, must have been repeated time and again in every local necropolis of Attica during the fourth century B.C.

As grave stelai became larger and deeper, more like statues beneath buildings, so the number, size, and importance of the statues in these funerary complexes led to new variations on the traditional Greek love of careful balance and orderly arrangement. The family plot of Dionysios in the Kerameikos cemetery is still admired for its butting bull that stood on a tall base over the central architectural stele, but the monument was not complete without the pair of lions in strict mirror reversal that adorned the front corners (figs. 6a, b). They were carved about 340 B.C.[8] Before such elaborate memorials to the dead were terminated by the antiluxury decree about 317 B.C., huge marble quadrupeds in mirror reversal came to stand not only on two or four corners of the family plot but also in front of the funerary structure, a small temple or a lofty podium of rusti-

cated masonry.[9] From near Menidi came a pair of females each seated crosslegged with head on one hand, in the traditional attitude of dejection that Romans were to adopt for conquered provinces or barbarians. Like the lions they adorned some funerary compound of about 340 B.C., and they are carved to balance each other in mirror reversal.[10] Many other examples could be adduced.

The artistic creation of mirror images in classical sculpture is, therefore, much older than the era of Graeco-Roman copyism. The practice had its roots in the Greek love of symmetry evident in geometric bronzes or pottery and continuing into the archaic period, becoming apparent in the lines of statues in sanctuaries, especially their sacred ways, and in the planning of architectural sculpture. In the fifth century B.C. the technique of duplication in different directions was used to create architectural details for buildings, some as large and as human as the Caryatids of the Erechtheum (fig. 2), others as subtle as the figures forming akroteria or even the angles of pediments. Around 400 B.C. these essentially architectural details had become the freestanding ornaments of funerary monuments.

In the fourth century B.C. freestanding statues and sets of reliefs were interrelated to create a balanced visual image. These practices, architectural and sculptural, were enlarged and multiplied in the Hellenistic Age. The periods of Roman patronage and Hellenic mechanical arts from about 80 B.C. brought new, vastly varied answers to traditional demands and to the proliferation of commissions surrounding far-flung empire and pyramids of prosperity. Greek sculpture and painting in the fifth and fourth centuries B.C., or in the pre-Roman Hellenistic Age, was displayed as a total entity, with architecture playing a relatively small part, even where frescoes on stoa or gymnasium walls were concerned. The Attic grave stelai and their balanced lions or dogs or servant women stand against the blue sky in clearcut phrases and in positive sculptural profiles (figs. 5–6). Roman notions of art as an ornament of engineering accomplishment rather than an end in itself were to set Greek statues and their copies, including duplications in reverse, in places where the subservience of sculpture to niches, facades, arches, vaultings, and even domes was obvious (fig. 7). There were thousands more Roman buildings than there had ever been Hellenic structures, and many of these Roman civic enterprises were conceived on a scale undesired or unknown save for a few temples in the centuries before Augustus.

Roman Copies

Greek sculptors and painters produced new versions of older works of art, replicas and variants, to satisfy the obvious commercial demands of the Graeco-Roman Age. Occasionally, a single copy of a statue or painting was created to replace a masterpiece looted by Roman imperators or destroyed in some unfortunate war. The majority was made in times of peace by firms of commercial artists to fill the public buildings and private gardens of the Roman Empire. In his letters to Atticus in 67 and 66 B.C., Cicero pinpoints this commerce quite neatly when he seems to plead for almost any sculpture to adorn the exercise area of his villa at Tusculum:

> And I pray you send them [Pentelic marble herms with heads of bronze] as soon as possible and also as many other statues and objects as seem to you appropriate to that place, and to my interests, and to your good taste—above all anything which seems to you suitable for a gymnasium or a running track?

> I implore you . . . to ship them [statues and herms] . . . , and also anything else which seems to you suitable for this place, . . . especially for a wrestling court and gymnasium. . . . the place itself informs me of what it needs. In addition I commission you to procure some reliefs which I could insert into the wall of my *atriolum* and also two wellheads ornamented with figures.

> Naturally I would like you, in accordance with what you have written, to decorate this place with as many works of art as possible.[11]

These letters reveal a Roman state of mind regarding the arts that would persist throughout antiquity, into the church facades of the Middle Ages, and to the formal pavilions and gardens of the High Renaissance. On a larger scale, Cicero's demands would determine the decorative programs of Roman imperial buildings, from shady, tree-lined porticoes to the stage buildings of theaters or the myriad niches large and small in vast bathing establishments such as those of Caracalla and Diocletian in Rome. The ordering of shiploads of statues (marble copies) and neo-Attic reliefs or well-heads to decorate a general setting would become a commercial pillar of the Roman Imperial Age. This is the tradition of art by mass consignment that would survive until the British country houses of the eighteenth and early nineteenth centuries, or Lord Astor's country seat of Cliveden above the Thames as late as 1900.[12]

Roman tombs, to be sure, continued to have similar sets of lions on their corners, and architectural sculpture for classicizing Roman temples partook of the same decorative duplications and pendants, including reversals, employed by the earlier Greeks.[13] In the main, Roman copies mean replicas of several dozen favorite originals in bronze and marble that were reproduced over and over again with standard variations. These originals were mainly statues by Pheidias, Polykleitos, Myron, and Alkamenes in the fifth century B.C. and Praxiteles, Skopas, and Lysippos in the fourth century B.C. In Roman buildings of the first three centuries of the empire the same statues, with variations, were used over and over again. Among the most popular are the resting Faun attributed to Praxiteles, the Eros unbending the bow associated with Lysippos, the Aphrodite of Knidos (fig. 1) and its variations (works of Praxiteles and his two other great contemporaries), the Farnese Hercules type of Lysippos (fig. 21), Athenas by Pheidias, and athletes with the discus that have been linked with Myron (fig. 46), Alkamenes, or the family of Polykleitos (fig. 32). There were several types of Hermes after Alkamenes or Praxiteles or Skopas, used for statues of gods, athletes, or famous citizens, and countless women were commemorated by means of the Large and Small Ladies from Herculaneum, Lysippic statues of Demeter and Kore.

It is not without coincidence that Lucian in his *Philopseudes* uses two much-copied masterpieces of the middle of the fifth century B.C. as foils for an example of brutally natural, proto-Hellenistic portraiture in a courtyard setting.

> "Did you not notice," he said, "upon coming into the courtyard the beautiful statue standing there, a work of Demetrios Anthropopoios?"
>
> "Surely you don't mean the one throwing the discus?" I said. . . .
>
> "Not that one," he said, "since that is one of the works of Myron, the *Diskobolos*, of which you speak. Nor do I mean the one next to it, the one binding his head with a fillet, a beautiful statue, for this is a work of Polykleitos. . . . Perhaps you saw a certain figure which was beside the running water, the one with a pot-belly, a bald head, . . . his veins showing clearly, just like the man himself . . . reputed to be Pellichos the Corinthian general."[14]

Ancient critics like Lucian were invariably looking at Roman copies when they made evaluations such as this. Even Pausanias on his wanderings through Greece was deceived on more than one occasion into think-

ing he stood before an original rather than a copy. The classic example is
the so-called Hermes of Praxiteles, and nowadays many an intelligent
tourist is deceived by the so-called Raphael in an Italian provincial
church. The exception among critics and their dependence on filtered
Hellenism was G. Licinius Mucianus, a source for Pliny the Elder, who
traveled up and down the Ionian and Carian coast; however, even his
judgments were anecdotal and sometimes fatuous, recordings only of the
odd and curious.[15]

Roman copies were produced equally in western Asia Minor, that is
at Smyrna, Ephesus, or Aphrodisias, in Greece, that is at Athens or
possibly Corinth, and in Rome. Surprisingly few routine copies of stan-
dard models have been found in Syria or Asia Minor. Ephesus has been
the source of a Myronian Discobolus and several other works. Cypriote
Salamis has yielded a Skopasian Meleager, a Lysippic Herakles, a satyr
attacking a hermaphrodite, and certain others. Greece and the islands
have fared better in numbers of copies excavated, thanks to a number of
unfinished statues or small souvenir bronzes for the export trade found
in Athens. The best Diadumenos or Fillet Binder of Polykleitos is the
marble from Delos, and the Roman baths at Argos, the agora at Corinth,
or the civic areas of Gortyna on Crete have supplied marble copies match-
ing in every sense and purpose those found in the Latin West. The
Roman cities of Asia Minor were too busy putting up imperial and civic
statues to order artistic copies wholesale, and the cities of Greece into the
second century A.D. still had enough true originals to satisfy their aes-
thetic needs.

Italy, both Greek (Cyrene) and especially Roman North Africa, and
Gaul were true homes of the Roman copy in its most commercial sense.
The force of numbers may be the result of exhaustive excavation, some-
thing still unrealized in Asia Minor. Theaters, baths, basilicas, and por-
ticoes have not only been fruitful sources, but imperial palaces, notably
those on the Palatine in Rome, and imperial or luxurious private villas
outside Rome, along the Alban Hills and on the coast, have swollen the
numbers of copies in excavations undertaken from the Italian Renais-
sance quattrocento to the present day. Such villas were hardly to be
found in Asia Minor where owners of vast estates lived in the cities or in
Greece, save perhaps for the pleasure gardens of Herodes Atticus at
Kiphissia and Marathon. Latin cities must have equated wealth with the
number of statues set about baths, theaters, and the arches of am-
phitheaters such as the Colosseum. The Mausoleum of Hadrian across

the Tiber was famed for its multitude of Greek statues in Parian marble. It is no unexpected coincidence that parts of a replica of Myron's Discobolus were found amid other Roman copies around the base of the building, where the statue had no doubt been hurled during the siege of Rome by Vitiges in A.D. 537.[16]

Imagination was used in unexpected places. Copies of the Erechtheum Caryatids adorned the upper story ("attic") of a portico or side colonnade in the Forum of Augustus (fig. 3). The same classical Greek source provided prototypes for an unidentified Julio-Claudian building at Corinth, for the temple erected just outside Rome by Herodes Atticus to his wife's memory, and for the decoration of the stage building in the theater at Vaison in southern France. Another series of Erechtheum Caryatids has achieved considerable fame as adornments of one of the small, templelike buildings along the Nilotic Canal at the Canopus of Hadrian's Tiburtine Villa (fig. 4).[17] Cyrene in North Africa had a huge, Hadrianic or later portico enriched with an endless row of colossal terminal figures after the Lysippic Herakles. Green basalt was used for over-life-sized copies in the Aula Regia of Domitian's palace on the Palatine, while the so-called stadium or sunken garden nearby contained a series of miniature copies of works such as Lysippos's Labors of Herakles in the same stone, calculated to suggest antiqued bronze (fig. 52a, b).[18]

Copies were often placed in new relationships to each other, juxtapositions never envisaged by the creators of the originals. An extreme instance occurred in two portrait statues located in one of the commemorative complexes near the city gates at Perge in Hadrianic times. A Hellenistic version of the canonical "Venus Genetrix" type was carved on a plinth with a portrait copy after a draped statue of the second century B.C. To make the trick of union closer, the left hand of the "Venus Genetrix" rests on the right shoulder of the draped semidivine lady standing at the viewer's right (fig. 27). The contrast, which must have been noticed by the ancients, is almost that of artless and sated love, as if a lady of easy virtue were portrayed in affectionate relationship with her prudish sister, who seems to withdraw at the sight and touch. To heighten the effect, "Venus Genetrix" holds a bunch of grapes in her left hand, as if drink had also been one of her problems.[19]

Other such groupings were more palatable from an aesthetic standpoint. The Hermes Psychopompos in Boston, a Graeco-Roman creation based on the most manneristic elements in the statues of young

athletes (boy victors) by Polykleitos, was found at Capua. The statue was
evidently placed beside or facing the so-called Psyche of Capua, now in
the Museo Nazionale at Naples, which has been identified as a Hellenis-
tic statue of a young lady, highly idealized and raised to the rank of the
gods for funerary or commemorative purposes.[20] The original setting for
both statues was probably a funerary monument, in which or for which a
gifted master, a skilled eclectic sculptor, of the late Republic or early
imperial period selected two general prototypes at least two hundred
years apart in origin and adapted them in his own personal style to a
contemporary setting. The sculptor's hallmark was the slender,
V-shaped male and female faces. The two statues bend in a subtle, poetic
relationship to each other, their interplay of pose, and presumably loca-
tion, similar to the best Attic grave stelai of 400 to 340 B.C.

Studies of statues and their settings in late Hellenistic and Roman
times should not neglect the smaller decorative copies created for the
courtyards of houses and private gardens, for small temples and shrines,
and for less overwhelming fountain houses and waterworks. The smaller
public buildings and homes on the island of Rhodes have yielded a
variety of decorative sculptures of the type favored in domestic settings.
Mirror reversals were used in such surroundings. Aphrodites and
nymphs seated or with their feet poised on rocks were popular features
of these buildings and their immediate gardens, the reversed copies to be
seen flanking the basins of the fountains or the doorways leading from
formal nature to the indoors.[21]

Curiously enough, there is very little evidence of sculpture and its
placement in Romano-Campanian mural painting, despite the elaborate
portrayals of architecture. Rustic herms and garden temples with statues
in them are standard features of the landscapes, but the opportunities to
show sculptural ensembles were perhaps too much or too specific for the
mural decorators. For example, in the mid-first century A.D. painting of a
seaside villa with projecting wings and a porticoed facade, from the
House of Lucretius Fronto at Pompeii, there are hints of statues (or are
they people?) under the portico at the right. The figures on the central,
stagelike area, in front of the portico and behind a low wall, are arranged
in pairs like statues, but they are animated, more like patrician fishermen
waiting for a boat. In short, the temptation to place sculpture all about
the foreground is passed over in favor of open space and bands of color.
Other early imperial paintings from Pompeii, showing terraced villas by

the sea, position the fishermen where the statues ought to be but omit the sculptures.

Settings for sculpture, however, were worked out with lively imagination in the "fantastic" architecture of the so-called Fourth Style, statues like those in gold, silver, or bronze on pedestals under canopies or serving as caryatids with slender columns rising through entablatures to frames painted just below the rooms' actual ceilings (fig. 8). The name mosaic in the House of the Mosaic of Neptune and Amphitrite at Herculaneum matches painting and, as we shall see, also exceeds reality in illustrating a setting for sculpture in the lands around the Bay of Naples. The two figures are Lysippic to early Hellenistic statues set between elaborate foliate panels, under a seashell canopy, and all within a portico with the roof shown in decorated tiles. The stuccoes of the suburban baths also at Herculaneum are like neo-Attic reliefs in their placing of well-known Polykleitan period statues on plinths in architectural framework. In their relationships to each other and to the doorways, windows, and marble veneer around the lower level they are like statues displayed in the galleries of a modern museum. They suggest the symmetry but exceed in indications of size what was actually to be found in the way of statuary and reliefs in a typical Campanian villa or public building of the Augustan and Julio-Claudian periods.[22]

The usual courtyard or houseside gardens at Pompeii and Herculaneum had herms at either side and in front of the central rectangular pool. Behind these could be, left and right, pendant (and reversed) pairs of Eros embracing Psyche, then pairs of the satyr playing with (teasing) a panther, and finally the nymphs on rocks and reclining Silenos or a watergod in front of the basin below the fountain spout. The niche above the marble lion's head or tragic mask out of which the water came was occupied by the owner's choicest topiary statue, a nymph or Aphrodite standing in hipshot pose or an old Silenos lifting up his wineskin (the end sometimes becoming a spout) or a languid, youthful Dionysos. These larger life-sized or heroic-scale statues for semiprivate settings were usually of a better quality than the statues set in theater niches and monumental nymphaeum facades, but they were not strikingly better (fig. 9). They were generally products of the period 50 B.C. to A.D. 80, while the massive municipal or imperial commissions for theaters, markets, gateways, and administrative, ceremonial halls belonged to the late Flavian through the Severan periods of the Roman Empire.

The fullest "breakthrough" for the imagination of the copyist was doubtless the development and circulation of the so-called neo-Attic relief. Given their ultimate origins in the reliefs of the Nike temple parapet or the altar of the temple of Dionysos next to the theater of that god in Athens, the possibilities of dissemination became unlimited at the hands of commercially minded imperial Athenians and their Italian clientele. The repertories of processional figures, of dancing "Horae," of raving maenads and intoxicated satyrs are well known. Their application to every form of marble furnishing, from altars and bases to vases and candelabra, or to garden panels and architectural friezes, stretched the imagination to its fullest. The series of rectangular panels found in the Piraeus harbor and nearby waters, reliefs connected with the shield of the Pheidian Parthenos and other sculptures from the Parthenon program, raised the level of this art to a most respectable plane. Indeed, removed from its eclectic, derivative contexts, the large relief of a Greek on foot joining battle with a mounted Amazon is almost as spectacular as a comparable metope of the Parthenon (fig. 10).

The catalogue of a neo-Attic atelier's offerings was far from narrow, far from dull. The Roman imperial decorator could have large reliefs of Athena flying her owl in the best monumental statuary style of around 440 B.C. (fig. 11). He could have Nereids and Tritons on sea creatures, all as grand as the panels identified with a large late Republican altar base (the "Ahenobarbus Base") in Rome; these designs could be applied to objects as unusual as large flat marble basins or "birdbaths" for temple, palace, or villa gardens. From related workshops the collector or decorator could purchase updated archaic art of all forms, archaistic reliefs being no different from their neo-Attic counterparts based on designs of the late fifth and fourth centuries B.C. What the wealthy builder ordered in marble, large in size, his budget-minded counterpart could purchase in terracotta (the so-called Campana reliefs) for setting as friezes in houses of wood and plaster (fig. 12).

Scale and Duplication of Copies

Roman decorators of the second century A.D. realized that statues should and could be scaled to architecture. There were many over-life-sized Greek sculptures, particularly in the Hellenistic period, and the colossal Nero as Helios demonstrates that the desire for such creations existed in

the Julio-Claudian period. Most Roman copies of Pheidian to Lysippic statues were life-sized or only somewhat larger. The Pheidian Athenas could range up to twice or three times life-size, in keeping with the scale of the originals and because free versions of these statues had already been created for Pergamon and other Hellenistic cities in the third and second centuries B.C. The Doryphoros and Diadumenos of Polykleitos were somewhat larger than life-size, but one usually thinks of them and of other Polykleitan and Praxitelean athletic statues as being of natural dimensions despite their superhuman scale and proportions.

In a word, Graeco-Roman copyists in the first two centuries of the Roman Empire generally reproduced the scales of their prototypes, an exception being small bronzes designed to decorate the banquet tables of the wealthy. Marble copies of the fifth-century Amazons (fig. 62) or the Praxitelean Sauroktonos or the Meleager attributed to Skopas (fig. 85) were churned out for Augustan, Julio-Claudian, or Hadrianic buildings and country estates with probably little thought as to the vertical scales of their settings. They were shipped in and out of Rome to stand under colonnades, against walls, or in garden exedras. In palaces, gymnasia, and baths they were probably not out of scale with their surroundings, since these settings did not begin to become universally grand until the Antonine period, after A.D. 140.

Aside from cult images in temples, the exceptions were striking. One of these was the regal hall of Domitian's palace on the Palatine, a structure that amazed everyone in a different sense from the domestic luxuries of Nero's Golden House. The colossal statues that lined its interior were based, not without reason, on Pergamene models, for the baroque sculptures of that city in the Hellenistic period had shown copyists where they could find ready-made prototypes for their titanesque needs.[23] The same exceptional urges governed the copyists who, possibly in the time of Tiberius but probably in the Flavian period, created the marble groups for the wondrous grotto at Sperlonga, a most imaginative setting for theatrical display of supercharged sculpture. The question remains whether the Sperlonga copies were created on a large scale independently or whether their Hellenistic originals of about 150 B.C. were also worked in the same grand dimensions.[24] The Lysippic Herakles, the Farnese type, was surely created on a nearly natural scale about 340 B.C., for the colonnade of the gymnasium at Sikyon or a similar structure at Argos. About 200 B.C. the Pergamenes appear to have made a colossal version, approaching the true scale of the Farnese Hercules (fig. 21), and

this colossus was being exported from Greece as early as 80 to 65 B.C., since a copy was found among the marbles of the Antikythera wreck.[25]

After Hadrian, the demand for large-size sculptures became widespread. His famous villa at Tivoli, a series of personal architectural forms, marks a transition from Hellenistic colonnaded architecture to the niche, vault, and dome structures of the Antonine to Constantinian periods (figs. 14, 44). Works such as the Farnese Hercules, the Farnese Flora, and the group of the punishment of Dirke, known as the Farnese Bull (fig. 58*a,b*) would look ridiculous in the niches and halls of the Baths of Caracalla if they were on the same scale as most Roman copies of the Augustan to Hadrianic periods. It is no great feat to double or triple the proportions of a Greek original when making a marble copy; the settings on the pointing machine are merely multiplied accordingly. The so-called Dioskouroi of Monte Cavallo (figs. 29*a, b*, 30), based on figures from the Parthenon pediments, show that such large-scale copies were manufactured for public buildings, notably baths, throughout the third century and into the Constantinian Age.[26] Such sculptures were undoubtedly projected for the Basilica of Maxentius and Constantine in the Roman Forum, although in the end, for political and religious considerations, perhaps only the Jovian colossus with features of Constantinus Magnus was actually carved.[27]

The popularity of marble copies in the imperial period, particularly during the pan-imperial prosperity of the Antonine Age, produced not only oversized copies but also reductions. The process of copying on a reduced scale is no different from enlarging an original; the settings on the pointing machine are simply shortened in even proportions. Little versions of the Farnese Hercules or Eros unbending the bow or the standing Herakles of Myron or the Pergamene Hanging Marsyas, a very popular excerpt from a three-figured group, were carved to stand in household courts or in the niches of miniature gardens and little fountains. The market for such works of copyism was no different from the demands of eighteenth- and nineteenth-century Europe and America, which admired small marble and metal replicas not only of ancient copies but of Florentine masterpieces from Donatello to Michelangelo and even Bernini.[28] Antonine, Severan, and later taste was as limited on a personal level as it was among imperial decorators, for the same limited repertory of classic Pergamene and slightly earlier athletic figures, sensuous creations like the Barberini Faun, or multifigured groups that were carved on a heroic or colossal scale were retailored to serve the trade in reductions

and miniatures. Naturally, there were many more miniatures than monsters, for many men of means demanded an erotic group in their household nymphaeum but one Barberini Faun could serve a very wide audience.

Roman decorators seemed to take pleasure in placing more than one copy of an original together so that they balanced each other in a semicircular series of niches or stood at opposite ends of a tree-lined vista. The same acquisitive urges that move modern collectors must have driven ancient spenders, whether emperors like Tiberius, Nero, or Hadrian, or private citizens such as Herodes Atticus, to buy duplicates or to concentrate on variations after the same limited range of Greek masters. It is not uncommon for a collector of United States coins to amass two or three sets of each series such as Liberty Head or "Barber" half dollars from 1892 to 1916. And if the owner of the Roman seaside villa on the small promontory dominated by the castello of Santa Marinella had two rather different copies of the Skopasian Meleager among other statues in his garden exedra, it might have been because he inherited the inferior (Berlin) example and purchased the sensitive (Fogg) copy to provide a contrast. The villa itself seems to have spanned the first and second centuries of the empire.[29]

At Tivoli Hadrian possessed copies of everything available on the market and also copies of a number of exotic Egyptian and Hellenistic prototypes that must have been executed especially to suit his tastes, much as a modern American will suddenly lust for something extraordinary in automobiles or architecture on the basis of a little nostalgia engendered on a grand tour or purely from affluent boredom (figs. 13–17b). He owned at least two copies of Myron's Discobolus. Two replicas of the Pheidian Amazon stood not far from each other, one at the end of the Canopic Nile and another in the gardens, along a cryptoporticus on the way to the main buildings (near the Casino Fede). In the lowland grove known as the Pantanello, Gavin Hamilton found two replicas of the Pergamene group identified as Menelaos with the body of Patroklos. They must have stood cheek by jowl in the grove which also sheltered a diversity of Roman copies, imperial portraits of Hadrian and the family of Antoninus Pius, likenesses of Antinous, and marble vases or decorative reliefs. There was even an Ephesian Artemis, worthy company at least for the famous four or five Amazons. Hadrian's pleasure dome offers numerous other instances of Roman copies acquired or at least installed in duplicate.[30]

Roman copies and imperial statuary found with them can be documented in duplicate sets at a number of other sites throughout the Mediterranean world. Of Gavin Hamilton's excavations in 1771 in the Tenuta di San Gregorio, then the property of Cardinal Ghigi, and commonly called "Tor Columbaro" (later named Torracio di Palombaro), A. H. Smith has written, quoting Dallaway,

> Two spots were selected, one upon the Appian Way, and the other about a quarter of a mile distant. The first, Mr. Hamilton supposed to have been a temple of Domitian, and the other a villa of Gallienus, . . . nine miles from Rome. . . . This temple had been probably robbed by Gallienus, and the ornaments placed in his own villa, as there were no competent artists in that low age. Mr. Hamilton is confirmed in this conjecture by the number of duplicate statues which he found in this excavation, of most, if not all, and one, in every instance, inferior to the other, consequently the one original, and the other a repetition or copy, by some artist in the reign of Gallienus.[31]

The fact of duplicate statues is obvious or, at least, incontrovertible, but Hamilton's chronologies and the reasons for the presence of duplicates have suffered other, less positive explanations. As in the villa at Santa Marinella, it would seem that the wealthy owners of the country house off the Appian Way craved pairs of similar statues. Like the Fogg and Berlin Meleagers, one of each statue was palpably a finer work of art. Hamilton's lists do not make clear just what happened to the inferior specimens. The heroic-scale young Marcus Aurelius as a Dioskouros ended up at Lansdowne House (fig. 61), but the head may have belonged to the other statue, and in any case the pendant must have portrayed another prince, perhaps Antoninus Pius or Lucius Verus.[32] Identifiable masterpieces of copyism include the Belvedere Hermes, presumably after Praxiteles, the standing Discobolus of Naukydes or Alkamenes (also Vatican), and the Lansdowne Amazon identified with Polykleitos or, less likely, Kresilas (fig. 62).[33] The Lansdowne correspondence mentions another Amazon, and Roman collections contained other copies of all three statues. Having sold his prime copies well, the canny Scot probably remaindered the alleged duplicates to restorers, other dealers, or friends among the Roman nobility. The Antonine portrait makes it difficult to identify the villa either with Domitian or Gallienus, but the effect of the statues of various sizes, duplicates and otherwise, in their niches must have rivaled the results achieved by Gavin Hamilton and Lord Shelburne in their installation of the dining room at Lansdowne House off Berkeley Square (fig. 45).[34]

Remarks attributed to the sage and crafty emperor Tiberius give a measure of the early imperial unimportance of statues in natural settings, their existence as decorative adjuncts rather than focal points of beauty. During the time of informers and tenuous accusations, a Roman was charged with high treason for having sold a statue of Augustus together with the parkland in which it (and presumably its aedicula or exedra) stood. Tiberius, however, gave the pointed and worldly judgment that his adoptive father had not been elevated to the ranks of the gods to trick citizens into misfortune, and that it was no worse to sell statues of emperors than images of gods together with the parks and houses in which they had been placed. The whole process, therefore, was reminiscent of England in the eighteenth and nineteenth centuries when country houses, their contents including portraits, and the statues in their gardens could pass by bequest, by private treaty, or by public auction to persons scarcely connected with or absolutely unrelated to the former owners.

Places of Manufacture

Copies were produced in Athens or close to convenient ports from the Piraeus to those of Corinth. They were also blocked out at major quarries from inland Attica to near Nicomedia in Bithynia or near Kition on Cyprus and then shipped, like roughed-out sarcophagi, to be given finishing touches where they were going to be installed. That there was a large traffic of finished or nearly finished marble copies flowing from the Greek East to the Latin West is deduced from the number of unfinished statues and busts found in Athens compared with relatively few such items from Rome or, for example, from Hadrian's Villa at Tivoli. Yet, the uniformity of style among decorative sculptures at the latter pleasure dome, and the sheer volume of mythological figures, herms, busts, columns, and vases in marbles and colored stones from Italy to Greece and Egypt suggest ateliers must have settled in the vicinity to carve, just as architectural carvers came from Athens or Ionia to the Villa Adriana by way of Olympia.

Whether the sculptures in the style of Aphrodisias around A.D. 200 (or a generation before and after) were carved in the city or at the quarries farther inland seems immaterial against the discovery of such statues as far afield as Tomi-Constanza on the west coast of the Black Sea or the

The Ancient City of Athens (Cambridge, Mass., 1953), pp. 207–10. Also J. Travlos, *Pictorial Dictionary of Ancient Athens* (New York, 1971), pp. 244–53: statues and books were displayed in the niches of the main room at the east end, the former also in the colonnades.

6. Brueckner, *Friedhof am Eridanos*, fig. 34, after a reconstruction by H. Kinch. Three reliefs from a base in the National Museum, Athens, of about 390 B.C. show horsemen, wearing petasoi, riding over fallen warriors; although the reliefs do not present true mirror reversals, it is obvious that the concept is being struggled with here for one presents the scene as if seen from the other side. See G. M. A. Richter, *AJA* 63 (1959): 242, pl. 52, figs. 6 f.; G. Karo, *AA* (1931), cols. 218 ff., figs. 1–3.

7. Brueckner, *Friedhof am Eridanos*, p. 71, fig. 43.

8. Brueckner, *Friedhof am Eridanos*, p. 82, figs. 47–49. Fig. 50 shows the bull in mirror reversal, on a Graeco-Roman gem. These bulls were also reversed in monumental Attic funerary sculpture as the example of about 345 B.C. now in Copenhagen, Ny Carlsberg Glyptotek; C. Vermeule, *AJA* 76 (1972): 57, pl. 12, fig. 6.

9. The best examples are the two colossal marble lions, about 320 B.C., found in front of a funerary compound at Tampourias in the Piraeus; they now dominate the garden of the Piraeus Museum. See F. Willemsen, *Die Löwenkopf-Wasserspeier vom Dach des Zeustempels*, Olympische Forschungen, vol. 4 (Berlin, 1959), p. 131, pls. 57, 60; C. Vermeule, *AJA* 76 (1972): 55, pl. 14, fig. 12.

10. R. Kekulé von Stradonitz, *Beschreibung der antiken Skulpturen*, Königlichen Museen zu Berlin (Berlin, 1891), pp. 195–96, no. 499. C. Blümel, *Katalog der Griechischen Skulpturen des Fünften und Vierten Jahrhunderts v. Chr.* (Berlin, 1928), pp. 13–14, K 13 a, b, pls. 18–21.

11. Quoted from Pollitt, *Art of Rome*, pp. 76–77: *Ad Atticum* i, 8, 2; i, 10, 3; and i, 4, 3.

12. Astor imported eight Roman sarcophagi from Italy and lined them up in groups of four on the lawn at Cliveden; the family also filled the grounds of Hever Castle in Kent with a varied collection of statues, busts, sarcophagi, and reliefs. See C. Vermeule, "Classical Collections in British Country Houses," *Archaeology* 8 (1955): 12; D. E. Strong, *The Connoisseur* 158 (April, 1965): 224–25.

13. Reconstruction of an anonymous tomb, Roman in form and evidently of the Augustan period, at Aquileia with lions on the corners of the podium: B. Andreae, "Fundbericht Nord und Mittelitalien 1949–1959," *AA* (1959), cols. 141–42, 143, fig. 19.

George Niemann's reconstruction of a section of the balustrade reliefs, the floral enrichment, and the metopes of the Trajanic victory monument at Adamklissi has included reversed lions, their heads facing outward, between the standing, bound captives in the upper paneling. See L. Budde, *Die Entstehung des antiken Repräsentationsbildes*, p. 12, fig. 28. Niemann's full view of the Trophaeum Traiani, with Roman legionaries seated on the steps or posturing in the middle ground and a rustic with his mastiff looking on in amazement, features these paired lions at intervals of four or five crenelations with standing captives, all around the monument: Budde, fig. 27. While only two-thirds of the monument of Philopappos in Athens survives, the semicircular central niche with the heroic seated statue and the rectangular niche to the viewer's left with the seated ancestor clad in Greek magistrate's dress give a good illustration of how Graeco-Roman mausolea or cenotaphs could relate statuary to reliefs in balanced compositions. The central figure was Philopappos himself, while Antiochus, son of King Antiochus, sat on the left and King Seleucus Nicator, son of Antiochus, sat in the rectangular niche which is now missing but which was preserved as late as the middle of the fifteenth century. The date of the tomb (C. Julius Antiochus Philopappos was placed, presumably in a sarcophagus, with other statues above him in the interior center of level B) was between A.D. 114 and 116: see J. Travlos, *Pictorial Dictionary of Ancient Athens*, pp. 462–65. On the analogy of so many other Greek and Roman monuments, perhaps with less grand schemes of triumphal or civic relief as the processional panels on the facade of level B, it is easy to picture pairs of pendant lions having been placed at the four corners of the base or podium, although they must have long since gone into fortification walls and thence to the limekiln.

14. Quoted from J. J. Pollitt, *The Art of Greece, 1400–31* B.C. (Englewood Cliffs, N.J., 1965), p. 135: *Philopseudes* 18.

15. See K. Jex-Blake and E. Sellers, *The Elder Pliny's Chapters on the History of Art* (London, 1896), pp. lxxxv–xci, sec. 8.

16. See Paribeni, *Sculture greche*, p. 24, no. 23. Procopius (*Bello Gothico* I. 22) reported, "statues of men and horses of (Parian marble) in the upper part." R. Lanciani, *Ancient Rome in the Light of Recent Discoveries* (Boston, 1884), p. 293, writes: "In 537, during the siege of Rome by Vitiges, the mausoleum of Hadrian, which had been long since fortified, was furiously assaulted, and the statues which adorned its forty-eight intercolumniations, for the most part masterpieces of Grecian art, were hurled down upon the heads of the assailants."

17. Caryatids in the Forum of Augustus, circa 4 B.C.: E. Schmidt, *Die Kopien der Erechtheionkoren*, pls. 1–5, figs. 1–22; G. M. A. Hanfmann, *Classical Sculpture* (Greenwich, Conn., 1967), p. 319, no. 147: "In a programmatic 'quotation' which makes Classical Greek art part of his ideal Roman state the emperor Augustus introduced copies of Erechtheum maidens into his Forum. Form and function

changes as the maidens march above representations of Roman triumphators from Aeneas to Augustus." (See fig. 3.)

18. One of these small copies, Herakles and the Nemean lion, is on loan to the Museum of Fine Arts, Boston, from a private collection in Cambridge, Mass. It was found during the excavations made in Lanciani's time. C. Vermeule, *The Burlington Magazine* 110 (1968): 549. (See fig. 52*a, b.*)

19. J. Inan, "Neue Porträtstatuen aus Perge," in *Mélanges Mansel* (Ankara, 1974), vol. 2, pp. 654–55, no. 7, vol. 3, pl. 206.

20. L. D. Caskey, *Catalogue of Greek and Roman Sculpture* (Boston and Cambridge, Mass., 1925), pp. 143–44, no. 70 (Hermes). B. Maiuri, *Museo Nazionale di Napoli* (Novara, 1957), p. 29: 'Quando, nei primi decenni del' 700, fra le gigantesche rovine dell' Anfiteatro di Capua, apparve questa bella scultura frammentaria, insieme con le accademiche e integre statue dell' Afrodite e dell' Adone," The differences are so great that one suspects the "Psyche" and the Hermes came from a monument next to (?) the amphitheater.

21. G. S. Merker, *The Hellenistic Sculpture of Rhodes,* Studies in Mediterranean Archaeology, vol. 40 (Göteborg, 1973), pls. 4–7, figs. 9–15. A fair number of Roman tombs were small-scale reflections of the Mausoleum at Halicarnassus, such as the local stone tomb of Lucius Poblicius, a contractor, in Cologne and originally on the highway toward Castra Bonna (Bonn): see *Art and Archaeology Newsletter,* vol. 3, no. 36/37 (1975): 7 (175).

22. These "villa maritima" paintings are illustrated in J. H. D'Arms, *Romans on the Bay of Naples* (Cambridge, Mass., 1970), pls. 13–15B, in comparison with actual sites. See also A. Boëthius and J. B. Ward Perkins, *Etruscan and Roman Architecture* (Baltimore, 1970), pls. 95, 160, etc. J. Lukas and Sir M. Wheeler, *Pompeii and Herculaneum* (London, 1966) illustrates paintings, mosaics, and stuccoes in their settings, including the mosaic of Neptune and Amphitrite, pp. 128–29, and the stuccoes of the suburban baths at Herculaneum, pp. 148–49.
The Khasne, the most spectacular of the rock-cut tomb facades at Petra in Arabia, used to be dated generally in the Antonine or Severan periods, but Margaret Lyttelton has suggested the early first century B.C. from analysis of architectural details: *Baroque Architecture in Classical Antiquity,* pp. 70–79, pl. 1. (See fig. 7.) The settings of the statues in high relief in the round "tempietto" and broken pediment above (a Tyche flanked by unusual trophies), and in the outer intercolumniations of the hexastyle pedimental facade below (seemingly pairs of heroic figures), correspond most in the realities of stone to what Romano-Campanian mural decorators were to do in paint, plaster, and stucco in the Second to Fourth Styles, from the late Republican and Augustan periods to the height of the Flavian era. M. Lyttelton (p. 202, pl. 116) illustrates part of the Fourth Style fresco from the House of the Gladiators at Pompeii, showing an Oil

Pourer on a plinth in front of an aedicula; this athlete, however, is hardly different from the more animated Apollo and Leto or a Muse (or actors?) a few niches to the right.

The garden nymphaeum in the House of Marcus Lucretius at Pompeii, excavated in 1847, gives the most succinct illustration of how a statue of purely Roman taste should be displayed in an appropriate niche of very elaborate character. The semicircular niche is relatively small and elaborately enriched with mosaic, ribbing, and patterns to match the curve of the hemicycle and the arched frame. The white marble statue in the niche is an old bearded Silenos, the wineskin on the support at his left side. Marble-covered steps lead up to the figure, which stands on its own small plinth as befits a decorative collector's piece. See N. Neuerburg, *L'Architettura delle fontane e dei ninfei nell' Italia antica,* pp. 131–32, no. 36, fig. 123.

All these relatively small adjuncts to Roman domestic architecture, as seen in numerous examples at Pompeii, or at Ostia (Neuerburg, fig. 124), and elsewhere are the "life-sized" creations similar to the famous tabletop fountain from Cobham Hall in Kent (fig. 9) and later in the art market (Spink and Son) in London: see Neuerburg, p. 76, fig. 141 (after B. de Montfaucon's engraving); also *AJA* 59 (1955): 133, pl. 42, fig. 10. Father Nile reclines in the central niche, and the taller niches at either side must have contained statues of Isis and Serapis, or similar small images of Africa and Alexandria, making the whole ensemble a miniature version of the Canopus and Euripus complex in Hadrian's Villa at Tivoli. One can go further and project such settings on a grand architectural scale for the colossal (or nearly so) statues of reclining rivergods (Nile, Tiber, Tigris, Euphrates) found in the Campus Martius and in the various thermal establishments of imperial Rome.

23. Survivors of these colossi, over twice life-size in green basalt or schist, were carried off by the Farnese to their provincial stronghold of Parma. See J. Sieveking, "Zwei Kolosse vom Palatin in Parma," *JdI* 56 (1941): 72–89, pls. 2–4. R. Brilliant, *Roman Art from the Republic to Constantine,* pp. 247–48, fig. VI. 32 (the Hercules, the surviving pendant being Bacchus supported by the satyr Ampelus).

24. The signatures of the Laocöon sculptors on the Sperlonga copies are, of course, adapted from the original sculptures or their bases. See Hanfmann, *Classical Sculpture,* p. 330, no. 238; and especially, A. Herrmann, *AB* 56 (1974): 275–77. How the sculptures were set up in relation to each other at Sperlonga has provoked considerable debate: see *Art and Archaeology Newsletter,* vol. 3, no. 36/37 (1975): 11 (179)–13 (181); *AP* 14 (1974); *Archaeology* 24 (1971): 136–45.

25. J. N. Svoronos, *Das Athener Nationalmuseum,* German translation published by W. Barth (Athens, 1908), vol. 1, pp. 54–86, esp. p. 58, pl. XI, no. 1; S. Reinach, *Répertoire de la statuaire grecque et romaine* (Paris, 1908), vol. 3, p. 248, no. 1, shows that the Antikythera Herakles once had a plaster head, from the copy

in the Palazzo Pitti, now removed; F. P. Johnson, *Lysippos* (Durham, N.C., 1927), pp. 197–200; J. Marcadé, *BCH* 81 (1957): 409–13, figs. 2–5.

For a bibliography of the Antikythera wreck see G. Bass, *Archaeology under Water* (London, 1966), pp. 79–82; P. C. Bol, *Die Skulpturen des Schiffsfundes von Antikythera* (Berlin, 1972), pp. 7–10.

26. Lippold, *Handbuch*, vol. 3, no. 1, p. 156, pl. 56, no. 4: as late works of Pheidias. H. A. Thompson, *Hesperia* 19 (1950): 121–22, pl. 77a, b.

27. Medallions of Constantine show the marble colossus, of which considerable fragments survive, was enthroned in the pose and traditions of the Pheidian Zeus at Olympia; the statue was thus the direct forerunner of Horatio Greenough's ill-received heroic statue of George Washington as Jupiter, now in the Smithsonian Institution in Washington. See H. Kähler, "Konstantin 313," *JdI* 67 (1952): 1–30. R. Calza, *Iconografia romana imperiale, III, Da Carausio a Giuliano* (Rome, 1972), pp. 228–31, pl. LXXIX.

28. The Neapolitan firm of De Angelis, later merged with Chiurazzi, made a practice of supplying such copies on all scales and in all materials during the Victorian and Edwardian eras. See *Chiurazzi Società Anonima, Fonderie, Ceramica, Marmeria* (Naples, 1929). The practice continues, although on the limited scale dictated by modern taste. See N. Neuerburg, *Herculaneum to Malibu, A Companion to the Visit of the J. Paul Getty Museum Building* (Malibu, 1975).

29. G. M. A. Hanfmann and J. D. Pedley, "The Fogg Meleager," *AP* 3, no. 3 (1964): 61–63, pls. 58–71; R. Kekulé von Stradonitz, *Beschreibung der antiken Skulpturen* (Berlin, 1891), p. 93, under no. 215, the Berlin statue: "Gefunden 1838 am Meeresufer unweit Santa Marinella bei Ausgrabungen der Herzogin von Sermoneta." The head and neck are restored. See also on the reversals of Meleagers: C. Vermeule, *Boston Museum Bulletin* 65 (1967): 175–76, figs. 1, 2; and chap. 2, nn. 19, 20.

30. H. Winnefeld, *Die Villa des Hadrian bei Tivoli* (Berlin, 1895), pp. 158–60; P. Gusman, *La Villa Impériale de Tibur (Villa Hadriana)* (Paris, 1904), pp. 271–300; Paribeni, *Sculture greche*, p. 57, no. 98 (Pheidian Amazon found in 1928); S. Aurigemma, "Lavori nel Canopo di Villa Adriana—I,—II," *BdA* (1954): 327–41; (1955): 64–77, points out that the two Amazons (Polykleitan and Pheidian) and other fifth-century statues found in the hemicycle of the Canopus have identical plinths and were therefore part of a specific order by Hadrian for the canal vista.

31. A. H. Smith, *The Lansdowne Marbles (Ancient Marbles at Lansdowne House)* (London, 1889), pp. 5–6; reprinted in *Lansdowne Marbles*, Christie's Sale, March 5, 1930, pp. 4–6, and under the various lots in question.

32. Lansdowne, no. 63; Christie's Sale, p. 15, lot 17. See also C. Vermeule, *AJA* 59 (1955): 131; *EA*, nos. 3058–59.

33. Amazon: Lansdowne, no. 83; Christie's Sale, pp. 39–40, lot 59; G. M. A. Richter, *Catalogue of Greek Sculptures*, Metropolitan Museum of Art, New York (Cambridge, Mass., 1954), pp. 29–30, no. 37, pls. 34–36. D. von Bothmer, *Amazons in Greek Art* (Oxford, 1957), pp. 219–22. Discobolus: see chap. 2, n. 16. Hermes Belvedere and replicas: M. Bieber, *The Sculpture of the Hellenistic Age* (New York, 1961), p. 17.

34. *Two* (were there once more?) copies of the so-called Demeter of Cherchel were found and stood in a building southeast of the "Esplanade" at Caesarea. They could have represented Demeter and Kore, although usually the mother and daughter differ in size and degree of majesty when seen together. See S. Gsell, *Cherchel, Antique Iol-Caesarea*, pp. 68–70, no. 102. S. Gsell suggested they might have been Horae or Seasons, but these seem awfully impressive statues for such abstract concepts presumably in the Hadrianic or early Antonine periods. They could have been geographical personifications of the most general sort such as Ge or Terra Mater (Mother Earth) and Oikoumene or the Universe. The copy of the Terra Mater–Italia relief of the Ara Pacis from Carthage shows that the North Africans in the imperial period had a taste for such concepts, and the only cuirassed statue (Augustus or Hadrian or a Hadrianic Augustus) other than the Primaporta Augustus with a purely symbolic breastplate is from Cherchel. Since at least one kalathos-bearing caryatid (?) of the Tralles type was found at Cherchel (pp. 70, 91, no. 103), the two "Demeters" could have had an architectural purpose in relation to their settings. In any case, the Romans of Iol-Caesarea were very serious-minded to have commissioned or imported two such grandly Pheidian figures for either cult or architecturally decorative purposes. The caryatid has been identified as a rare and sophisticated creation of the period from 370 to 330 B.C., of which very few versions have been recorded, making the taste of the Roman imperial Cherchelians all the more selective. See Lippold, *Handbuch*, vol. 3, no. 1, p. 244, and further parallels.

II: Creative Commercialism for Architectural Display

Graeco-Roman Mirror Reversals of Greek Statues

Although mirror reversals represent a seemingly unusual deviation from the normal province of copyists, this type of image was as easy to produce as enlarged or miniature replicas. The horizontal arms of the pointing machine are merely made to pivot on an axis of 180 degrees, and all postures or details would be duplicated in reverse as if the original were reflected in a looking glass. The Greeks, never without an aesthetic purpose in creating works of art, had made reversed versions of sculpture to balance specific settings, notably the corners of buildings or platforms. The Romans ordered mirror reversals of Greek originals as part of their use of marble copies in grand schemes of engineering and architectural decoration of a theatrical nature. If eight statues were needed to fill the eight niches of an apse with melon half-dome, such as Hadrian invented at his villa (fig. 44), the outside pair or the two statues closest to each other could be mirror images. If a garden house called for only two statues under its portico or on its balustrade, it would have been a triumph of invention to make one a mirror reversal rather than to choose two complementary copies of different originals. After all, the Erechtheum Caryatids had been near versions of mirror images in their ponderation and handling of attributes (fig. 2), and such taste would have received the blessings of the Pheidian Age in being transferred to freestanding Roman copies. The most widespread uses of mirror copies, however, must have been in connection with the grand facades of theater buildings, fountain houses, and market halls of the second century A.D. inspired by the painted interiors of the so-called Fourth Pompeiian Style.

Mirror images are not plentiful among surviving Roman copies of Greek originals, but enough exist among standard types of the fifth and fourth centuries B.C. to make the subject important not only to the whole scheme of Roman decoration but to the aesthetic study of copyism in itself. In one instance, the celebrated Apoxyomenos identified with Lysippos, our understanding of the awkwardness of the surviving copy in marble is sharpened if we realize that the statue found in the Trastevere shortly before the middle of the last century is nothing more than a mirror reversal of the lost bronze original. In arguing that the Vienna rather than the Vatican Apoxyomenos is the true Lysippic type, Charles Morgan wrote, "The adherents of (the Vatican) type have always explained the lack of other copies in the observation that the pose of the projecting arms made too difficult a transition from bronze into marble,"[1] The awkwardness or lack of dependence on precise details of a Lysippic bronze may have been the copyists' adaptations, first in the correct order and then in reverse. The Vienna bronze Apoxyomenos, a life-sized copy found at Ephesus, also exists in marble on various scales, down to tabletop miniature,[2] and in mirror reversals.

In the year 1819 a number of statues, now in the Braccio Nuovo of the Vatican, were found near Tivoli, in the so-called Villa of Quintilius Varus or of Cynthia. A pair of satyrs sitting with wineskins on their laps and bunches of grapes in their raised hands, at which they stare, are exact mirror reversals, the prototype having been created during the so-called Hellenistic rococo of the second or early first centuries B.C.[3] A pair of Nereids on hippocamps are not precise reversals, both probably copying akroteria of the age of Timotheos at Epidaurus about 370 B.C., but they are close enough in their opposition to have been commissioned, like the satyrs, to balance each other on fountains or in small exedras and niches (fig. 18). In niches of one room were found a series of at least four marble athletes, all slightly smaller than life and copied in pairs after the so-called Dresden-Munich Oil Pourer and the Ephesus-Uffizi-Boston Apoxyomenos.[4] Neither of the two Oil Pourers is a mirror reversal. It is impossible to tell about the two athletes scraping themselves since only the head of one copy was installed (on the body of the first Oil Pourer) in the Vatican. The balance and reversal are, in a sense, more subtle since the scrapers are ponderated in opposite direction from the Oil Pourers and since the arms of the two types form a juxtaposition and partial reversal. Thus, all four statues could have been intermingled, two by two, in the niches of a room, to create a form of total visual

harmony worthy of the architecture. Another statue, perhaps a Herakles, no doubt separated the pairs, just as such statues are arranged within architectural facades on so-called Campana architectural terracotta plaques of the first and second centuries A.D. (fig. 19).[5] It is not without an instinct for tradition that the remains of this group from Varus's or Cynthia's villa are displayed in the niches of a rotunda in the Braccio Nuovo (fig. 20*a, b*).

One of the most dramatic sources of mirror reversals amid oversized copies is the Baths of Caracalla in Rome (fig. 57). This program of architecture, sculpture, plastering, mosaic, and painting summed up tendencies in titanism that were to persist from the third century well into the fourth. Alexander Severus (222–35) finished the portico of Elagabalus (218–22) around these baths, and the *Historia Augusta* noted the penchant for giant sculptures in connection with the career of Alexander, last of the Severans: "He set up colossal statues in many cities, made by artists summoned from all over the world."[6] The author was referring chiefly to portraits, but decorative statues in the tradition of the Farnese Hercules must have been a part of current imagery also. The Farnese Hercules is one of the statues from the Baths of Caracalla of which a pendant was found in modern excavations on the site (fig. 21).

> Da questo luogo infatti provengono un numero notevole di copie in doppia edizione, alle volte identiche, altre volte antitetiche, come rivelano i frammenti di un secondo Herakles Farnese e di un secondo Atamante in schema inverso.[7]

The presence of a second Farnese Hercules of this nature may alter the emphasis placed on the copy signed by Glykon of Athens which has excited the imagination of many generations since the age of Michelangelo. Among other versions on various scales from finds throughout the Mediterranean world, from Salonika to Delos to the Latin West, a half-life-sized reversal of the Farnese Hercules type exists in the museum at Chania on Crete. This statue is an awkward creation, produced by some provincial sculptor after a more polished mirror image. The local artist altered the left arm to rest on the hero's hip, thus recalling an older Herakles of about 350 B.C., the Copenhagen type, that has sometimes been identified with Lysippos like the forerunner of the Farnese Hercules.[8] If such be the case, the Herakles of the Copenhagen type was probably a work of Lysippos fairly early in his career, while the prototype of the Weary Herakles was created no earlier than the outset of the reign of Alexander the Great (334–323 B.C.).

A statuette in marble, in the Walters Art Gallery at Baltimore, came from the Dattari collection and therefore, presumably, originated in Egypt. The Weary Herakles of a type popular among the inland and southern coastal cities of Asia Minor is shown in mirror reversal, the head looking upright as on many later Greek and Roman imperial coins. The figure in Baltimore is so small that it could only have been placed on a table in a building or in a miniature garden setting. Mirror reversals were no more difficult in miniature than on heroic or life-sized scale, and they were as popular as their grander counterparts. A life-sized or larger reversal of the Lysippic Weary Herakles was on the art market in London not long after the First World War (fig. 22), and several catalogues of old collections record such variations in marble in which the lion's skin is worn as a cap over the head or in which the weary old hero has been changed to Eros with club, skin, and apples or intoxicated old Silenos, perhaps watching the drinking contest between Dionysos and Herakles. One could imagine a large mythological mosaic of Dionysos outdrinking Herakles, flanked by a copy of the canonical Weary Herakles, a Dionysos of Praxitelean type, and an Eros or a Silenos complete with the appropriate attributes, in mirror reversal. Since such combinations occurred in decorative programs of wall painting and floor mosaic and since they will be seen to have been adapted from freestanding statues for the niches of columnar sarcophagi (figs. 38–40*b*), they can certainly be presumed to have existed where copies of all types were used with the imagination characteristic of the Graeco-Roman decorators and their patrons.

Of the "Armed Aphrodite" on Acrocorinth, one of the cult images of the city, O. Broneer has written,

> The original, of which the Aphrodite of Capua is considered to be the most faithful copy, Furtwängler assumed to have been made in the fourth century B.C. for the Corinthian acropolis. At the destruction of the city in 146 B.C., this original statue, according to the same author, disappeared and was replaced by a copy at the time of the colonization of Corinth by the Romans. The only difference between the late copy and the original was the reversal of the sides. On nearly all the coins from Corinth which show on the reverse a figure of Aphrodite with the shield, the goddess holds the shield on her right side, whereas the opposite was supposedly true of the Aphrodite of Capua.[9]

This new creation should be classed as a partial mirror reversal, for the positions of the himation about the lower limbs and the legs beneath seem to have been similar to the lost pre-Roman statue of which the Roman copy known as the Aphrodite of Capua is a fairly faithful mem-

ory. Regardless of the date when the second image was executed (and it must have belonged to the revival of Corinth under Julius Caesar and Augustus), the statue testified to the habit of early imperial artists to reverse familiar compositions, to create novelties that were based on thoroughly tested designs. Both the old statue, relief, or painting and the novelty could then, side by side, provide useful sources for the mechanical copyist and imitator in the minor arts. The Aphrodite of Capua was quickly turned into a Victoria supporting a shield, plaque, or scroll, and the same Graeco-Roman decorators used the new statue, the partial reversal on Acrocorinth, as prototype for the Victoria that balanced the trophy or inscription on the other side.[10]

The Aphrodite known as the Venus Genetrix type, one often used for portraits of Roman ladies of fashion, can be found in two general groups of replicas, one a mirror reversal of the other.[11] The statue in the Villa Torlonia-Albani at Rome belongs to the group with the left arm raised behind the shoulder (fig. 23), while the figure from the Roman baths at Argos has the raised right hand tugging at drapery from the shoulder (fig. 24). Various copies used as portraits differ from the prototype in a detail of the garment—chiton or long transparent outer himation—which covers the breasts, according to the modest desires of the Roman matrons whose heads were substituted for those of Aphrodite. Fortunately, historical references seem to allow us to pinpoint the date when the mirror reversal entered the repertory of Graeco-Roman art. This date was doubtless not long after the cult image of Venus mother of the Julian Gens and therefore of the Roman race was created by a neo-Attic sculptor named Arkesilaos for the temple of Venus Genetrix in the new forum laid out by Julius Caesar and completed by his heir Octavian or Augustus (figs. 25, 26). This must have been about 45 B.C.[12] The ultimate prototype, like that of the new Aphrodite of Acrocorinth, was much older, in this case going back to an Aphrodite created by Alkamenes or Kallimachos about 420 B.C. The image of Venus Genetrix may have been a mirror reversal of the classic post-Pheidian type, but it is more likely that the group of reversed statues came out of the imaginative search for novelties that characterized decorative sculpture in the first century of the empire (fig. 27).

As reversals of each other or as derivations from separate Pheidian prototypes, the Dioskouroi of the Quirinal belong to a class of quasi-architectural sculpture that derived from over-life-sized models to begin with or that magnified their sources in Hellenistic or Graeco-Roman times. With the Dioskouroi, in the problem of sources and reversals,

belong the Tritons and giants from the rebuilt Odeon of Agrippa in the
Athenian Agora, works of the Antonine period (fig. 28), or the idealized
eastern captives from the Stoa of the Colossal Figures at Corinth, colossal
carvings of the early Severan period.[13] The Amazons set against pillars
from the Antonine theater at Ephesus were a logical extension in Greek
imperial architectural terms of the settings originally planned for the four
or five Amazons created around 435 B.C. for the Ephesian Artemision.
There is no telling how many copies of the original Amazons were
adapted to the architecture of the theater, but there may have been up to
a dozen or more, and the several survivors confirm the use of mirror
images, like the traditional Caryatids.[14] The relationships of the Dios-
kouroi on Monte Cavallo to their building (figs. 29*a*, *b*, 30), the Baths of
Constantine or Aurelian's Temple of the Sun, have been defined by H.
A. Thompson: "Since each of the Tamers forms an angle of 90° with his
horse, the human figure presumably stood against the outer face of the
jamb while the horse, facing outward, stood parallel to the reveal of the
doorway."[15]

Myron's Discobolus exists in miniature, but to my knowledge no
mirror copy has as yet been discovered or identified. There is at least one
marble version of the standing Discobolus attributed to Alkamenes or
Naukydes that is both a radically reduced copy and a mirror reversal (fig.
31). Another reduction, correctly oriented, has been noted, but the four
or five principal marble replicas of the lost bronze statue are all just a trifle
larger than life (fig. 32), like most of the athletic statues from the school of
Polykleitos.[16] Mirror reversals are common among Roman copies after
Hellenistic rococo statues of Erotes and children. They include the Eros
running with an object such as a torch in his outstretched hand, the Eros
or child seated and asleep, mourning, or just plain daydreaming, often
turned into a figure atop a fountain, and the child pressing down one
hand on a small goose. Related to the last are the figures, found in
reversal, of the infant Herakles (and his brother) wrestling with the
snakes in the crib. In this manner, pairs of Erotes, one in reverse, could
be thought of as Eros and Anteros. In one instance there is some evi-
dence that just such a pair of little figures were placed as if to watch a
satyr and a maenad dancing in a group created before 67 B.C. and set up
in the shrine of Poseidon and Amphitrite at Kionia on the island of
Tenos.[17]

Pheidias and his associates created several majestic, fully draped
statues of matronly goddesses, principally Hera, and these have been

recognized in full-scale marble copies, in reduced versions, and in reversals. A statuette in Copenhagen, perhaps once with a portrait head but perhaps merely an ideal copy, relates to the type known as the Hera of Ephesus. There are several exact copies of this work, large marbles after an original contemporary with the Hera Borghese, but the reduction in Copenhagen is a variation in reverse. A portrait statue in Berlin also presents the same Pheidian type in reverse.[18] In addition to possessing the famous Meleager from Santa Marinella, the Fogg Museum of Harvard University also possesses the only reversed Meleager known to me. The head of this full-sized, rather summary version survives. The owner of the Roman villa at Santa Marinella would doubtless have been extremely happy if he could have purchased one or two reversed Meleagers to supplement his orthodox copies. Perhaps he did, and they remain to be discovered or identified. Romans had themselves portrayed in the guise or motif of Meleager, and the unfortunate hunter was a popular theme on sarcophagi. A sarcophagus in the Museo Nazionale Romano from the Vigna Mellini gives an illustration of what the mirror reversal could have suggested; the figure in question is carved in relief on the right end.[19] Meleagers were popular everywhere (fig. 85), one replica, softer in appearance and complete save for its head, coming from the gymnasium at Salamis on Cyprus and the statue in Copenhagen having been found in a Roman theater at Monte Cassino.[20]

The so-called Narcissus, a Polykleitan statue of a boy leaning against a pillar in meditation, has been recorded in at least twenty marble copies and several small versions in bronze. The original was undoubtedly a funerary monument.[21] Several mirror reversals exist, in full size in marble and on a reduced scale in bronze. The soft forms of the body and the strongly hipshot pose were symptoms of Polykleitan reaction to the soldier athletes typified by the Doryphoros. The Narcissus led to the youthful creations of Praxiteles in the fourth century B.C., most notably the Apollo Sauroktonos, and the strong sense of direction imparted to the relatively self-contained original was perfect fodder for the Graeco-Roman creators of statuary in mirror reversal. One of the most frequently reversed statues was the Lysippic Poseidon, who normally stands with his right foot on a rock or prow and with a dolphin or wave in his right hand, a trident in his left. The bronze original is thought to have been created by Lysippos for the shrine at Isthmia near Corinth; the most famous marble copy is the statue, slightly larger than life-size, long in the Lateran Museum (fig. 33). At Eleusis, Heraklion on Crete (fig. 34*a*, *b*), and else-

where there are versions in marble which are both radically reduced in scale and are mirror reversals.[22] Both types occur on Roman coins from the early empire through Hadrian (A.D. 117–38), and therefore the reversed type must have been as old as the first century B.C. Hadrian circulated both versions widely on imperial sestertii, and this would indicate that a sizable number of the twenty-five or so surviving Roman copies of both types belonged to the classicizing creations of his reign.[23]

Among the many statues of satyrs that exist in their original form and in mirror reversals, two have been mentioned in connection with the sculptures from the so-called Villa of Quintilius Varus or of Cynthia near Tivoli. The type known generally as "The Satyr in the Orchard" was one of the most popular. There were many minor variations. Basically, the statue presents a young satyr who trips along in a twisted, Hellenistic rococo version of a Praxitelean pose, a bunch of grapes or similar delicacy in the hand extended over his head and a pedum in the lowered hand. He wears a wreath of grapes or pinecones in his hair; the twisted action is usually carried out for the benefit of a small panther at his feet.[24] Whether or not the ultimate original was a statue in bronze, the compact composition is a relatively easy one to carry out and its transformation into a direct reversal can be accomplished with equal ease. There is enough clutter of movement and secondary detail to make the mirror images seem almost like new designs altogether. Some replicas place a nebris filled with fruits or cones on the body (Villa Torlonia-Albani [fig. 35]; Palazzo dei Conservatori) and others introduce the infant Dionysos into its folds, in a kind of mockery of the famous Praxitelean statue at Olympia (British Museum). The purest statues show the satyr nude, with all the extra attributes piled on the plinth and supports (Cherchel [fig. 36]; a mirror reversal of this statue has reduced the crown to a mere rolled fillet (Elvehjem Art Center [fig. 37], and this may be how the oldest version of the statue appeared.

Excavations and comparative analyses have offered further explanations why so many of these satyrs were produced by the copyists. The Roman penchant for duplication was at the root of the matter. In the baths at Cherchel, for example, a replica of the Hellenistic rococo group of a satyr or faun battling with an excited hermaphrodite stood in each corner of a room.[25] Single copies have been found in Rome, as the example in Berlin from the Villa Aldobrandini on the Quirinal testifies, and in the gymnasium at Salamis on Cyprus.[26] Fragments from groups in reverse are known. Satyric figures in architectural reversal are typified by

the famous pair of Pans found in the Theater of Pompey at Rome, long ornaments of the Museo Capitolino and the sources for the name Piazza dei Satiri. They are almost freestanding, with a pilaster behind; the arms and legs are reversed, as befitted architectural supports.[27] In groups of satyrs, duplication and reversal could be used to give a feeling of greater variety to figures taken over in the later Hellenistic period from the masterpieces of major sculptors. Such is the case with five small marble figures of satyrs in battle with giants, found in 1886 in a nymphaeum near the Porta San Lorenzo at Rome and now in the Palazzo dei Conservatori. The ensemble around the curved ledge or in the center of the sprays in a fountain building must have been very effective and was most probably a popular concept, for other figures from this and similar groups are known.[28]

Heraldic reversal entered the sphere of curious minor mythological figures. The Tritons or sea centaurs found with the Conservatori bust of Commodus (180–92) as Hercules, leader of the Amazons, are mirror images, with one arm supporting something while the other held an oar. The ensemble came to light in a room of a garden building in the Villa Palombara on the Esquiline, site of the Horti Lamiani.[29]

Mirror Reversals in Painting and Relief

The transition from satyrs as statues to reversals in the two-dimensional media can be seen in the Aphrodisian group of a satyr, maenad, and Eros or Anteros which seems to copy the Hellenistic dedication at Kionia on Tenos.[30] The central two figures, a satyr twirling a maenad in a lively Mediterranean dance, appear in high relief on the right front of a Bacchic sarcophagus in the Isabella Stewart Gardner Museum at Boston, from the Palazzo Farnese and the Villa Sciarra in Rome.[31] Two such groups also appear, one in mirror reversal, on a sarcophagus from the same workshop, now in the Atrio of the Museo Capitolino; the cataloguers were probably correct in connecting the designs with a Hellenistic painting.[32] A free reversal of the subject also graces a Roman decorative relief in Würzburg, and there are parallels in mosaics and paintings from Italy and North Africa.

Sarcophagi of the late second through the fourth centuries A.D. constitute major sources for understanding the architectural settings of Graeco-Roman sculptures in the imperial period and for documenting

mirror reversals in these series of statues translated into high relief. Columnar Asiatic sarcophagi show derivation in the third century A.D. from the Trajanic through Antonine architectural and sculptural facades of theaters, nymphaeums, gateways, forecourts, marketplaces, and other civic structures, or even the interiors of temples such as the so-called Temple of Bacchus at Baalbek. Since these sarcophagi with statuesque figures were produced by sculptors of no mean talent in large workshops of Greece, Asia Minor, and Italy, it is natural they reflected types of mythological and portrait statuary being produced contemporaneously in ateliers of copyists. C. R. Morey likened the architecture of these sarcophagi to theaters such as the one at Aspendos or to libraries such as that at Ephesus, and to the painted forerunners of these buildings at Pompeii.[33] This comparison holds true for statues too, which are contemporary versions of traditional figures and even groups going back through the Hellenistic period to the ages of Praxiteles and even Pheidias.

As an example of the sculptural subtleties that could be involved, a season sarcophagus of the late third century A.D. in the Palazzo dei Conservatori uses two pairs of mirror reversals on the front (fig. 38). The schema for the genii amid animals is $A^1 B^1 B^2 A^2$, making the inside and the outside pairs antithetical. A^1 and B^1 are arranged under one baldachino with twisted columns and reversed seamonsters for akroteria, while B^2 and A^2 stand with their fruits of field and forest in an identical setting. These two separate complexes are united by the busy portals and paired statuary of the tomb in the center; the pediment of the sepulcher is replete with Nereids in mirror reversal as akroteria on the roof.[34] Translated to the facade of a basilica the whole experience would have been the ultimate in Greek imperial luxury.

The same rhythms of curved or pedimented architecture and balanced figures, almost statues in front of the architecture, characterize a group of columnar sarcophagi with married couples in the central niches. The curved outside niches on examples in Florence (fig. 39), Pisa, and from Tipasa are filled by balanced pairs of Dioskouroi with their horses, but, unlike the settings proposed for the Dioskouroi of Monte Cavallo, their horses are on the inside.[35] In other words they have been set in their niches in the way the Horse Tamers of the Quirinal are now displayed, rather than in the way proposed as most sensible architecturally for the colossal statues in Rome. The celebrated sarcophagus in Istanbul from Sidamara shows its enframing Dioskouroi with their horses arranged

according to the schema proposed for the Roman statues (fig. 40*a*, *b*).³⁶ All this demonstrates the imaginative variations which Graeco-Roman architects and sculptors could achieve in their combinations and uses of reversed pairs of statues. The Sidamara sarcophagus, or the similar composition on a sarcophagus in Istanbul from Seleucia on the Kalykadnos, gives a sweeping sensation of lifelike conversation and movement in the statues on the principal face. The schematic balance of figures and architecture does nothing to detract from this sense of optic life. In fact, it aids the impact of the figures by keeping the total presentation within the circumscribed framework, if not the bodily forms, of classical art.

Reconstructions of buildings such as the Library of Celsus at Ephesus or the stage building of the theater at Aspendos show how the rhythms of statues in their complex, columned niches with their curved and triangular pediments were hardly different from the overall surfaces of these giant sarcophagi. Restorers, that is architectural draughtsmen, always populate the niches of their reconstructions with famous, recognizable statues. Such may have been the usage in the Latin West, but in the Greek East the emphasis on personal commemoration was so strong that most architectural statues were members of the imperial family or local worthies. Roman triumphal architecture in the Latin West, or at eastern imperial colonies such as Antioch in Pisidia, made the balanced reversal a key feature of architectural decoration, statues, or high reliefs. Thus, the Augustan triumphal gate at Saepinum (Sepino) in Central Italy has bound captives with their legs crossed, in mirror reversal, on the external facade, flanking the dedication in the names of Tiberius and Drusus.³⁷ The relation of these two captives, presumably barbarians, to statues is evident since they are placed on the type of lofty pedestals commonly used throughout the Roman Empire for statues of emperors and magistrates. Iconographically, the figures, their positions, and their poses derive from the Hellenistic funerary Erotes or genii who flank the portals of a tomb, usually standing with their legs crossed and their heads and arms resting on reversed torches.

The socles or sculptured bases of engaged columns on Roman triumphal arches, such as the Arch of Constantine in Rome, present an interconnection of scene and a linking of reversed figures from one base to another that follows the decorative traditions of public building, palace, and country villa traced in these pages. The two bases in the Giardino Boboli at Florence, originally from a destroyed Antonine or Severan arch in Rome, demonstrate this decorative coordination.³⁸ The

Victories on the fronts balance each other in a general way, one that was doubtless more explicit when the full complement of bases (four or eight) was installed, and the Dioskouroi who stood opposite each other as if to usher themselves and the Roman troops through the arch are naturally precise reversals of each other (figs. 41, 42). The continual vista of balance and reversal in Roman triumphal art must have been as monotonous to many Romans as the use over and over again of the same themes in that art. If the Dioskouroi of Monte Cavallo did stand in the Baths of Constantine, they were not the only large-scale groups of balanced sculpture in those halls. The huge effigies of the rivergods Nile and Tigris (later changed to the Tiber) which were pulled from those ruins in 1518 and now adorn the stairways to the Palazzo Senatorio are free reversals, not precise in details, designed to be set opposite each other in conjunction with architecture, just as they have been seen in their present locations since 1566.[39]

The scene of Mars Pater, sponsor of the Roman race, descending on the sleeping Rhea Silvia to father Romulus and Remus is one that exists in painting as early as Corridor 16 of Nero's Golden House, in Roman decorative reliefs, on late Antonine and Severan sarcophagi, and on Roman imperial coins of the emperor Antoninus Pius (138–61).[40] The composition is found as much in full reversal, Mars descending from the right, as in the seemingly basic design of the god coming down from the left to the princess who is stretched out from right to left. The coins, which are naturally involved in the reversal of designs as part of the process of cutting dies (which are negatives), seem to have inspired a new round of popularity for the scene, especially on sarcophagi. These coins were struck after A.D. 147, the nine-hundredth anniversary of Rome, when myths of Rome's founding were given new official stimulus in the arts.[41]

Conclusion

The Greeks taught the Romans theories of balance and reversal in the art of decoration. Like so much else in Greek art, the Romans exploited Greek notions that were basically simple and direct. They turned them into grand expressions of an art that was as much a tribute to engineering as it was an expression of creative beauty. On the Athenian Acropolis in the fifth century B.C., Greek architects and the sculptors who worked

with them invented mirror reversals and balanced groups of dedicatory sculptures. The fourth century found these two techniques of installation admirably suited to funerary art, grave stelai, and the statues of men and animals that accompanied them.

The Hellenistic Age added grandeur of scale and diversity of subject to the search for balance in Greek installation. Pergamon and other cities also added complexity of subjects, such as the Gaul groups and their settings. The Hellenistic rococo gave ancient sculpture and painting the myriad satyrs, maenads, nymphs, and Erotes which the Romans loved so dearly in their garden decoration. Copyism from about 80 B.C. on, the period of Sulla's return from Athens, put all these tastes and urges on the level of highly organized, commercial mass production. Augustan and Julio-Claudian princes and patrons applied this new combination of Greek decorative balance and Roman-ordered productivity to adornment of every form of public structure, including the pressure towers of aqueducts, and of town gardens and country estates.

Hadrian's Villa at Tivoli was the culmination of imperial garden and country house decoration. At the same time Hadrian's bold architectural experiments, melon domes and hemicycles with niches, led to the mighty Antonine and Severan baths and basilicas in concrete and plaster with their huge recesses that demanded Roman copies three or four times the size of their Greek originals. As domes, vaulting, theater backgrounds, and hydraulic systems became more complex, with more niches to be filled by statuary, mirror reversals of selected Polykleitan through Lysippic statues came to play a definite part in schemes of balanced decoration. Graeco-Roman columnar sarcophagi preserve in a thorough way the sense of overwhelmingly rich setting that these statues in architecture and their balancing reversals achieved.

Once firmly established as a decorative formula in the Roman Empire, the integration of architecture and statuary was transferred to official Christian needs, first through sarcophagi and later in such mighty undertakings as Romanesque and Gothic church facades. Renaissance revival of classical rationalism in architecture was naturally accompanied by new urges to decorate with harmonious sculpture both contemporary creations and excavated works of the Graeco-Roman copyists. It is no coincidence that sculptures from Hadrian's Villa at Tivoli were set up in arrangements similar to those of Roman antiquity in the cinquecento Villa d'Este above their original settings at Tivoli. Statues and reliefs from a number of villas and baths around Rome came to stand in the 1770s in

niches at Lansdowne House in London, one facing another in fashions fully worthy of Hadrian or the Antonines (figs. 45–47). In short, civic decoration from 1400 to the twentieth century perpetuated forms of organization worked out by the Romans in the second and third centuries of the Roman Empire. Any state capitol, city hall, war memorial, or large public library in the United States is a living testimonial to these methods and values. Two perfect examples in Boston are the exterior of the Public Library and the interior of Symphony Hall.

NOTES

1. C. H. Morgan, "The Style of Lysippos," *Commemorative Studies in Honor of T. L. Shear, Hesperia* Supplement 8 (Princeton, N.J., 1946): 228–34, especially p. 231, n. 17.

2. Morgan, "The Style of Lysippos," pls. 24 f.

3. W. Amelung, *Die Sculpturen des Vaticanischen Museums* (Berlin, 1903), vol. 1, pp. 115–20, especially under no. 99. Satyrs: Braccio Nuovo, nos. 32, 33; Nereids on Hippocamps: Braccio Nuovo, nos. 34, 35.

4. Amelung, *Die Sculpturen des Vaticanischen Museums,* vol. 1, Braccio Nuovo, no. 99 (Munich Oil Pourer with Ephesus Apoxyomenos head); no. 103 (Oil Pourer); and no. 105 (Apoxyomenos).

5. As Boston, Museum of Fine Arts, accession no. 03.883: G. H. Chase and C. C. Vermeule, *Greek, Etruscan, and Roman Art, A Guide to the Classical Collections* (Boston, 1964), pp. 234–35, 273, fig. 276, includes two boxers, one athlete crowning himself, and an Apoxyomenos.

6. Quoted from Pollitt, *Art of Rome,* p. 200: *Historia Augusta, Alexander Severus* xxv, 8–10. For other remarks on the size of sculpture in relation to architecture, see C. Vermeule, "Greek Art in Transition to Late Antiquity," *Greek, Roman and Byzantine Studies* 2 (1959): 16–20.

7. Paribeni, *Sculture greche,* p. 25, under no. 26; mentioned in C. Vermeule, *Essays in Memory of Karl Lehmann* (New York, 1964), p. 370.

8. Lippold, *Handbuch,* vol. 3, no. 1, p. 219, pl. 78, no. 4; Poulsen, *Catalogue of Ancient Sculpture,* pp. 188–89, no. 250. J. J. Pollitt, *The Art of Greece, 1400–31* B.C. (Englewood Cliffs, N.J., 1965), p. 146, comments on the surprising effects created by the colossal and miniature sculptures of Lysippos. The Tarentine Herakles was over-life-size, but, being seated, this Lysippic colossus was not the prototype of the Farnese Hercules.

9. O. Broneer, "'Armed Aphrodite' on Acrocorinth and the Aphrodite of Capua," *University of California Publications in Classical Archaeology*, vol. 1, no. 2 (Berkeley, California, 1930), pp. 65–84, pls. 7 f. The marble statuette of the earlier type in the Corinth Museum (postcard no. 14) postdates Broneer's article.

10. G. M. A. Hanfmann et al., "A New Trajan," *AJA* 61 (1957): 245–46; C. Vermeule, *Victoria in Roman Imperial Numismatic Art* (London, 1956), pp. 1–9.

11. See P. Arndt, W. Amelung, and G. Lippold, *EA*, no. 3251 (Rome, Villa Albani).

12. The Forum of Caesar, its Temple of Venus Genetrix, and, presumably, the statue were destroyed in the great fire under Titus, A.D. 80, and were rebuilt or reordered by his younger brother Domitian (81–96). Statue: M. Bieber, "Die Venus Genetrix des Arkesilaos," *RömMitt* 48 (1933): 261–76 (the possible alternate, a Republican type); G. Gullini, "Kallimachos," *Archeologia classica* 5, no. 2 (1953): 133–62; C. G. Harcum, "A Study of the Type called Venus Genetrix," *AJA* 31 (1927): 141–52.

13. H. A. Thompson et al., *The Athenian Agora, A Guide* (Princeton, N.J., 1962), p. 73, pl. V (Odeon's north facade, as rebuilt ca. A.D. 150). The ensemble of architectural sculpture, reliefs, and statues of philosophers or teacher-magistrates in a row in front was truly Graeco-Roman imperial. In the right foreground is a traditionally Greek row of statues on a single base, like those of the eponymous heroes which stood in front of the Metroon-Bouleuterion complex.

14. They have been excavated, identified, and pieced together at various times during the century of archaeology at Ephesus; the aesthetic value of these Amazons has always been based upon their physical proximity to the original statues. See generally, G. M. A. Richter, "Pliny's Five Amazons," *Archaeology* 12 (1959): 111–15; P. E. Arias, *Policleto* (Florence, 1964), p. 143, under no. 56, pl. 56. See also B. S. Ridgway, "A Story of Five Amazons," *AJA* 78 (1974): 1–17.

15. H. A. Thompson, "The Odeion in the Athenian Agora," *Hesperia* 19 (1950): 103–30, with full parallels; quotation from p. 122; pls. 60–77 give all necessary visual documentation for the giants' and Horse Tamers' sources in the art of Pheidias.

16. F. P. Johnson, *Lysippos* (Durham, N.C., 1927), p. 89, pl. 2; Lippold, *Handbuch*, vol. 3, no. 1, p. 199, pl. 68, no. 2 and bibl.; D. Mustilli, *Il Museo Mussolini* (Rome, 1938), pp. 115–16, no. 4; C. Vermeule, *JHS* 77 (1957): 287, n. 18: statuette closest to the Museo Mussolini statue is in the collection of C. Ruxton Love, Jr., in New York City. The statuette in mirror image is in the collection of Benjamin Rowland, Jr., at Cambridge, Mass. (M.F.A., *Sculpture in Stone*, no. 152.)

17. C. Vermeule, *Essays in Memory of Karl Lehmann* (New York, 1964), pp. 359 ff.

18. See under Poulsen, *Catalogue of Ancient Sculpture,* p. 224, no. 307.

19. H. Sichtermann, "Das Motiv des Meleager," *RömMitt* 69 (1962): 44 ff., pl. 19, no. 1; 70 (1963): 174–77, pl. 67, no. 4. See also chap. 1, n. 29.

20. V. Karageorghis and C. Vermeule, *Sculptures from Salamis* (Nicosia, 1964), vol. 1, pp. 18–19, no. 8, pl. 16; Poulsen, *Catalogue of Ancient Sculpture,* pp. 257–58, no. 387.

21. Lippold, *Handbuch,* vol. 3, no. 1, p. 165, pl. 60, no. 2 (Louvre); Poulsen, *Catalogue of Ancient Sculpture,* pp. 242–43, under no. 350. S. Reinach, *Répertoire de la statuaire grecque et romaine* (Paris, 1898), vol. 2, pp. 101–2, shows nine statues or statuettes, of which two are reversed (the "Young Asklepios" in Karlsruhe and a statue, p. 102, no. 4, labeled "Adam 37").

22. Johnson, *Lysippos,* pp. 142–49, with list, 144–48: nos. 1–12 (Lateran type), nos. 18–20 (Eleusis, Heraklion, Pergamon).

23. C. Vermeule, *JHS* 77 (1957), pls. 2 f.

24. Text to P. Arndt and W. Amelung, *EA,* nos. 3559–60 (Rome, Villa Albani); Poulsen, *Catalogue of Ancient Sculpture,* pp. 346–47, under no. 487; B. Schweitzer, *Antiken in ostpreussischem Privatbesitz* (Halle, Saale, 1929), p. 17 (list of statues); S. Gsell, *Cherchel, Antique Iol-Caesarea* (Algiers, 1952), pp. 70–71, no. 104.

25. Poulsen, *Catalogue of Ancient Sculpture,* pp. 348–49, under no. 488a; P. Gauckler, *Musée de Cherchel* (Paris, 1895), pp. 123 ff., pl. X, 3.

26. R. Kekulé von Stradonitz, *Beschreibung der antiken Skulpturen* (Berlin, 1891), pp. 83–84, no. 195 (Berlin).

27. Stuart Jones, *Sculptures of the Museo Capitolino,* p. 22, no. 5, p. 25, no. 23.

28. Stuart Jones, *Sculptures of the Palazzo dei Conservatori,* pp. 81–82, Galleria, no. 8, pl. 28; Poulsen, *Catalogue of Ancient Sculpture,* pp. 345–46, no. 486.

29. Stuart Jones, *Sculptures of the Palazzo dei Conservatori,* pp. 138 ff., nos. 19, 21, especially p. 142; R. Lanciani, *New Tales of Old Rome* (Boston, 1901), pp. 219 (with plan of finds) –225.

30. See chap. 2, n. 17.

31. C. Vermeule, *Boston Museum Bulletin* 70 (1972): 35, fig. 15; idem, *Essays in Memory of Karl Lehmann*, p. 361 and n. 5; idem, "Roman Sarcophagi in America: A Short Inventory," *Festschrift für Friedrich Matz* (Mainz, 1962), p. 100, no. 2; F. Matz, *Die Dionysischen Sarkophage*, I (Berlin, 1968), pp. 106–10, no. 3, pls. 13–15.

32. Stuart Jones, *Sculptures of the Museo Capitolino*, pp. 29–30, no. 10a; F. Matz, *Die Dionysischen Sarkophage*, pp. 110–12, no. 10, pl. 16.

33. Morey, *Sardis V*, pp. 90–97, figs. 141–46. H. Wiegartz, *Kleinasiatische Säulensarkophage* (Berlin, 1965), passim.

34. Stuart Jones, *Sculptures of the Palazzo dei Conservatori*, pp. 49–51, Sala dei Trionfi no. 4, pl. 17. G. M. A. Hanfmann, *The Season Sarcophagus in Dumbarton Oaks* (Cambridge, Mass., 1951), vol. 2, p. 165, no. (336), gives the date as circa A.D. 240.

35. Morey, *Sardis* V, figs. 102–4. Compare the famous sarcophagus, used as the tomb of the kings of Sicily, in the Cathedral of Catania: V. Tusa, *I sarcofagi romani in Sicilia* (Palermo, 1957), pp. 37–39, no. 9, pls. XIX f., figs. 29–30, with reversed Dioskouroi on either long side.

36. Morey, *Sardis* V, figs. 65 and 61 (Seleucia on the Kalykadnos). Compare also the late Antonine, extremely baroque columnar sarcophagus in the Museo delle Terme, Rome, where the mirror reversal extends from the Dioskouroi to the reclining personifications of ocean and earth at their feet. N. Himmelmann-Wildschütz, "Sarkophag eines Gallienischen Konsuls," *Festschrift für Friedrich Matz*, pp. 118–19, pl. 37, no. 1. The relationship of these Dioskouroi as freestanding statues to architecture, such as the theater at Lepcis Magna in North Africa, is also discussed in chap. 4.

37. B. Andreae, "Fundbericht Nord und Mittelitalien 1949–1959," *AA* (1959), cols. 225–26, fig. 64 (now called Porta di Boiano).

38. P. Arndt and W. Amelung, *EA*, nos. 3410–15. Balanced figures and reversals dominate the spandrels of triumphal arches, as the rivergods on the Arch of Constantine: E. Nash, *Pictorial Dictionary of Ancient Rome* (London, 1961), vol. 1, fig. 110; Victoriae on the Arch of Septimius Severus: fig. 138. R. Brilliant, *The Arch of Septimius Severus in the Roman Forum* (Rome, 1967), pls. 35–43.

39. E. Nash, *Pictorial Dictionary of Ancient Rome* (London, 1963), vol. 2, pp. 446–47, figs. 1248 f. (a bibliography of the Thermae Constantinianae appears on p. 442). H. von Hülsen, *Römische Funde* (Göttingen, 1960), pp. 61–67.

40. E. Strong, *Art in Ancient Rome* (New York, 1928), vol. 2, p. 25, fig. 286, etc.

(painting). S. Reinach, *Répertoire de Peintures Grecques et Romaines* (Paris, 1922), p. 58.

41. C. Vermeule, *JHS* 77 (1957): 293–95, figs. 7 (sarcophagus, Lateran collection), 8 (panel in the Vatican Belvedere), pls. 2 f. (coins); see also n. 44. Amelung, *Die Sculpturen des Vaticanischen Museums,* vol. 2, pp. 87–88, no. 36, pl. 9. The subject was also represented in mosaic.

III: Literary and Archaeological Evidence for the Display and Grouping of Graeco-Roman Sculpture: Italy and the Latin West

Descriptions of ancient statues in relation to each other, in their settings in Graeco-Roman times, are few, but the evidence is probably no more or less difficult to interpret than in any other aspect of classical antiquity. The evidence of the spade is somewhat more plentiful and precise, but there have been too many excavations in which no records were kept of where and how ancient sculptures were placed. A considerable amount is known about programs in painted decoration, particularly in the mythological frescoes of early imperial Rome, since so many such paintings have been found on their walls at Pompeii, Herculaneum, and in Rome itself.[1] A classic example of literary reconstruction was essayed by Karl Lehmann, who put together a plausible museography of the pronaos of the Temple of Divus Augustus in Rome, on the basis of an ancient's visit to the pronaos and the temple's famous library nearby. The observant visitor was the Roman poet Martial.[2] Unlike most famous Roman buildings, unfortunately the site and plan of the temple are not precisely known. The collection was evidently created by the art-loving Tiberius and kept in the deep recesses of the porch. It was not destroyed by the great fire of A.D. 69, the end of the civil wars, but was perhaps only slightly damaged.

The excavators in and around Rome from 1400 to 1820 undoubtedly had the greatest opportunities for testing literary notices against actual arrangements of works of art. At least they had unrivaled occasions to observe and record the discovery of Roman copies, and even Greek

originals, in their pristine settings. The statues themselves, and materials for building, were prime objects of exploration and plunder. The golden opportunities, therefore, mostly slipped by, and only in rare instances, as in the case of the Laocoon in Room 80 of Nero's Golden House or an occasional columbarium with its contents intact, were notices taken of how and where statues stood. The Farnese explorations of the Baths of Caracalla in the cinquecento, for example, would have told us all about the specific settings of the colossal sculptures, and the various early campaigns at Hadrian's Villa could have been equally revealing. Few sketches of antiquities made before the discoveries of Pompeii and Herculaneum record statues and reliefs during discovery, for most antiquarian artists were interested in their artistic rather than archaeological messages. These artists were content to do their drawing in collections such as the Casa Galli (fig. 43) or the Cesi Gardens; if they wished the flavor of sculpture seemingly *in situ*, they studied the statues assembled on the Capitol or the various treasures brought to the Belvedere of the Vatican.[3] Mural paintings were recorded before disintegration or destruction, if they were unusual, since they could only rarely be detached from their settings. Architects made much of ancient buildings, but their purposes were creative rather than historical, and in numerous instances an architect who sketched a monument in Rome then presided over its destruction for building materials.[4]

With the advent of neoclassicism in the second half of the eighteenth century, more attention was paid to circumstances of discovery. The new inquiring humanism was partially responsible for publications which showed the site as well as the loot derived therefrom. Pompeii and Herculaneum had made the physical details as well as the artifacts or masterpieces of ancient civilization important. More attention was being paid to Graeco-Roman decorative art and its uses because decorators were being called upon to reproduce the details as well as a general impression of antiquity in contemporary art. Gavin Hamilton wrote so much about his diggings in the villas and small towns around Rome not only to whet the appetites of his lordly clients in England but also because he was mildly moved if not smitten by archaeology and his customers hungered for some facts about their acquisitions. Most of Hamilton's British correspondents were busy building stately homes in the styles of "Athenian" Stuart or the brothers Adam, and the statues and reliefs shipped out of Italy were destined for niches in the Roman halls or cabinets in the "Etruscan" rooms of these town and country houses. In his letters to

Lord Shelburne, Hamilton was as much concerned with the harmonious integration of his merchandise as he was with promoting further sales. He offered to take back statues that did not suit and seemed, in the case of the Lysippic Hermes ("Cincinnatus") and the Myronic Discobolus ("Diomedes"), actually to hunt for Graeco-Roman copies to suit preconceived notions and planned or executed niches (figs. 44–47). Being a painter, Hamilton was also charged with supplying the walls of Lansdowne House with mythological paintings to complement the antiquities. All this made the entrepreneur and his equally perceptive contemporaries aware of the surroundings in which Greek and Roman statues were unearthed.[5]

Rome

THE HORTI LAMIANI

The first reasonably accurate recordings of just where statues stood coincided with the rise of modern scientific excavation after 1870. Typical of the reports that paid more attention to topographical relationships and scraps of architecture is Rodolfo Lanciani's identification of the Horti Lamiani with statue-laden rooms, a gallery, a colonnade, and baths in the grounds of the old Villa Palombara on the Esquiline (fig. 48).

> These beautiful gardens were largely excavated under my own supervision between 1873 and 1876, and they yielded the richest archaeological harvest we have ever been able to gather in Rome from a single spot since 1870.[6]

The diggings of November, 1875, traced the extent of a

> gallery 276 feet long, the pavement of which was inlaid with the rarest and costliest specimens of alabastrine-agate, while the ceiling was supported by twenty-four fluted columns of giallo antico resting on gilt bases.

The rooms discovered at the south end were equally luxurious. As inevitably in modern cities the finds were made during the sacrifice of the old Villa Palombara to a modern piazza, streets, and blocks of apartments; there was an air of commercial urgency about the operations, as first streets and then buildings chewed up the picturesque ruins.

When the Via Foscolo was being driven through at the north end of the gallery in December, 1874, a very important group of sculptures was found in a crypt or cellar leading off the gallery's apse. The building has been dated to the time of Severus Alexander (222–35), and the sculptures had apparently fallen into a lower chamber from a floor above.[7] They comprised the Conservatori bust of Commodus as Hercules, the flanking Tritons or marine centaurs (already discussed), two statues of females thought to be Muses but based on funerary figures, the Esquiline Venus, a portrait identified as the young Commodus, a head of Artemis, a semi-colossal Dionysos with drapery of gilt bronze (missing), and about twenty-five limbs, hands, and feet of statues with bronze drapery (stolen before concealment). Lanciani's plan of the site shows that the Lancellotti Discobolus was found on January 14, 1781, in a room off the colonnade, a portico or double stoa, which ran roughly parallel with the gallery from north to south toward the baths and their reservoir. These baths evidently served as shelter for the group of Niobids, their mother, and their old teacher, found in 1583 and now in the Uffizi, Florence. Lanciani listed a varied group of other statues from the Horti Lamiani, including the Hermes in the Belvedere; evidently these were displayed for their qualities as copies rather than for cult or historical purposes. A free version of Myron's Cow seems to have been found here, in a wall of the sixth century A.D.; it is amusing to think that this fine work might have stood near Myron's Discobolus, and the two might have contemplated each other in this area of imperial, quasi-public, and private gardens.[8] In Rome's post-Resorgimento building boom there was no thought of leaving the gallery with its beautiful floor or restoring the colonnade. We can only be thankful for what records were kept of the sculptures in relation to their settings. Paintings were there once too, for the Nozze Aldobrandini were found here, not long after the discovery of Niobe and her ill-starred brood.

THE PALACE OF THE CAESARS

The excavations of the past four centuries on the Palatine Hill give many insights into the richness of imperial sculptural decoration and its precise setting. Old masterpieces were mixed with the contemporary creations of the sculptors who followed architects and planners laying out the succession of temples, courtyards, public halls, and domestic apartments commissioned by emperors from Augustus through Septimius Severus.

In 1888 Rodolfo Lanciani collected a number of these evidences for placement of statues and reliefs, instances of works of art now lost or surviving in museum settings thoroughly divorced from their imperial purposes.

> On the top of the central arch [of the state entrance leading to the sanctuary of Apollo] Augustus had placed one of Lysias's master-pieces, a chariot drawn by four horses, driven by Apollo and Diana, the whole group being cut out of a single block of marble. This arch-way seems to have been rediscovered about 1575. Flaminius Vacca, a sculptor and antiquarian of the time of Sixtus V., who has left a diary or register of discoveries which took place in his lifetime, says: "I remember to have seen in the palace of the Caesars, near the Farnese grounds, the remains of a colossal gate, with posts of Greek marble twenty-nine feet high, and with a niche of African marble which must have been formerly on the top of it."
>
> The peristyle, surrounding the sacred area paved with white mar-ble, contained fifty-two fluted columns of *giallo antico,* many of which, more or less broken, were discovered on the spot by Pope Alexander VII, by Vespignani in 1869, and by ourselves in 1877. As regards the number of the shafts, there is no doubt that there were at least fifty-two, because fifty intercolumniations were occupied by the statues of the Danaids, and one by the statue of their prolific father. In the open space, in front of the figures of the Danaids, stood equestrian statues of their miserable husbands, the sons of Egypt. Many torsos and frag-ments belonging to this army of statues, the work of the best Greek chisels of Augustus's age, were recovered on the spot, just three cen-turies ago. The account of their discovery is given by the same Flaminius Vacca whom I mentioned above: "I remember to have wit-nessed the discovery of eighteen or twenty torsos, or statues, repre-senting Amazons, a trifle larger than life-size. They were lying under the Ronconi garden, in the centre of the palace of the Caesars. I recol-lect, also, that in mending the wine-press, the said Ronconi discovered a beautiful marble statue imbedded in the wall. It represents Hercules, and bears on the plinth the signature *Lysippou Ergon,* the work of Lysippus. Duke Cosimo de' Medici bought the figure from Ronconi for 800 scudi, and removed it to Florence, where it is still to be seen." It is evident that Flaminius Vacca, a faithful but simple and unlearned diarist, mistakes Danaids for Amazons. As to the fate of the twenty statues, I am afraid they must have come to their end in a limekiln or in a foundation wall.[9]

The Danaids provided as large a group of sisters as mythology could produce, and, with the addition of father and "miserable husbands," the "best Greek chisels" had virtually unlimited scope. The peristyle of the

sculptural programs of the area around the temple of Apollo. What was evidently a long, oval area of grass and flower beds, under the last of the Flavians, became a two-story portico and imperial tribune or exedra under Hadrian and Septimius Severus (figs. 50, 51). The hemicycle at the southwest end, leading to imperial balconies or boxes for the favored few over the Circus Maximus was a natural area for monumental statues in niches. The northeast end led to the libraries and the peristyle of the sacred complex of Augustus. The focus of the "Stadium" was the vaulted tribunal or exedra in the middle of the eastern side, looking across toward the Domus Augustana, and here illuminations or floral displays could be arranged for viewing from the palace. There were eleven or twelve major niches, one for each Olympian including perhaps a deified Hadrian as one of the gods, like the colossal Augustus near the temple of Apollo. Here above all, in this exedra, important statues like the Farnese Hercules with the signature of Lysippos would have had a logical place in the harmonious arrangement of architecture and nature.

Catalogues of the Museo Nazionale Romano and of the Antiquario on the Palatine, not to mention marbles taken elsewhere by the Farnese family, various popes, or even Napoleon III, all reflect the high quality of copies found throughout the imperial palaces, homes, temples, and gardens. The so-called Stadium was no exception. Imperial portraits were represented among the documented finds by a bust of Antoninus Pius. In addition to the small (nymphaeum type) Labors of Herakles in greenish black basalt or schist (fig. 52a, b), there was a dry but excellent white-marble Muse or nymph (one of two), seated on a rock, a Hellenistic ("Rhodian") statue admirably suited to gardens. There was also a goddess of late fifth-century B.C. type, probably a Hygeia like the famous figure now in the Los Angeles Museum of Art from Ostia by way of the Hope collection at Deepdene, Surrey.[10] These two sculptures have the look of Hadrianic classicism, like the best ideal statuary from Hadrian's Villa at Tivoli, and the groupings by subject or period of the original must have been similar to those in various parts of the villa in the countryside west of Rome.

The fragment of the head from a marble copy of the "Aspasia" type is also of excellent although predictably dry workmanship. The fact that the statue, or at least the head, was carved in island marble is an index of the extra effort involved in commissioning a copy from the Aegean (probably the quarry on Naxos) or importing the marble for finishing by a Greek atelier working in Rome. The choice of subject suited an architec-

tural garden, for the statue was pensive, dignified, and suitably vertical in its ample himation to match the columns and cornices of the setting. The subject has been debated, but the "Aspasia" was certainly a major figure from Greek mythology, Europa being a candidate based on parallels in vase painting of the fifth century B.C. Such a person would have been suitable enough to the Palatine "Stadium" where the geographical history of the world would have been mixed with the favorite gods of the emperors and their portrait statues.[11]

Among the imperial portraits in the Palatine "Stadium" the bust of Emperor Antoninus Pius (138–61) deserves particular mention. Carved of Greek island marble in a style suggested by portraits from Athens or Olympia, this bust is of striking quality and lifelike vigor. It is thought to have been executed just before Hadrian's death when Antoninus Pius was designated Caesar or in the first years of the Antonine Age. Although evidence is conflicting, the bust appears to have been found in the northern or library end of the "Stadium," rather than at the southern curve which faced toward the eastern end of the Circus Maximus. Antoninus Pius wears Greek armor, over which an ample cloak has been arranged and pinned with a brooch on the right shoulder.[12]

DOMUS AUGUSTANA

The shoulder-and-chest fragment of a colossal marble cuirassed statue among the excavated spoils in the entrance of the Palazzo Farnese has been identified with Domitian's monuments in the Domus Augustana (Flavia) on the Palatine (fig. 53). The statue, if not of Domitian himself then of his father Vespasian or his brother Titus, stood as pendant to a ruler in the heroic nude, cloak over his left shoulder.[13] When set among the dark green stone statues of gods and heroes, like the Hercules and the Apollo in Parma, these white-marble Flavians (the nude ruler doubtless Domitian in imitation of Alexander the Great's successors) must have turned the vast architectural setting into a dazzling spectacle. No one knows just where these statues stood in relation one to another, but they can be presumed to have filled the side niches or bays of the Aula Regia (central audience hall), or the intercolumniations within the adjacent basilica. The bays were enriched with decorative aediculae; they were framed by tall fluted columns in Phrygian marble with an elaborate high-relief order above. All this, matched by the Numidian marble of the columns in the basilica, formed the background for the colossal gods and

divine rulers.[14] The picture of major statues in military or Olympian guise was echoed further by the trophies and symbols carved on the bases of the columns.

THE FORUM OF AUGUSTUS

The Forum of Augustus was excavated first under Sixtus IV in 1477, then in the seventeenth and eighteenth centuries, with the temple of Mars Ultor partly excavated in 1842 and (always moving from north to south) the southern hemicycle excavated in 1888. The great civic area, however, had to wait until the giant undertakings of the 1920s and 1930s to be brought into its present form (fig. 54). The caryatids of the upper stories of the hemicycle have already been discussed in connection with other such architectural statues, one of the earliest instances of copyism from prototypes already in mirror reversal, depending on the figures from the Porch of the Maidens on the Erechtheum in Athens. The cult image of Mars Ultor, based on the Ares of Halicarnassus in the fourth century B.C., was well known from Roman imperial coins, particularly of the second century A.D. and from small images in bronze or the precious metals. The prototype group of the Ares Borghese joined with a draped Aphrodite of Capua to represent Mars and Venus, popular as a vehicle for portrait statues of emperors and empresses from Hadrian through the Antonines, appears to have stood under the portico of the temple.

Pliny the Elder listed important works of art in all media which had found their way to the temple. One of the four paintings by Apelles, representing the victory of Alexander the Great, was repainted in the reign of Claudius (41–54) to substitute the likeness of Augustus for the face of the Macedonian conqueror, an understandable desecration which happened all too often to statues, both Greek originals and figures created to represent a Roman worthy in the Greek or Roman traditions.

Rodolfo Lanciani, overseer of the 1888–89 excavations in the southern hemicycle of the forum, describes what must have been most arresting in terms of interrelationship between architecture and sculpture outside of the temple's interior treasures. He makes it clear that what Augustus initiated here was to be continued on a grander scale in the Forum of Trajan beginning in the second decade of the second century A.D. Lanciani also shows us that Augustus and perhaps his successors honored the heroes of the Roman Republic going back to the third century B.C., as well as distinguished contemporaries, although selection for this gallery

of statues, busts(?), inscribed pedestals, and biographical plaques placed below the appropriate niche soon came to have political and autocratic emotional overtones. The surviving walls of peperino blocks, both to the south and the north, give a perfect idea how the worthies were spaced and displayed, although more statues certainly stood in front, under the columns of giallo antico, and even in the open areas of the forum around the temple.

"The main point of interest of this forum," Rodolfo Lanciani wrote in 1897, "was the gallery of statues, raised by Augustus to the generals who by their exploits and victories had extended the boundaries of the Roman Empire." The forum would have been a most appropriate place to honor such men, and fragments that were found indicate that many of them must have been shown cuirassed. The implication was that most statues were of marble, and, despite the shift of emphasis to the Forum of Trajan, the practice of setting up these commemorations in the Forum of Augustus lasted at least until the time of Diocletian. Lanciani's account continued:

> The rules formulated by Augustus for the giving of so great a distinction were very strict, but his successors soon relaxed their severity, and statues were offered right and left, just like the equestrian orders of nowadays [a political note from Rome of the revived House of Savoy]. L. Silanus, although a minor, was given a statue after his betrothal to Octavia, daughter of Claudius. Another was raised in honor of Q. Curtius Rufus, legate of Germany, for having opened a silver mine [near Nassau on the right bank of the Rhine] which brought little profit to the treasury, but caused great toil and hardship to the soldiers. Nero, after the conspiracy of the Pisones was revealed to him, convened the Senate, and obtained the *ornamenta triumphalia* for those who had turned informers [presumably honored with statues in or near the niches here, although they and Domitian's favorites could have been immortalized elsewhere, the latter in Vespasian's Forum of Peace].
>
> Pliny the younger reproaches Domitian for having given statues to men who had never been in action, not even in camp, and who had never heard the sound of a trumpet except from the stage.
>
> The Forum of Augustus lost its privilege of being the national *protomotheca* with the construction of that of Trajan. The honors were then divided between the two places, as shown by the inscription of M. Bassaeus Rufus. [The setting up of more than one statue of one man was a commonplace in the Roman Empire, not only the several busts of Antoninus Pius in the Baths of Caracalla but the many Hadrians in the Olympeion at Athens or in the ceremonial buildings around the gate and forecourt at Perge in Pamphylia.]

Many important discoveries illustrating this point were made in 1888–89, when the municipality of Rome, at my suggestion, pulled down the houses and factories which concealed the southern hemicycle and laid bare its boundary wall and the niches once occupied by the statues of the Roman heroes.

Besides fragments of statues in military attire, columns of giallo antico, capitals, friezes of exquisite workmanship, we brought to light the base of a donarium, for which one hundred pounds of gold had been used, offered to Augustus by the Spanish province of Baetica; a pedestal of a statue dedicated to Nigrinianus, nephew of the Emperor Carus, by a financier named Geminius Festus; and inscriptions—in a more or less fragmentary state—which accompanied the statues of some victorious generals, giving a short account of their exploits. . . . these eulogistic biographies, dictated by Augustus, are divided into two parts,—one giving the name in the first case, like—

> M. AIMILIVS . Q . F . L . N
> BARBVLA . DICTATOR

engraved on the plinth of the statue; the other giving the account of his career, being engraved on a marble tablet placed below the niche. . . . I was able to prove thus that many eulogies of illustrious men—the place of discovery of which was not known—belonged to the Forum of Augustus.

Lanciani concluded this fund of information about sculptural art and historical commemoration in the Forum of Augustus with the following statistics or sampling of those honored:

The eulogies, or fragments of eulogies, found in 1888–89 are now preserved in the Museo Municipale al Celio. They belong to Appius Claudius Caecus, the builder of the Via Appia; to C. Duillius, who destroyed the Punic fleet on the coast of Sicily [and whose Columna Rostrata or Columna Duillia erected in memory of the victory of 260 B.C. has left remains in its Julio-Claudian form in the Roman Forum]; to Q. Fabius Maximus, dictator; to L. Cornelius Scipio, who led a successful war against King Antiochus in 190 B.C.; to Q. Caecilius Metellus Numidicus; to L. Cornelius Sulla Felix, dictator, etc.[15]

The many copies of portraits of Roman Republican worthies surviving from various sites in and around Rome, whether or not the subjects can be identified with certainty, like Cicero or Pompey the Great, give us some idea of what such statues must have looked like. The heroic statue of an imperator, cuirass as support by his side, excavated in the substructures of the temple of Hercules at Tivoli and sometimes identified from coins of 49–48 B.C. as A. Postumius Albinus, Consul in 99 and Sulla's

legate in 89, shows precisely what one of these statues, either a nearly contemporary original or an Augustan copy, would have constituted when preserved in a state of virtual completeness. The marble statue of the Roman general of about 40 B.C. in Munich from Tusculum, also nearly intact, demonstrates how those of these statues in armor in the niches of the Forum of Augustus would have appeared, again as prototypes transported to the Augustan complex or as excellent copies created to adorn the civic area.[16]

THE HOUSE OF THE VESTALS

Excavated primarily in the early 1880s, the rectangular peristyle court and the adjacent buildings of the House of the Vestals are symbolic of the problems wrought by limeburners, diggers, and modern tourism. The marble Vestals standing in the main court in the Severan to Constantinian periods of the Roman Empire cannot be repositioned with certainty, but a feeling for statues on inscribed bases in relation to architecture can be conveyed with accuracy (figs. 55, 56).

> The chief decoration of the court consisted in the statues of the Head-Vestals which stood in the portico and were accompanied by inscriptions on the bases, celebrating the virtues and the merits of each person portrayed. Only one solitary inscription was found in its original place: most of the bases and statues were discovered at the close of 1883, at the west end of the Atrium. They were heaped up in such shape that it is clear they were intended to be thrown into a mediaeval lime-kiln. The stones containing the inscriptions lay flat upon the ground, upon them rested the torsos of the statues, and the arms, hands, feet, and all projecting parts had been hacked off, and the fragments used to fill up the spaces between the statues. On this account it is not possible to connect a single one of the inscriptions with its original statue.[17]

Statues of imperial women, and at least one man (the Trajanic version of King Numa), were included among the Head Vestals. The appearance of the Atrium Vestae was, as intended, that of a large house of devotion and commemoration, rather than just a ladies' residence. The rows of statues against the walls behind the columns of the portico gave fitting focus to the Roman national traditions represented by the cult of Vesta and those charged with its perpetuation.

The finest surviving portrait of Emperor Gallienus (253–68), with the neck worked for insertion in a draped statue, also comes from the House

of the Vestals. This infamous yet sensitive ruler doubtless kept company with the ladies in his capacity as Pontifex Maximus and guardian of the traditional rites of the state religion.[18] Certainly Septimius Severus and Julia Domna, as refounders of the cult, would have been commemorated. Perhaps, at one time, Domitian was honored because of his devotion to Minerva and the Palladium (housed in Vesta's temple), and because he rebuilt the House of the Vestals, as did Hadrian and Constantine the Great. Domitian would not, however, have deserved sculptural commemoration for his incestuous private life or for his having ordered important Vestals tried on charges of incest (trumped up in at least one instance) and buried alive.

While there appear to be no surviving sculptures of Septimius Severus and Julia Domna from the House of the Vestals, a handsome, nude, nearly half-figure bust of the young Caracalla was found there. To be dated after 198, when the child was made emperor, and before 202 or 204, Caracalla wears a paludamentum or Greek hero's cloak pinned with a large brooch on the left shoulder and an ornamented swordbelt running from right shoulder to left side.[19] Although the child is arrayed as Alexander the Great, whom he and his family sought to imitate, the face, although already self-indulgent, is innocent and pretty enough to have maintained a place for the bust in the House of the Vestals whatever later evil associations the name of Caracalla may have had.

Not so, however, the second bust of Caracalla from the House of the Vestals. This evil-eyed, frowning portrait of the emperor from about the year 214 or 215 shows all the signs of ruthless selfishness which characterized the last three or four years of his rule.[20] How and why this bust came to the sacred mansion is pure speculation. Perhaps it was set up there in the late antique period, in the decades from about 340 to 370, when Caracalla enjoyed even more favorable regard than Elagabalus or Severus Alexander were able to promote for him, as a champion of the games and circuses so popular with Rome's pagan aristocracy. The temple of Vesta was closed by Theodosius in 394.

THE BATHS OF CARACALLA

The evidence from the great Severan Baths on the way from the Palatine to the Via Appia is almost entirely archaeological, but the tradition of digging is so old and so long to have become as one with the references from antiquity. By their sheer size and splendor as ruins, the Baths of

Caracalla claim a central place in the history of archaeology, and of what knowledge of ancient taste could offer to generations concerned with the classical past (fig. 57). This knowledge has been resurrected in a random way, as Renaissance historians well know, and has been used only in flashes, the two or three largest and most famous sculptures found in the main halls of the baths claiming all the attention. These sculptures, the Hercules (fig. 21), the Farnese Bull (fig. 58*a*, *b*), and the so-called Flora have been admired for their size and for their reflections of famous prototypes in the past.[21]

The sculptures found in, under, and around the Baths of Caracalla tell us much in a general way about setting and decorative taste but very little of a specific nature. The biggest groups, the Farnese Bull and the Landing at Troy (or on Lemnos or Naxos), along with other such ensembles, must have stood in the exedras or as centerpieces (surrounded by water in the second instance) in the main halls. The oversized copies, like the Farnese Hercules and the even larger Farnese Flora, must have filled niches in hemicycles or flanking staircases, like the statues of Presidents Cassatt and Rae in old Pennsylvania Station in New York. A colossal Athena, like the Pheidian Athena Farnese, would have been appropriate for the library.

Every colonnade, every watercourse in the entire complex of the baths had its decorative sculpture, and the types of life-sized figures fell into a pattern identical to that at thermal, exercising, and literary establishments combined elsewhere around the Mediterranean. The peristyle courtyard had its ideal herms, and a good marble copy of the Polykleitan Doryphoros-Achilles presided over the niches as part of the art-historical decorative sculpture at one end. An excellent copy of the Hermes Propylaios of Alkamenes stood beside the library. Aphrodite of the Knidian type (in a predictable variation) or Aphrodite drying her tresses (the Anadyomene) was the perfect marble copy for a pool or one of the lower watercourses. Doubtless the women's sections of the baths were fitted with statues of this type and with the most ideal male statues. Certain sections for men only might have been equipped with the Pergamene groups of heroes, like the problematical ensemble in Naples of a warrior carrying a dead or dying infant or like the Menelaos with the body of Patroklos, or the various gladiators in poses which included mirror reversals.

Beyond a desire for showy splendor and for the clichés encountered elsewhere in such decorative undertakings, there seems to have been no

especially literary or intellectual themes in various parts of the baths, unlike the programmatic arrangements in Hadrian's Villa at Tivoli. Since the Severans were heirs of the Antonine baroque, with its particular taste for reviving Pergamene sculptural and painterly styles and themes, the sculptures in marble from the baths, such as Glykon's Farnese Hercules, ran to the neo-Pergamene dramatic in subject, scale, and naturally style. The same held true for the monumental mosaics of gladiators, which went much further than Glykon's Hercules in combining Pergamene muscles with Severan bad taste, and also for the architectural enrichment, notably the large composite capitals of the central halls with their figures of imperial divinities (such as Virtus-Roma and the overblown Hercules again) in high relief.

There were certainly honors to Caracalla himself and, presumably, other Severans in the complex (like the giant statue of Elagabalus or Alexander Severus in Naples), and the Antonine so-called ancestors were included, for the handsome busts of Antoninus Pius and probably of Caracalla in Naples (or elsewhere from the Farnese holdings) came from the latter's baths. Since the building bore the name of Antoninus Pius, as did Caracalla himself, the two would by rights have been connected in the building. Whether the fragments of one or more equestrian statues from the baths were those of emperors seems impossible now to tell. If they were not imperial statues, they must have represented Caracalla's favorite, Alexander the Great, and his companions or those mythological persons who more often ride than walk.

Combinations of evidence from the cinquecento and nineteenth-century excavations confirm the popularity of paired mirror-image statues, already discussed in treating copies and their dissemination. The reversal of the Farnese Hercules has been mentioned, and excavations published by L. Savignoni at the outset of the present century suggested that the group of the warrior with the enigmatic child in Naples (the so-called Atreus with the son of Thyestes) had its balancing counterpart, perhaps representing one of the other instances where a hero did away with or saved a child. The numbers of statues of similar subject, the Herakleses, the gladiators, or the Aphrodites (some of which could have been portraits), remind us how vast was the scale of the complex, the area of its colonnades and courts. As at Villa Hadriana, although without Hadrian's systematic forethought, there was ample space to display copies of originals from diverse epochs all representing the same god, goddess, or hero. While copies were grouped on occasion by schools,

styles, centuries, or even sculptors (of the originals) at Hadrian's Villa, in the Baths of Caracalla originals of different epochs were copied more with reference to their uses in the architecture than, it would seem, with art-historical concern for groupings of the prototypes.

Representations of Herakles and of Aphrodite were most popular in the baths, the former probably around the exercise areas and the latter, as mentioned, in the sections where women admired themselves, or men admired and thought about the goddess of love and beauty. The colossal head of Asklepios, a dry, accomplished copy of the Melos type, belonged to a statue which may have stood in the service areas of the tepidarium and was probably the focal point of a chamber or corridor devoted to healing or first aid. The eyes were inlaid in a separate material, and the statue was polychromed, doubtless to match the decor of paintings and mosaics in which it was set. Since a tabletop version of this Asklepios was found in the large villa at Paphos on Cyprus, like the Anadyomene, the Severan Asklepios represented a large version of a statue probably best known to the average late Antonine or Severan connoisseur from copies on a near-miniature scale. The presence of the familiar Asklepios of the Melian type on such a large scale in the baths must have made the immediate area seem all the more impressive, a familiar work of art blown to giant size in Herculean settings.

The replica of Myron's Discobolus, of which the right leg down to the knee and support for the hand with the discus (Museo Nazionale Romano) and probably the hand with the discus (Museo Barracco) are preserved, would have stood with the Herakleses and the ideal herms in the palaestra area. The Discobolus was recognized by Enrico Paribeni as an acceptable Antonine replica. In present-day terms, that one part of the baths could exhibit a replica of the Polykleitan Herakles while another contained the colossi after Lysippos made the entire building complex no different from a modern European museum, or indeed the Museo delle Terme (in Diocletian's Baths) in particular. For what decorative purpose the baths had the "Bacchus Hermaphrodite" in Naples, one can only begin to speculate. The over-life-sized head of ideal, fourth-century B.C. type, resembling the so-called Eubuleus (but in this case not a portrait of Alexander the Great), must have belonged to a male personification, and a colossal genius (like an overblown Lar) in Naples has been suggested as a representation of the Genius Populi Romani, although the iconography might have better suited a genius of the imperial household or of the baths themselves. In short, these and other examples confirm that the

Baths of Caracalla seemed to have offered all things in sculpture to all manner of Romans.

Two of the colossal statues in Naples, the genius just mentioned and a Pheidian female personifiation or kore, show that these decorative colossi were made truly hybrid, updated Roman versions of what the classical or Hellenistic Greeks had admired. The Aphrodite Anadyomene from the lower service areas demonstrates that the bigger replicas and variants of familiar Greek statues were to be found in normal or larger architectural settings, with water in front or around if the statues were placed in baths and the types were like the Anadyomene, usually found in miniature. In summation, what evidence we can collect demonstrates that the Baths of Caracalla must have given copyists a special opportunity to execute replicas on several scales and must have offered the master decorator an occasion to place these in settings according to their subjects and mythological implications.

The excavations of 1912, published by E. Ghisaloni, where precise records of provenance were plotted on the plans, have given some picture of how and where the decorative sculptures were placed. The Doryphoros in Luna marble graced a niche in the semicircular exedra and peristyle at the northwest side of the calidarium. The excellent herm after the Hermes Propylaios of Alkamenes probably stood outside Building G, which looks like the Library of Celsus at Ephesus, on the southwest side of the rectangular peristyle. Indeed, in this part of the baths, where exercise and thought could be pursued in close proximity, the statues must have been set like those in the gymnasium and baths of Salamis on Cyprus. Much more, alas, cannot be said about the upper central areas of the Baths of Caracalla since they were plundered rather than excavated for so many centuries.

That the builders of the Baths of Caracalla "bulldozed" over the area, filled it in to create their supporting platform, and swept the area clean before rebuilding is evident from a number of sculptures. Chief among these, in terms of heirloom sculpture, was the discovery of a head in Parian marble of Caius or Lucius Caesar in the atrium of the house under the baths. This suburban villa complex, replete with extensive frescoes and mosaics, was used into the Antonine period. Other sculptures found included the life-sized torso of a nude gladiator "di ottima scultura," a "most beautiful torso of Venus" under-life-sized, a Diana huntress "di mediocre style," an over-life-sized marble head of a philosopher, and the torso of a statuette in rosso antico "di ottima scultura." These other

sculptures, as reported from the review of the excavations after the middle of the last century, are predictable (a term used before in dealing with the baths) in terms of Roman taste in the second century of the Christian era. In short, what was left around the atrium was all the equipment of a well-decorated suburban villa, nearly all to be filled in to make the baths.[22]

A. Pellegrini's 1867 publication, concentrating mainly on the frescoes and mosaics, was titled "The Gardens of Asinius Pollio." He pointed out that the group of the Farnese Bull was either saved from the gardens or copied for the baths on a larger scale.[23] The "torso of a nude gladiator" shows that the near-urban villa exhibited sculptures which were baroque in taste. Other sculptures may have been moved from the gardens to the baths, or copied for the vastly greater scale of Caracalla's architecture. That so many excellent sculptures were left in the villa under the new baths demonstrated either the shocking expendability of such art or the ruthless speed at which the Severans planned and put together their baths. Since the excavations of 1867 to 1873 yielded a mass of Greek statuary marble with a quarry mark showing the consular date A.D. 206, at that time or probably in the years 212 to 216 (when the baths were being built and dedicated) an atelier was carving a certain proportion of the statues for the baths close to the sites of construction. Thus, as in Chicago at the World Columbian Exposition of 1892 to 1893, one could imagine the harmonious workings in concert of painters, plasterers, mosaicists, and sculptors of various classes, all toiling under pressures and deadlines to create one of the great structures of the later classical world within the space of a few years.

SAN MARTINO AI MONTI

The brick chapel found about 1885 near the church of San Martino ai Monti on the Esquiline in Rome, beside the door and stairs to an underground mithraeum, is one of the few surviving instances in the imperial capital where sculpture large and small could be identified in its precise ancient setting (fig. 59). The building, termed the "Lararium" or "sacrarium" of a house, alas was evidently destroyed, and the finds were taken to the Museo Capitolino and the Palazzo dei Conservatori, where some are to be identified in the catalogue of those collections. A large marble Fortuna (Redux) with Isiac headdress stood in the principal elevated niche of brick with stucco and paint overlay at the center rear,

facing the door of the chapel. On either side from top to bottom sub-divisions of two pedimented recesses or shelves with tiers of elaborate moldings contained statuettes of Lares of the canonical pendant types, a seated Serapis with Cerberus at his side in Luna marble, a triple Hekate also in Luna marble, a nude Apollo or possibly a young Herakles with attributes missing and (beside him) an Aphrodite with a tiny Eros crouching at her side in Greek marble (the Medici type in miniature), and, finally, a large Luna marble bust of Serapis on the floor at the lower right. A number of decorative herms were found round about, perhaps from the garden in front of the brick chapel, and several of the statues appear to have been broken, with parts missing.

Aside from the report of breaks to some of the statues, ones which appear whole or nearly so in the reconstruction, the only disturbing note, of a type found so often in excavators' graphic re-creations, is the suspicion that someone rearranged the side niches in modern times to suit his fancy. A second, partially side view of the aedicula by the draughtsman and engraver L. Ronci shows three busts of (seemingly) Roman worthies or replicas of philosophers like Epicurus and Metrodorus in the upper two niches on the left, where the first engraving had shown a bronze Lar and the small, seated Serapis (fig. 60).[24] Still, the effect of ancient installation is almost unparalleled for its excellence of preservation, down to the painted (red) ceiling and the alternate shades of dark hexagonal and white trapezoidal tilings in the floor. The date of the chapel must lie between the late Antonine period (around A.D. 180 or during the reigns of Marcus Aurelius and Commodus) and the age of Gallienus (253–68), for the divinities are a conventional mixture of what was popular at the height of the empire, without the emphasis on Sol (Helios), Victoria (Nike), or the deified military emperors so popular on the coinage in the period from Aurelian (270–75) to Constantine the Great (306–37). For this reason—a date after the age of great Roman villas but before the changes wrought by Christianity—the popular Genius Populi Romani was not emphasized in place of Fortuna, and yet the chapel has the austere exterior and enclosed spatial principles of a late antique basilica or a small Christian church. Significant parts of the house to which the brick chapel with its images belonged were evidently constructed or extensively rebuilt in the Constantinian period. The ultimate owner could have been a conservative worshipper of the old imperial divinities and their Olympian to Nilotic companions, or a collector of major and minor statuary who used an old sacrarium for purposes of display.

Rome's Surroundings

MONTE CALVO

Typical of a site about which one would like to know more, because of the importance of Roman copies found there, is Monte Calvo in the Sabine mountains. The villa there was erected in the middle of the second century A.D. by Bruttius Praesens, father-in-law of Emperor Commodus. It was excavated in 1835, and the seven best statues passed at the turn of the century from the Borghese collection to the collection of Carl Jacobsen in Copenhagen, where they now ornament his Glyptotek. There must have been a garden of poets and Muses. Besides part of a set of Muses, comprising Melpomene, Klio, Polyhymnia, and Erato, there is the "Hera" Jacobsen, the standing Anakreon, and the seated poet with his lyre, often identified as Pindar.[25]

The Muses are all good copies of well-known types, probably Hellenistic versions of fifth- or fourth-century works. The "Hera" is a copy of a draped goddess of the Pheidian Age. Anakreon, a copy of a bronze statue of this period, is the only complete likeness of the bawdy bard surviving from antiquity, and the so-called Pindar is one of the most powerful Hellenistic statues in the realm of ennobling presentations of famous men of Greek literature. Whoever assembled this collection of sculpture must have been a man of considerable taste, and it would have been fascinating to know just how he arranged his statues.

Another, similar villa with all the sculpture demanded by wealthy Romans with literate tastes was excavated by Domenico de Angelis, in the so-called Pianella di Cassio, not far from Tivoli in the year 1772. Here were found, in what precise arrangement we can only imagine, "the group of Muses and the terminal portraits of men of letters, now forming the chief contents of the Hall of Muses in the Vatican."[26]

LAGO DI PAOLA

The evidence of J. J. Winckelmann, curator of the Albani collections and a founder of modern approaches to the history of art, could be both revealing and tantalizing in his mention of discoveries in the eighteenth century. He saw the building in which the Cassel Apollo was found. This famous, complete marble copy of a late transitional statue of about 460 B.C. came to light at Lago di Soressa, now Lago di Paola, northwest from

Monte Circello (Circeo) between Nettuno and Terracina. The statue stood in a little temple at the edge of the sea in a marble niche with very finely worked decoration.[27] This suggests that the Cassel Apollo was treated both as an expression of the god's divinity and as a work of art, much like the Knidian Aphrodite by Praxiteles.

PORTO D'ANZIO

From 1711 Winckelmann's patron Cardinal Alessandro Albani had excavated at Porto d'Anzio, in the ruins of Antium. Winckelmann speaks of the discovery in 1718 of four statues in a hall near the theater, and these must be the standing Zeus and the standing Asklepios in the Museo Capitolino, and an athlete and a satyr in the Glyptothek at Munich. All are about two-thirds life-size, and they are uniformly of black marble. The cardinal's contemporary, Francesco Bianchini, who excavated extensively on the Palatine, mentions a statue found in the apse of the left hand of the two halls behind the stage of the theater, and this may or may not refer to the finds discussed by Winckelmann, that is, the four statues in black marble.[28] In any case, it would seem that someone purchased or commissioned four or more statues of Hadrianic to early Antonine date, subjects with only aesthetic or sentimental rather than religious or historic connections, and placed these works of an unusual material in a gallery adjoining the theater of another small seaside resort frequented in the social season by wealthy patrons from Rome.

ROMA VECCHIA

Among Gavin Hamilton's excavations outside of Rome, his work in 1776 at Roma Vecchia may be cited as an example of what sculptures reveal about a site. He dug in ruins five miles from Rome on the roads to Albano and Frascati. They were identified much later with the Domus Quintiliana, a suburban villa of Commodus and the scene of the death of Cleander.[29] Hamilton wrote to Charles Townley, who had acquired most of the sculptures from these excavations,

> A considerable ruin is seen near this last upon the right hand, and is generally believed to be the ruins of a Villa of Domitian's nurse. The fragments of Collossal Statues found near this ruin confirms me in this opinion, the excellent sculptour found in this place strengthens this supposition,

He then lists his finds, five of which passed with Townley's marbles to the British Museum and the sixth, a large relief of Asklepios, to Lansdowne House.[30] A draped bust of a young man, dedicated by the judicial Decemvirs, may have been the young Marcus Aurelius about A.D. 138, or his son Commodus as a youth. The bust inscribed by Lucius Aemilius Fortunatus "to his best friend with his own money" could be Aelius Verus or Antoninus Pius but is probably a private person. Art, rather than officialdom, was represented by a statue of Endymion sleeping on Mount Latmus and another, identified as Ariadne. She is merely a draped female with a bunch of grapes in the left hand and a panther beside the lower limbs. Finally, there was a neo-Attic relief of a maenad and two satyrs, a replica of a standard type.[31] This complex, therefore, seems to have been more of a semiofficial villa and less of a hunting resort than, say, the part of the Villa of Antoninus Pius at Monte Cagnolo where Hamilton dug in 1774, because of the magisterial, inscribed busts dedicated at Roma Vecchia.

TOR COLUMBARO (TENUTA DI S. GREGORIO)

In the autumn of 1771 Gavin Hamilton commenced work at the sites of Tor Columbaro, or Tenuta di S. Gregorio (later called Torracio di Palombaro). The statues from these finds have already been discussed briefly in connection with the creation of multiple copies. One spot was on the Appian Way, and the other was about a quarter of a mile distant. Gavin Hamilton supposed the first to have been a temple of Domitian and the second a villa of Gallienus, both being nine miles from Rome. At the "temple" site he found only a large column of red granite and some fragments of porphyry and giallo antico. He conjectured that this temple had been robbed by Gallienus, and the sculptures transferred to the villa, for want of competent artists in the 260s of the Christian era.

This conjecture seemed confirmed in the eyes of Hamilton's contemporaries by the number of duplicate statues found in the second excavation, one copy having been much superior to the other. This suggested that the better copy belonged to the age of Domitian, the second to that of Gallienus, but the discovery of two heroic imperial statues of the young Marcus Aurelius and Antoninus Pius (or Lucius Verus) upsets the dating and indicates that the villa had pairs of statues as at so many imperial palaces and country seats elsewhere. The broken-up condition of the statues and the corrosion in the soil may have

given rise to the theories about the late imperial construction of the villa, surmises doubtless fortified by discovery of inscriptions of the time of Gallienus.[32]

Since none of the "duplicate" statues can be identified and since the second "Marcus Aurelius" was "broken into many pieces," the rule of pairs and mirror reversals at Tor Columbaro is, as already mentioned, hard to test. The statues which can be identified, however, present the equipment considered standard for a villa of a member of the imperial court in the Antonine Age, an establishment reflecting the traditions of country places from Flavian to Severan times. There was the standing Discobolus which passed to the Vatican, the Electra and the youth on horseback (probably a family portrait) long at Marbury Hall in Cheshire, and the three magnificent statues sold to Lord Shelburne for Lansdowne House, the Marcus Aurelius already mentioned (fig. 61), the Hermes of the type made famous by the statue in the Belvedere of the Vatican, and the Amazon copied after Polykleitos or Kresilas now in the Metropolitan Museum, New York (fig. 62).

A torso identified as Apollo, a Venus, and the usual under-life-sized, rococo seated Faun rounded out the recorded picture. As discussed earlier, the deviousness of the British dealers working around Rome in the years just before the American Revolution and the scattered destinations from Ireland to Russia (the torso of "Apollo" and the little Faun) make identification of further statues from Tor Columbaro very difficult. Some of the fragments, from parts of bodies to extraneous limbs, doubtless went into restoration of statues from other excavations, or into the creations of sculptors such as Bartolommeo Cavaceppi , who could make a complete antiquity from a host of disparate parts.

MONTE CAGNOLO

The fruits of Gavin Hamilton's excavations, as Dallaway described the location, "at Monte Cagnuolo, the site of the Villa of Antoninus Pius, near the ancient Lanuvium" fell mainly to Charles Townley (or Towneley) and are now in the British Museum. This must have been an especially rich and well-adorned country seat, containing not only many statues but also such decorative objects as the three-foot high marble vase ornamented and enriched with Dionysiac figures and symbols. The fact that so many statues of hounds, dogs, and bitches were found there over the centuries seemed to have given the site its name, testimony to

the persistence of identifications from antiquity through the Middle Ages and the Renaissance.

Gavin Hamilton himself wrote to Charles Townley about the excavations at Monte Cagnolo, which "alone answered my expectations" among the sites along the Alban Hills where so many rich Romans had country places, as did their Renaissance, Baroque, and later successors.

> This is a small hill betwixt Gensano and Civitalavinia, commands a fine prospect towards Velletri and the sea, and from the magnificence of the ruins and other things found there, one must judge it to have been antiently part of the Villa of Antoninus Pius, which he built near the ancient Lavinium. This spot had been reduced in the lower age to a vineyard and consequently strip'ed of its ornaments, some of which I found thrown promiscuously into one room about ten feet underground,[33]

He goes on to enumerate the sculptures found in this room and the surrounding ruins. The only statue in the traditional sense of a life-sized or larger standing or seated figure was the Paris which passed from the Duke of Buckingham's collection at Stowe to that at Hamilton Palace. Everything else had a rustic nature or pertained to cultivation of the vine and to the chase, a situation applying also to Paris if we think of his career on Mount Ida. There was a child Dionysos wearing a *nebris,* and with this were found the *two* statues of the Polykleitan Pan, the pair of copies signed by one Marcus Cossutius Cerdo in the first century A.D.

The dogs came in pairs, like the Pans and the groups of Nikai slaying bulls, dated in the second century A.D. and designed to be seen against a wall, or the two groups of Acteon being devoured by his dogs. Thus, Charles Townley purchased a group of a bitch caressing a dog, while the Vatican collections received the pendant composition of a dog caressing a bitch. Metal collars were added to the marble animals to give them a specially lifelike feeling. Finally, there were the purely decorative sculptures, necessary adjuncts to the gardens of an imperial villa: an archaistic terminal figure of a satyr playing on a flute, a large and elaborate decorative support in the form of a seated sphinx, and various marble candelabra, in addition to the big Dionysiac vase already mentioned.

That the villa extended over considerable terrain and had sections with different types of sculpture in each, like Hadrian's Villa at Tivoli, is apparent from finds made by Cardinal Albani in 1701 at Civita Lavinia (Lanuvium) not far from Albano, in property belonging to the Cesarini family. These portraits are now in the Museo Capitolino in Rome.[34] Car-

dinal Albani must have found the caesareum or augusteum of the villa, as well as possibly part of a hall of philosophers, for the core of his discoveries was a collection of Antonine imperial busts: Antoninus Pius, a head of Faustina I, Marcus Aurelius (as a youth, draped, and middle aged, in armor), Annius Verus, Lucius Verus, Commodus, and Philip the Younger, the last being evidence that the villa was maintained as late as the middle of the third century A.D. The philosopher, who could have stood as a centerpiece for the busts (and thus as an inspiration to the Antonine princes and their consorts), has not been identified. He has the rough appearance of a Cynic, a simple man most appropriate for an area of country houses and villas or garden complexes full of dogs, in marble and doubtless in reality.

HADRIAN'S VILLA AT TIVOLI

Every authority who has written extensively on the villa has made lists of the sculptures found therein, some of these being arranged according to the modern, conventional names for sections of the entire area.[35] Hadrian's Villa was lived in by the Antonines and the Severans, not to mention such later, military emperors who might have had the tastes or the time for such a life. The villa's later life made it natural that Antoninus Pius, Faustina the Elder, Julia Domna, and even Caracalla at the height of his career should have left their portraits there. Naturally, the villa should have had three or more busts of Hadrian himself, statues in various costumes (mostly heroic), a head of Sabina (who probably did not care much for life at this particular villa), and many images of Antinous, six busts in various aspects from Dionysos or Hermes to those in Egyptian garb having been documented. There appears to have been at least one hall in which the imperial family was honored, including figures from the past such as Nerva. In terms of quality and imagination, the statues, busts, and reliefs of Antinous showed greater individuality and artistic enterprise than the many dozens of academic copies produced for halls, colonnades, niches in melon-domed hemicycles, and pedestals on avenues through the gardens.

The goddess Artemis was everywhere, as befitted a villa in the country. One statue was in the palaestra, and another was to be found in the vestibule of the palace. Around the peristyle colonnades or the undulating main rooms of the Piazza d'Oro area were set herms of men of literary fame, including Zeno, Karneades, Aristophanes, Isocrates, Heraklitos,

Miltiades, Aristogiton (*sic!*), Demosthenes, Aeschines, Aristotle, Homer, Socrates, Bias, Pythagoras, Theophrastes, Solon, Perikles, Anakreon, Alexander the Great, and others, poets, philosophers, scientists, and generals from the entire Hellenic past being set together in what were doubtless significant groupings. The collections in the Louvre and the Vatican exhibit double herms, supposedly Sophocles and Aristophanes in one case, and Periander with Perikles in the second instance. Whoever all the specific worthies were, these herms demonstrate that selected areas of the villa could serve as illustrated lessons in intellectual history, while other areas might stress the aesthetic grouping of copies after masters from the transitional period through the Hellenistic rococo. The effect of such statuary, massed over wide and scattered areas, must have been impressive at the least.

That Emperor Hadrian felt as seriously about his Villa at Tivoli as he did about the precinct and surroundings of the Temple of the Olympian Zeus in Athens or as he and his heirs did about the decorative program, notably the reliefs of the podium, of the Hadrianeum in Rome is apparent in the lineup of personified provinces in one of the halls or courtyards of the Villa at Tivoli. The colossal statue of Parian marble, long at Ince Blundell Hall and now in the Liverpool museums' collections, is the grandest survivor of this series. Wearing a mural crown and leaning on a large tympanum, this female in cape and chiton has been identified first as Phrygia but later, probably more correctly, as Cappadocia, such statues at the villa having been three-dimensional counterparts to the provinces on Hadrian's coins and one by one in high relief against neutral backgrounds around the lofty podium of the giant temple to Divus Hadrianus in Rome (fig. 64).

The goddess Roma was also represented, and this was most natural since Hadrian toward the end of his life witnessed the completion of the huge double-cellaed temple to Venus Felix and Roma Aeterna on the little hill between the Roman Forum and the depression filled by the Colosseum. All this concern with stately and geographical iconography was an indication that Hadrian could not escape from or be relaxed about the paraphernalia of imperium even within the confines of his own stately country retreat. Neither, however, could the lordly possessors of English country seats escape the urge to mix triumphal history with domestic decoration. Excellent examples at Woodstock near Oxford are the trophies on the balconies at Blenheim or the park planted to simulate the formations of French and British troops at the battle which gave the

Dukes of Marlborough their fame. When Cardinal Ippolito d'Este included a "Rometta" in one section of his villa gardens at Tivoli, complete with an image of the goddess above the Wolf and Twins, he was doing no more in the cinquecento than Hadrian had done fourteen hundred years earlier.

The Canopus and Euripus of Hadrian's Villa

The hemicycle with colonnade at the north or drainage end of the Euripus, the long rectangular lake in the Canopus of the Villa Adriana, afforded perfect placement for nine or more just over-life-sized statues (figs. 13–15, 63). They were set between the columns in balanced but not reversed positions, the figures of importance under the arcuated entablature, which alternated from column to column with a rectangular section. The emphasis in this small but spectacular part of the villa was on copies of statues by the great masters of the Pheidian Age. An Amazon of Pheidias balanced one of the Lansdowne type, attributed to Polykleitos or Kresilas. A Hermes identifiable again with Polykleitos or Kresilas (perhaps depending on the authorship of the Lansdowne-Berlin Amazon) was paired off against an Ares most likely to be associated with Alkamenes.[36] Here, then, albeit in sometimes overdetailed, dry, academic marble copies, was to be found a kind of circle of classical purity by the mighty masters of the Periklean Age. These exercises in tradition stood as foils to the Hellenistic sculptures elsewhere along or in the Euripus (the river gods Nile and Tiber, and the Scylla group for instance), and as complement to the Erechtheum Caryatids lined up with the Sileni on the eastern side (figs. 4, 13).

Traces of Sculptural Settings in and around Rome

In this chapter we have concentrated on what has been found in documented contexts, notably the athletic sculpture and herms in the gymnasium areas of the Baths of Caracalla or the statues at Villa Adriana. Traces of supports or recessed areas in existing architecture give us considerable information about the settings of statues and reliefs. We can easily see how single statues stood in the niches of the large exedras of the Forum of Augustus or within the large hemicycle and small central niches of Domitian's garden (later a hippodrome for shows rather than

races) on the Palatine. We must look harder, however, for traces of statue bases in columnar settings or between the pillars of arcades.

Aside from the less formal arrangements in the courtyards of Romano-Campanian villas, as early as the underground basilica beside the Porta Maggiore, in the age of Augustus or Tiberius, we see that statues were probably set on low, rectangular bases between and against the pillars. Whether these statues were Dionysiac or funerary, we can only speculate. They were relatively small, but hardly more than slightly under-life-size, like so many rococo groups of satyrs, maenads, nymphs, and hermaphrodites. Examples of these types of groups must have adorned the larger pedestals in the forecourt of the basilica, the area in front of the stairs leading upward to ground level.

In the large rectangle of Villa Adriana recently reexcavated between the "praetorium" or attendants' quarters and the baths, leading toward the moated circular structure with its curving marine architraves, we find that two long rows of life-sized statues alternating with columns marked off the center strip from the wide vistas on either side. Some statues and columns (with their architraves) opened on the sky, while others were under the vaulted-over areas, creating alternating spaces of light and shade. The effect must have resembled that re-created before and after 1800 in the long corridors and courts of the Vatican museums, the Braccio Nuovo and the Galleria dei Candelabri for instance, where statues, reliefs, and colored marbles are crowded in among and upon the elements of architecture.

While we refer to the unconscious influence of antiquity's settings on baroque or neoclassic architecture, we must always recall that such antiquarian vistas from the Roman imperial world were often seen by the diggers around Rome from the sixteenth through the nineteenth centuries in the buildings they were uncovering. Writers like Flaminio Vacca and architects or artists like San Gallo and Piranesi recorded on paper what their contemporaries were privileged to see beneath the spade, before ancient architecture and Graeco-Roman sculptures were permanently parted from each other.

Looking outside Italy for such effects, we find that between the columns outside the main, western part of the "House of Jason Magnus" at Cyrene stood statues of the nine Muses. Six have survived, including an inscribed though headless Thaleia. Both columns and Muses presided over the main ceremonial apartments of this large private complex of the time of Commodus (180–92), perhaps in imitation of effects at Hadrian's

Villa. Sarcophagi of the Antonine through Severan periods with rows of Muses, as well as their contemporary figures on little plinths in the main hemicycle at the left of the orchestra pit, against the stage of the theater at Sabratha, can give us an excellent indication of what effect such statues would have created on ancient viewers, most of whom must have been sufficiently educated to recognize generally if not identify in detail the nine Muses and their Olympian companions.

Ostia

THE CLAUDIAN AND TRAJANIC PORTS

The setting of sculptures in the city of Ostia was routine, hardly spectacular. The copies found in niches of the House of Fortuna Annonaria were typical of the fifth century to Hellenistic sources drawn on as late as the third century A.D. The basilica contained portraits of Trajan, Hadrian, Antoninus Pius, and Marcus Aurelius, a dynastic commemoration like the big inscription put up in the theater under Septimius Severus. The most interesting locations for monumental statuary and reliefs in the Ostia area were the Portus Augusti (Claudian) and the Portus Traiani Felicis (the hexagonal inner harbor).[37] The sestertii of Nero and Trajan, and the famous Torlonia harbor relief, give considerable evidence as to how over-life-sized statues of Annona, Ostia (as a lighthouse-crowned Tyche), the genius of the harbor, Neptune, and Bacchus or Liber Pater were disposed on columns and in a temple around Trajan's protected warehouses, docks, and anchorage (figs. 65a–c–67).

A colossal cuirassed statue of Trajan stood on a base at the focal point opposite the harbor entrance, and a heroic statue, probably of Nero but possibly of Claudius, was visible on the third story of the stepped lighthouse at the entrance to the Portus Augusti. Indeed, the Torlonia harbor relief is a compressed view of both harbors, from a point between Trajan's statue and the temple of Liber Pater, through the entrance of the Portus Traiani Felicis, and toward the pharos of the Claudian harbor mouth in the distance. The triumphal arch at the right rear, possibly a monument to Domitian (riding an elephant quadriga and carrying a human-headed scepter), must have stood in the palace complex to the left of the entrance to Trajan's harbor and seems to be visible on his coins. Other ancient harbors were doubtless similarly adorned with statues,

and the artistic fortunes of these ports followed the prosperity of the cities which they served. The ports of Asia Minor, for example, seemed to have grown rich in sculptural ornament, or so the coins indicate, at the time when public buildings, theaters, markets, and fountain houses, not to mention gates and bridges, were being decorated. The moles and quays at Ostia were not unlike Roman bridges, and statues on columns (emperors, personifications, and eagles, as in the Torlonia relief) were natural adjuncts to these aquatic and marine constructions. The Triton on a rock or a sea beast just beyond the right wing or mole of the Claudian harbor (looking seaward) was an indication, recorded on coins, of the rich secondary sculptures possible around the Mediterranean's major ports.

Velleia

THE JULIO-CLAUDIAN BASILICA

Provincial conservatism characterized the settings of at least twelve marble statues of Augustus, Livia, Claudius, and their families in the basilica enclosing the southern rectangle of the municipal complex at Velleia near Parma in northern Italy.[38] The basilica, presumably built in the first half of the first century of the Christian era, must have been embellished with statuary late in the reign of Claudius since Agrippina the Younger and young Britannicus figure among the statues. Additions were made, however, for the cuirassed imperator found at the right end of the right-hand group (facing out to the forum, or the left group as one looked in through the door toward the tribunal) was first Domitian and was later recut to turn the portrait into Nerva (or conceivably a Germanicus recut into a Domitian).

The statues were lined upon two protruding ends of the long, rectangular podium, seven on one side and five on the other, but the number may be incomplete (fig. 68). Livia and her children to the third generation (with or without Augustus and Tiberius) dominated one group, and Claudius with his women and children comprised the other (fig. 69). The setting was simple, direct, and most impressive as one entered the basilica from the forum with its equestrian and other statues, which included Claudius just in front of the building and Augustus in the very center of the forum. The entire civic center, from the basilica on the south

side to the temple, curia, and magistrates' hall on the north, formed a small, rectangular, regional forerunner of the Forum of Trajan in Rome. Velleia disappeared from history just as the Tetrarchs came to power (in 284), and, though evidently toppled by barbarians or plundering soldiers in a civil war, the Julio-Claudian statues were not disturbed by mediaeval builders or limeburners. Livia and her descendants lay peacefully on the floor in front of the long platform and tribunal of the basilica until 1761, when they were found as they had fallen forward in two rows and were carried off by Don Filippo di Borbone, Duke of Parma, to his museum.

NOTES

1. K. Lehmann, "The *Imagines* of the Elder Philostratus," *AB* 23 (1941): 16–44; M. L. Thompson, "The Monumental and Literary Evidence for Programmatic Painting in Antiquity," *Marsyas, Studies in the History of Art* 9 (1960–61): 36–77; idem, "A Pompeian Painting of a Samothracian Myth," *Essays in Memory of Karl Lehmann* (New York, 1964), pp. 329–43.

2. K. Lehmann, "A Roman Poet Visits a Museum," *Hesperia* 14 (1945): 259–69, especially p. 268 for a diagrammatic reconstruction. See the general remarks in H. Kähler, *The Art of Rome and Her Empire* (New York, 1963), pp. 19–20.

3. Care was always taken to record on the corner of the drawing where the sketch was made, but artists never asked about the provenances of what they studied. Pirro Ligorio in the middle of the cinquecento was one of the first to concord the two disciplines. See E. Mandowsky and C. Mitchell, *Pirro Ligorio's Roman Antiquities*, Studies of the Warburg Institute, vol. 28 (London, 1963), Introduction.

4. See, generally, chap. 1 of C. Vermeule, *European Art and the Classical Past* (Cambridge, Mass., 1964).

5. A. H. Smith, *The Lansdowne Marbles* (London, 1889), passim; idem, *JHS* 21 (1901): 314–20. For a view of the apse of Lansdowne House, modeled on Hadrian's Villa or the Pantheon and with the "Cincinnatus" and the "Diomede" balancing each other in niches on either side of a seated goddess, see P. Arndt and W. Amelung, EA, no. 3048 (here fig. 45).

6. R. Lanciani, *New Tales of Old Rome* (Boston, 1901), p. 219.

7. Stuart Jones, *Sculptures of the Palazzo dei Conservatori*, p. 142.

8. Stuart Jones, *Sculptures of the Palazzo dei Conservatori,* pp. 97–98, Galleria, no. 39, pl. 34.

9. R. Lanciani, *Ancient Rome in the Light of Recent Discoveries* (Boston and New York, 1888), pp. 110–16.

10. R. Lanciani, *The Ruins and Excavations of Ancient Rome* (Boston and New York, 1897), pp. 172–78, figs. 65 ("Muse"), 66 (head of "Hygeia," of fifth century B.C. type).

11. "Aspasia": Helbig, *Führer,* 4th ed. (Tübingen, 1969), vol. 3, pp. 121–22, no. 2203; Paribeni, *Sculture greche,* pp. 53–54, no. 91.

12. Antoninus Pius: Helbig, *Führer,* pp. 229–30, no. 2314; B. M. Felletti Maj, *I ritratti,* Museo Nazionale Romano (Rome, 1953), p. 107, no. 205.

13. K. Stemmer, *AA* (1971): 563–80, figs. 3-6, 7.

14. A. Boëthius and J. B. Ward-Perkins, *Etruscan and Roman Architecture* (Baltimore, 1970), pp. 231–35.

15. R. Lanciani, *The Ruins and Excavations of Ancient Rome,* pp. 304–7. The emperor Severus Alexander, who ruled from 222 to 235, is reputed to have improved, enlarged, or rearranged the sculptural and epigraphic installations of the Forum of Trajan (or a part of it) and the much smaller Forum Transitorium (the Forum of Nerva). "Aelius Lampridius" wrote (at some much-disputed time between the late Tetrarchy and the end of the fourth century): "He placed statues of the foremost men in the Forum of Trajan, moving them thither from all sides": D. Magie, *Scriptores Historiae Augustae,* ed. Loeb (Cambridge, Mass., London, and New York, 1924), vol. 2, pp. 226–27 (*Severus Alexander* XXIV, 4). "In the Forum of Nerva (which they call the Forum Transitorium) he set up colossal statues of the deified emperors, some on foot and nude, others on horseback, with all their titles and with columns of bronze containing lists of their exploits, doing this after the example of Augustus, who erected in his forum marble statues of the most illustrious men, together with the record of their achievements" (pp. 232–35: XXVIII, 6). Since these statues and their inscriptions were visible to the readers of "Aelius Lampridius," as well as the compiler of the *vita,* there is no reason to doubt this activity, similar to what the portrait statues with the Farnese collections in Naples suggest Severus Alexander did on the Palatine and in the Baths of Caracalla. The emperors Honorius and Arcadius about the year 402 dedicated a statue of Claudius Claudianus, tribune, Permanent Secretary, and "the last poet of classical Rome" in the Forum of Trajan, the inscribed base(?) now being in the Naples Museum: see M. Platnauer, "Introduction," *Claudian,* ed. Loeb (Cambridge, Mass., and London, 1963), vol. 1, pp. xii, xvi, etc. The writer of Alexander Severus's biography, then, at almost any sub-

sequent time could have seen statues being set up in these Westminister Abbeys of the Roman Republican and imperial worlds.

16. B. M. Felletti Maj, *I ritratti*, Museo Nazionale Romano, pp. 33–34, no. 45; J. Sieveking, *Eine Römische Panzerstatue in der Münchner Glyptothek*, 91 Winckelmannsprogramm (Berlin, 1931).

17. Ch. Huelsen, *Das Forum Romanum* (Rome, 1904), pp. 162–74; quotations from the English language edition: *The Roman Forum* (Rome, 1906), pp. 192–205.

18. S. Aurigemma, *The Baths of Diocletian and the Museo Nazionale Romano* (Rome, 1958), pp. 125–26, no. 328, pl. LXVIIIb.

19. Helbig, *Führer*, 4th ed., vol. 3, p. 416, no. 2462. B. M. Felletti Maj, *I ritratti*, Museo Nazionale Romano, p. 129, no. 254.

20. B. M. Felletti Maj, *I ritratti*, Museo Nazionale Romano, p. 135, no. 267. The much-published canonical head and neck of Emperor Gallienus at the height of his career, about A.D. 263, is Felletti Maj, *I ritratti*, pp. 152–53, no. 304. A head of a baby boy, perhaps imperial, of the period 235 to 255 is Felletti Maj, *I ritratti*, pp. 145–46, no. 290.

21. S. B. Platner and T. Ashby, *A Topographical Dictionary of Ancient Rome* (Oxford and London, 1929), pp. 520–24, and older references; R. Lanciani, *The Ruins and Excavations of Ancient Rome* (Boston and New York, 1897), p. 539; Ruesch, *Guida*, passim (the Farnese collections)—various updated but undated excerpts have been published; E. Nash, *Pictorial Dictionary of Ancient Rome*, vol. 2, pp. 434–37, and a full bibliography on p. 434. (See also Appendix.)

22. F. Castagnoli, "Documenti di scavi eseguiti in Roma negli anni 1860–70," *Bullettino della Commissione Archeologica Comunale di Roma*, vol. 73 (1949–50, 1952): 171–72.

23. A. Pellegrini, "Orti di Asinio Pollione," *Bullettino dell' Instituto di Corrispondenza Archeologica per l'anno 1867* (Rome, 1867): 109–19.

24. See *Bullettino Comunale* 13 (1885): 27 ff., pls. iii–v; Stuart Jones, *Sculptures of the Palazzo dei Conservatori*, p. 229, no. 37 (bust of Serapis).

25. Poulsen, *Catalogue of Ancient Sculpture*, pp. 186 ff., no. 247 (Hera); pp. 262 ff., nos. 392–95 (Muses); pp. 279–80, no. 409 (Anakreon); and pp. 304–5, no. 430 (Pindar).

Collectors of copies must have loved the majestic, Junoesque "Hera" Jacobsen or Borghese very much, for the small seaport site of Baia (Baiae) has yielded two copies, found together in the bay of the little city, which was surrounded by

pleasure villas. One statue was signed by the copyist Afrodisios (*Bullettino Comunale* 61 [1933]: 41, pl. A) and the second by Caros (p. 43, fig. 15). The type has been attributed in recent years to Agorakritos, about 420 B.C.: Paribeni, *Sculture greche*, p. 63, under no. 111.

The villa of Domitian in the Alban Hills, at Castel Gandolfo, has been a mine for works of art, statues, reliefs, busts, stuccoes, and mosaics. Like so much from Hadrian's Villa at Tivoli, the finds made over the past 350 years have been noted but not scientifically recorded. See G. Lugli, "La Villa di Domiziano sui colli Albani," *Bullettino Comunale* 48 (1922): 3–72, pls. 1–5, and the earlier articles in the same series. Sculptures were recorded from the nymphaea, the theater, and certain galleries or peristyles, and they are as diverse as, yet similar to, those from the more famous pleasure dome near Tivoli.

26. A. Michaelis, *Ancient Marbles in Great Britain*, p. 82.

27. M. Bieber, *Die antiken Skulpturen und Bronzen des Königl. Museum Fridericianum in Cassel* (Marburg, 1915), pp. 1–5, no. 1: citing: J. J. Winckelmann, *Geschichte der Kunst*, vol. 3, 2, pp. 11 and 22; vol. 5, 5, p. 26.

28. Stuart Jones, *Sculptures of the Museo Capitolino*, pp. 272–73, nos. 1 and 5, pl. 64: citing: Winckelmann, *Geschichte der Kunst*, vol. 2, p. 105 f., p. 248; vol. 5, p. 31; also Fr. Bianchini, *Inscrizioni sepolcrali*, p. 79. The statues in Munich are described in A. Furtwängler, *Beschreibung der Glyptothek König Ludwig's I* (Munich, 1900), nos. 458, 466.

29. A. H. Smith, *The Lansdowne Marbles* (London, 1889), p. 72.

30. A. H. Smith, *JHS* 21 (1901): 316.

31. Smith, *Catalogue of Sculpture*, p. 174, no. 1940 (bust dedicated by the Decemvirs); p. 160, no. 1903 (bust dedicated by L. Aemilius Fortunatus); p. 24, no. 1567 (Endymion); pp. 51–52, no. 1638 (Ariadne); and pp. 255–56, no. 2193 (neo-Attic relief). Also the standing Fortuna Redux, dated in the second century A.D. and in the British Museum: A. H. Smith, *Catalogue of Sculpture*, pp. 76–77, no. 1701.

Thomas Ashby has concluded that Gavin Hamilton's excavations seem to have been made "not at the Villa of the Quintillii close to the Via Appia [between the Via Appia Antica and the Via Appia Nuova], but at or near Sette Bassi. For this must, it seems [to him to], be the 'considerable ruin near this last (the road to Frascati) upon the right hand.'" See *PBSR* 4 (1907): 91–92. Thomas Ashby goes on to describe a number of other finds from "Roma Vecchia," whether from the Villa of the Quintillii or elsewhere in the area encompassed by the *tenuta*. Both sites or villas contained all the sculptural apparatus of Roman country seats in the second and third centuries of the Christian era. Ashby's section 8 (pp. 97–112) is devoted to "The Villa called Sette Bassi." This great structure, which appears

to have yielded many sculptures associated with "Roma Vecchia," dates from throughout the second century A.D. and could have belonged to Septimius Bassus. A number of scholars believed that this villa was united with that of the Quintillii to form one immense property, by Emperor Commodus (180–92), presumably in an effort to rival the Albano villa of Antoninus Pius and the Villa of Hadrian at Tivoli. In keeping with the less relaxed, rustic tone to the latter part of the second century A.D., the complex had more statues of serious divinities, and of quasi-virtues such as Fortuna. The days of Antinous in every material and numerous hunting dogs and other pets in white marble had passed with the Germanic and Balkan wars under Marcus Aurelius.

32. A. H. Smith, in *Lansdowne Marbles*, Christie's Sale, London, March 5, 1930, pp. 5–6; idem, *JHS* 21 (1901): 311–13.

33. J. Dallaway, *Of Statuary and Sculpture Among the Antients*, pp. 339–40; idem, *Anecdotes of the Arts in England*, pp. 312, 375. Quotation is from A. H. Smith, *JHS* 21 (1901): 313, with lists of the sculptures in the British Museum. These are catalogued by him in *Catalogue of Sculpture*, vol. 3, pp. 47–218, no. 1625 (child Dionysos), nos. 1666–67 (the Pans), nos. 1699–1700 (the Nikai slaying bulls), no. 1719 (the table support or a similar sculpture), no. 1745 (the terminal satyr), no. 2131 (the group of two "greyhounds"); etc.

34. Stuart Jones, *Sculptures of the Museo Capitolino*, pp. 347, no. 8, pl. 86 (the philosopher); pp. 197–209, nos. 35, 36, 37, 40, 41, 43, 63, 69, pls. 50–52 (the various busts). The Paris long at Hamilton Palace is A. Michaelis, *Ancient Marbles in Great Britain*, p. 301, no. 9. The Paris, six feet, three inches in height, was sold at auction in New York in 1921: see *AJA* 59 (1955): 136.

35. See especially, H. Winnefeld, *Die Villa des Hadrian bei Tivoli*, pp. 150–61.
Other imperial villa sites along the hills to the east and southeast of Rome offer tantalizing glimpses of what could have been seen in a careful, planned excavation. For example, in 1709 in the ruins of a late Julio-Claudian and Flavian imperial villa off the Via Latina at Frascati, so Thomas Ashby writes, statues of Domitian and Domitia were found, each in its own niche, in the Villa Cremona. They passed into the Palazzo Rospigliosi (Matz-Duhn, nos. 1343, 1501), and may be actually Titus in *adlocutio* pose and Julia Titi or Domitia. See T. Ashby, *PBSR* 5 (1910): 304.

36. S. Aurigemma, *Villa Adriana*, pp. 100–133. See also E. Berger, *RömMitt* 65 (1958): 6–32, "warrior" as Pheidian, perhaps after the Athenians' commemoration of Marathon at Delphi, a hero(?). The Hermes (pl. 6) copies a similar model, one with widespread relationships among the great masters of the Periklean Age. Copyists, of course, created their own variations on Periklean statues.

37. R. Meiggs, *Roman Ostia* (Oxford, 1960), especially pp. 149–71 (chap. 8, "Portus") and pp. 431–36 (chap. 17, "The Arts").

James Dallaway reported (*Of Statuary and Sculpture,* p. 355) that the Hope Athena and the Hope Hygeia, both now in the collections of the Los Angeles Museum of Art from that of William Randolph Hearst, were found at Ostia in 1797 "among the ruins of a magnificent palace, and thirty feet below the surface of the ground, broken into fragments, and buried immediately under the niches, in which they had been once placed."

38. A. Boëthius and J. B. Ward-Perkins, *Etruscan and Roman Architecture,* pp. 305–6, pl. 167, fig. 118; S. Aurigemma, *Velleia* (Rome, 1940), pp. 17–20, and illustrations. The forum of Velleia is also seen in the model of the ruins exhibited in Room XXXII of the *Mostra Augustea della Romanità, Catalogo,* p. 508, no. 19, pl. LXXXII.

IV: Archaeological Evidence in Greece, Asia Minor, and the East

Greece

OLYMPIA

The true opportunities to relate statues to their settings in the period of late-Victorian precision came in a careful, controlled excavation of a famous site unencumbered by mediaeval or later buildings and unfettered by pressures from building contractors or similar commercial interests. Such an occasion was the German excavations at Olympia in the 1870s. The full publications of the first decade of work extracted much more from the evidence than nearly all excavations had since the dawn of the Renaissance.[1] Pausanias in hand, Ernst Curtius and his collaborators could immediately identify what the ancient Baedeker had thought was the Hermes of Praxiteles. The fact that a statue of Poppaea, Nero's tragic second wife, stood in the section of the cella of the Temple of Hera next to the marble divinity with the infant Dionysos had no effect on the statue's immediate claims to being an original of the fourth century B.C. rather than a Roman copy. Not since the appearance of Pliny's Laocoon was the world of learning so thrilled with the discovery of a single statue. Compared to the recorded precision of the Germans at Olympia, contemporary discoveries of archaic sculptures on the Athenian Acropolis or in the clearing in the Roman Forum, the two most important spots in the classical world, seemed almost like work of the bulldozer.

The main results of the campaigns at Olympia, so far as statues were concerned, were in the realm of Roman imperial dedications, but the methods of giving a plan of just where each statue or fragment was found, a reconstructed plan of where it stood, and a graphic reconstruction of the monument as a whole could have been applied with profit to

dozens of other sites from 1880 to the present day. Such care confirmed that the metroon at Olympia had been turned into a shrine of the Julio-Claudians and the Flavians, for the plan revealed a statue of Augustus in the guise of Zeus as the cult image at the rear of the cella and Claudius (41–54) opposite Agrippina the Younger between the columns on the side of the cella. This suggested that Claudius had reconsecrated the building about A.D. 51. About A.D. 80 to 82, statues of Titus (79–81), Domitian (81–96), and the ladies of the house were added to the four remaining spaces between the columns (fig. 70). The penchant for this type of dedication affected the Temple of Zeus as well, for Pausanias wrote about the pronaos, "There are also statues of emperors, one of Hadrian in Parian marble set up by the cities which form the Achaean confederacy, and one of Trajan, set up by all the Greeks."[2]

The nymphaeum donated to the sanctuary by Herodes Atticus and placed among the treasuries against the slope of Mount Chronos was the grandest testimonial to careful documentation of statues (fig. 71). Without such recordings during excavation, the complex dynastic messages of the figures within the domed hemicycle would have been lost. The nymphaeum was a mixture of honors to the family of Marcus Aurelius (161–80), in whose reign the structure was completed, and of Herodes Atticus. The latter was elevated to quasi-imperial or regal status by association with the former, and the viewer must have had difficulty in deciding who was honored the more. Hadrian, Sabina, Antoninus Pius, and Faustina the Elder shared the larger, curved niches with the living rulers, while the Atticus family filled the smaller, rectangular alcoves, but Herodes and his wife Regilla were placed in the very center, beyond Regilla's bovine and behind the water basin. The statues, some headless, had tumbled down into the pool, but almost without exception their bases remained in place so that the correct figure could be associated with its niche (fig. 72). Such care in recording sculptural associations, carried out in the nineteenth- and early twentieth-century excavations of the palaces on the Palatine or the later explorations of the imperial fora could have said much about the uses and importance of Roman copies in the world of Augustus, Domitian, Septimius Severus, or Constantine the Great.

ATHENS

The Olympeion of A.D. 124 to 132 in Hadrian's "new city" of Athens certainly overwhelmed its surrounding rectangular precinct wall and

single, small gateway, but the concourse of statues, their sheer numbers, must have been a cataloguer's delight. Of this temple, which Hadrian dedicated in person, Pausanias wrote: "... before you enter, ... , there are portrait statues of Hadrian, two in Thasian marble and two in Egyptian stone. In front of the columns stand bronze statues which the Athenians call 'the colonies.' The whole *peribolos* [circuit of the sanctuary] is about four stades in circumference and is full of statues. For a portrait of the Emperor Hadrian has been set up by each city, and the Athenians have outdone the others by setting up a colossus, well worth seeing, behind the temple"[3] (fig. 73).

There was an image of Zeus in gold and ivory within the temple. The colossus set behind was a Hadrian presumably fashioned of marble and in the half-draped, heroic guise of a standing Zeus. The plan of the temple and precinct wall allows rectangular pedestals for 136 statues of Hadrian (and perhaps a few of Antinous, and one or two of Sabina) around the inner circuit. When these urban dedications (about 10 percent of the bases survive, all to Hadrian) were set facing the bronze statues of "the colonies" (city or regional personifications such as those on Hadrian's imperial coins or in the reliefs from the podium of his memorial temple in Rome), in front of the columns, the effect must have been confusing to the visitor seeking the might and majesty of the Olympian Zeus.[4] So many Hadrians added up to one of the most personal overstatements in antiquity since the Nile-side temples of the pharaohs. The setting of these statues should have left no doubts in anyone's mind that Athens regarded Hadrian as the thirteenth Olympian.

If a worshipper of Zeus felt uncomfortable in the presence of so many Hadrians at the Athenian Olympeion, a spectator with good, central-section seats in the Theater of Dionysos at Athens must have been even more disturbed. Statues of Hadrian dating from his own reign and that of his predecessor Trajan, presumably also a statue of Trajan, probably one of Antoninus Pius, and other famous "citizens" of imperial Athens were ranged on large square or rectangular bases in the third and fourth rows behind the thrones for the leading religious and civic officials.[5] It was as if Emperor Hadrian was intended to be a perpetual spectator at events in the theater. Some statues were patently cast or carved showing their subjects seated, but at least one statue was standing. All this provided a noble, intellectual setting for works of commemorative sculpture, but the patrons holding tickets for the eight or ten seats directly behind each statue must have felt very cheated as the dramatic presentation unfolded.

The Greek Islands

THERA (SANTORINI)

The agora and public buildings along the southeastern ridge of Thera's archaic to late classical city and harbor beaches had a strong royal and Roman imperial bent, because they were laid out by the Ptolemaic garrison and later filled with statues and busts honoring the emperors. Thus one of the finest surviving portraits of Ptolemy I Soter was found on the terrace of what came to be the "Kaisareion," and a splendid, sensitive head of the veiled Hadrian was excavated in or near the stoa basilike in the agora. The small temple of Dionysos may have been rededicated to Augustus as Neos Dionysos, and the orchestra of the theater contained one or more statues of Emperor Claudius. All these and more too were arranged in a tight, compact fashion, since the site was long, slender, and spectacular, and ranged along the spine of the mountain. The stoa basilike in particular was crowded with statues of and tablets to the Julio-Claudians and later the Flavians. The same phenomenon was observed in front of the skene of the theater, where a row of statues on contiguous blocks honored (from left to right), Titus, Vespasian, Agrippina, Germanicus, and Caligula, all of whom (Caligula as a child perhaps) probably visited the island on their ways to or from Syria, Palestine, or Egypt. The stoa basilike was restored in 149 by one Flavius Kleitasthenes, at which time dedications, including statues, were added to all the Antonines.

In terms of setting what makes Thera attractive is not the platoons of Ptolemies and Roman princes but the sculptures carved into the living rock of the mountain, together with appropriate inscriptions. Ptolemaic eagles and divine lions, medallic busts of divinities and sacred symbols, all gave the skyline buildings, agora, gymnasia, temples, and theater, a greater sense of architectural, sculptural, and natural relationship than encountered at most sites, large or small, in the pan-Aegean world. While the divine or ideal statues from the sacral and civic areas of Thera appear, from their fragments, to be routine decorative copies, probably of the so-called Rhodian school, the portraits are exceptional, as would suit a small area with many dedications. A bust, perhaps to be set on a herm pillar, could be an ideal Julius Caesar, and the heads which resemble Faustina the Elder and the young Lucius Verus (the latter worked for insertion in a draped statue, bust, or shaft) are as spirited in purely Greek

imperial forms as the Ptolemy Soter is of the Pergamene Age or the Hadrian among the many concepts of that ruler.

Aside from a lady draped in a full fringed cloak and wearing a chiton which falls over her sandaled feet, a Hellenistic portrait statue from the Ptolemaic gymnasium, there are several hermlike ideal heads of athletes who must have brought fame to the Hellenistic settlement. They are little different from the Polykleitan ideal or commemorative heads which stood alongside them. While the draped busts are big and conventional in scale and type, the decorative statues are of the size which could fit either in a private house or in a small temple, an Aphrodite binding up her sandal or a miniature Knidia in marble. The theater must have been replete with a set of the Muses of the standard Hellenistic type, for a small Apollo Musagetes or Pythios of the Skopasian circle and its Hellenistic derivatives was found on the classical site and is patently too decorative in nature to have formed the cult statue of one of the temples or shrines.[6]

Asia Minor

The major cities of Asia Minor from Smyrna, Miletus, or Ephesus to Perge and Side in Pamphylia or Soli-Pompeiopolis in Cilicia had their Hellenistic traditions, with statues in the marketplace or exedras dedicated to rulers and famous local worthies. From Augustus onward, Roman commemorative influences were felt in the settings for sculpture. There were triumphal gates, such as the example at Antioch in Pisidia, and there were exedras enlarged into fountain houses or piazzas, such as the ensemble to Trajan at Ephesus. The small fountain building constructed at Side in A.D. 71 and focusing on a statue of Vespasian, flanked by local ladies and gentlemen or regional personifications, has been recognized as the forerunner of the giant, multistory facades with statues in pedimented aediculae or semicircular niches. These could be adapted to the stage buildings of theaters, to fountain buildings, or just to empty spaces in complexes of civic and commercial buildings.

In the peace and prosperity which existed in Asia Minor from Trajan through the Antonines, these buildings were constructed by the dozens, every city large or small needing one in the same way that American cities crave skyscrapers. Stone blocks, concrete, and sometimes brick were used, but the hallmarks of class and quality were the amounts of

marble flooring, veneering, carved decoration, and, of course, statuary
which could be incorporated into these ensembles. The architectural
carving was generally more exciting than the copies of Greek statues.
Theater balustrades, friezes, and soffits often rose to a high level of
quality in marbles from western and northwestern Asia Minor, partly
because the sculptors carving figures were ranked with the best artisans
fashioning sarcophagi of Asia Minor type, with animal heads, garlands,
busts in high relief, and even mythological scenes. The challenge of
creativity implicit in the lavish scale of architecture apparently passed
from planners and architects to the "guilds" of carvers brought to work
and to train local sculptors in Pergamene, Ephesian, or Aphrodisian tra-
ditions over the decades. Many of these men, or families, had doubtless
begun their careers roughing out blocks of marble at the quarries. After
all, Michelangelo and a number of other distinguished Renaissance or
High Renaissance sculptors commenced working in this fashion in the
quarries of Carrara.

Architectural sculptors worked in the lively traditions of the Per-
gamene baroque, Aphrodisian rococo, or Praxitelean classicism which
Athenian sarcophagus carvers were circulating widely in the second cen-
tury A.D. The guilds responsible for the statues filling the facades of these
outdoor architectural stage pieces or the similar interiors of public halls,
in baths and elsewhere (dedicated to emperors and local divinities), were
peopled with artists of lesser imagination. Since the contents of most
niches in a building, in a city, or even in a province were interchangeable,
the challenge was just not there. Only the portraitist called upon to turn a
nearly nude Hermes into a local athlete of fame or a Demeter of the
Herculaneum type into one of the rich ladies from Perge could be said to
face some unpredictable novelty. Even here, since the focal statues were,
as likely as not, widely circulated, widely copied portraits of emperors,
their consorts, or their children, portraitists were often merely casting or
carving from standard, shopworn models or merely fitting heads and
necks imported from workshops in Greece or along the Ionian coast into
the conventionally copied bodies.

The copies, whether ideal or adapted as portraits, are what one
could truly call decorative vehicles. The same types occur over and over
again, as if each city was determined to overwhelm a visitor by the sheer
numbers of nude heroes, emperors in armor, draped divinities, or
idealized ladies. In a desire to impress by repetition, the donors and city
planners of Asia Minor had ample precedent in the activities of latter-day
Athens, the setting up of so many statues of Hadrian in the precinct of

the Olympian Zeus at Athens. These Greek imperial tendencies toward repetition were neither a Greek nor a Roman phenomenon, although the archaic lions on the terrace near the temple of Apollo on Delos might point to an early precedent. The source must be sought in the temples of the Egyptian rulers, already mentioned. These multiplications of ruler images were much admired by Roman visitors to the banks of the Nile, from Germanicus Caesar to Hadrian.

MILETUS

Miletus, along the Aegean coast of Ionia, was the site of one of the earliest and most impressive of the great architectural and sculptural facades. Anonymous burghers of Miletus (the inscription with their names is missing) claimed credit for the so-called Great Nymphaeum Facade, which was commissioned under Emperor Trajan (A.D. 98–117). The inscription of the lower architrave, in Latin, records the dedication to Trajan's father, Marcus Ulpius Traianus, legatus of Syria from A.D. 76 to 77, proconsul of Asia from 79 to 80. The emperors Vespasian and Titus, under whom Traianus Pater served, are mentioned as Divi. There were bases for statues, again with the Roman flavor of inscriptions in Latin, to M. ULPIUM TRAIANUM PATREM, and to FILIUM IMPERATOREM.[7] Since coins from the mint of Rome in 112 to 117 hail Trajan Senior as Divus and show him seated as a presiding Roman magistrate, the facade at Miletus had every reason to take on the characteristics of a temple to the Gens Ulpia.[8]

Under Emperor Gordianus III, in the years A.D. 241 to 244, the building was enlarged or rebuilt. An inscription in Greek on the upper architrave bears witness to this activity, and a number of statues may have been made or ordered for the building's adornment at this time. If so, these statues must be among the few sculptures in the round of the period, certainly the few of mythological or ideal subjects. The statues have been mostly copied from works of classical and Hellenistic times; the level of craftsmanship, technically speaking, is good, if, as usual, not inspiring. The statues ran through the full repertory appropriate to facades and interiors of this type. Included were a Muse, a nymph, a Silenos, a copy of the Pasitelean "Electra" (used often to balance the Venus Genetrix), a nude hero or a ruler in heroic guise, a Nike of the type close to representations of Artemis (also found at Side), a fountain nymph of the widely circulated type, the inevitable Venus Genetrix, and

other subjects. How many were portraits is now difficult to say, but the mixture was undoubtedly similar to that at other cities in Asia Minor.

PERGE

The arrangement of statues in the horseshoe-shaped court of the inner, older gate (G) at Perge has provided, thanks to careful excavation, a good insight into the choice and placing of decorative and commemorative copies about A.D. 120 and slightly earlier (figs. 74, 75). Of this choice of subject and the balancing off of the statues within the shadow of the older circular towers, George E. Bean has written,

> In the walls of the court are niches which once held statues, and on a ledge at the foot of the wall stood other statues. The bases of these latter have survived with their inscriptions, which designate the statues as those of the founders of the city. Nine of these have been recovered. . . ; it is probable that there were five on each side and that one is lost. The "founders" include heroes of the mythological age, such as Mopsus and Calchas, familiar, others obscure or quite unknown. No doubt all of these were supposed by local tradition to have come with the settlers after the Trojan War.

Bean then turns to the statues of the contemporary "founders," the family who had paid for these sculptures, their refurbished settings, and statues of the imperial family. He continues, "But two of the bases—the first and third from the south on the east side—bear the names of M. Plancius Varus and his son, C. Plancius Varus. The inclusion of these Romans with the heroes of the distant past is due to the use of the word 'founder' in late times to describe anyone who had paid from his own pocket for the construction of buildings in the city;" Bean further notes that these distinguished men are described as father and brother of Plancia Magna, priestess of Artemis and the Mother of the Gods, of whom, "In and around the south gate, and elsewhere in the city, at least fourteen other texts have been found recording either dedications of statues made by her or statues of her decreed by the city authorities. Those presented by her are all of members of the Roman imperial house and were erected about A.D. 120." The family had held high office in Rome and Asia, and they were well established at Perge in Hadrian's time.

Other so-called early founders comprised the Lapith Leonteus, Rixos, son of Lykos, and Machaon, son of Asklepios. There were also statues of deities, notably Apollo, Hermes, the Dioskouroi (fig. 76), Pan, Herakles, and Aphrodite. Four statues of Nike, less than life-sized, deco-

rated the corners of the attic or pediment, and to the north, or beyond the three-winged arch, stood statues on bases with inscriptions in Greek and Latin. There were Diana Pergensis, Genius Civitalis, Divus Nerva, Divus Traianus, Diva Marciana, Diva Matidia, Plotina Augusta, Sabina Augusta, and Hadrianus Augustus, he at least appearing both in military costume and elsewhere in the area in the heroic nude.

The statues are of the most conventional type, the Trojan War heroes looking like Antinous or Androkles-Antinous the mythological hunter from Ephesus, and the divinities copying standard bodies, the half-draped Aphrodite-nymph leaning against a pillar as a fountain figure, the Dioskouroi in partly reversed pairs, and parts of what could be a Herakles not far from the Lansdowne type or a Meleager after Skopas. The emperors, as indicated, came as portrait vehicles in the heroic nude, in cuirass, and occasionally, like the local magistrates, in the Greek himation. Finally there were the women, chiefly Plancia Magna (so influential in a city with a goddess and female priesthood) but including Trajan's and Hadrian's ladies. They were arrayed as repetitions of the same draped types of the fourth century B.C., most notably Demeter and Persephone (or the Large and Small Ladies from Herculaneum).[9]

In short, the architecture might have been said to have been more imposing than the mass of sculpture probably produced on location within a relatively brief span of time on commission from a wealthy patroness. Still, the white statuary marble against the blue sky and the brown stone of the circular towers, all intermixed with the columns and pediments or friezes and set above and around the water which gushed down the main avenue of the city toward the arch with its three passageways, the inner court with its (columned) niches, and the giant round towers of the inner gate must have been as impressive as any similar complex in the Greek imperial world.

SIDE

The way in which Gavin Hamilton planned a replica of Myron's Discobolus (from Ostia) as pendant to a sandal-binding Hermes identified with Lysippos (from Hadrian's Villa at Tivoli) in the tribuna of Lansdowne House, London, had its perfect ancient parallel in the balancing of two such copies in the upper story of a large imperial civic center at Side in Pamphylia, the so-called Building M (figs. 77, 78). The architectural niches and baldachinos of the broken entablature and jutting dados within the main, central hall of this complex featured just under-life-

sized statues above, copies of works from the fifth and fourth centuries
B.C., and similar, over-life-sized figures below. The statues in the upper
story were bending, throwing, or seated, while those below were majes-
tic standing verticals (fig. 79). Those in the lower row were at least twenty
in number and arranged on the three sides facing the large, open peri-
style court, like that of a gymnasium or agora. They were centered on a
cuirassed emperor. While he was in the central niche, his protective
Nemesis occupied the right corner niche, and a Nike in the same fourth
century B.C. to Hellenistic style could have stood in the niche at the
opposite or left corner. A statue in the costume and pose of Persephone
of the type known best as the Small Lady from Herculaneum, must have
portrayed a young empress.

The roll call of other statues in this lower series of richly carved
architectural settings included the gods, goddesses, and virtues of the
Roman imperial state during the Antonine Age, the original date of the
cuirassed statue and seemingly of all the polished, drilled copies.
Asklepios was balanced by a Hygeia of the period about 380 B.C. An
Apollo of the type from Tivoli in the Museo Nazionale Romano, ascribed
to Myron, could be paired off with a Hermes whose immediate ante-
cedents were in the Pasitelean workshop of Stephanos in the Augustan
Age. The Ares Borghese, also found in Hadrian's Villa at Tivoli, has a
large cuirass with *pteryges* and fringed straps on the treetrunk support
beside the left leg. A Herakles would have been a potential pendant.
There were other male torsi, and draped females, the former perhaps
belonging to imperial statues in heroic guise, if not to divinities, and the
latter to ladies of the imperial house. The head of a youth in an eclectic
type, mixing the work of Pasiteles with the transitional period around 460
B.C., belonged very likely to a statue of a genius or male virtue, like
Honos.

I would venture to guess the building, a sebasteion with side halls
for reading or public events and an open court for markets, was con-
structed in honor of Lucius Verus, when he must have stopped at Side
on his way to or from the Parthian War, about 165. A coin with his
cuirassed bust on the obverse and a war galley in progress on the reverse,
a design copied from a Roman sestertius and marking the revival of
large-flan coinage at Side, seems to support such a visit. The statue in the
central niche was Lucius Verus, and by the middle of the third or early
fourth century his memory was of such minor importance that the head
could be recut from the bearded Verus to Licinius, Eastern colleague of
Constantine the Great from 308 to 324. Licinius, more than Constantine

or any of his sons, would have been happy in the company of so many divinities from Rome's pagan past. The young empress was originally Lucilla or her mother Faustina the Younger, wife of Marcus Aurelius, who would have appeared as co-emperor somewhere in the complex. The cuirassed statue was certainly a full-bearded Antonine emperor, and Antoninus Pius could have been the original recipient of these honors. Marcus Aurelius is less likely, only because he did not favor himself in cuirassed statues throughout the East in his mature years (the example as Caesar from Alexandria being an exception), and Commodus was represented in this fashion in the East, as at Tyre, only posthumously in conjunction with statues of Septimius Severus and his family.[10]

The East

CYPRUS: SALAMIS

The peristyle gymnasium, covered baths, stadium, and theater complex at Salamis on the eastern coast of Cyprus was developed in the Trajanic to Antonine periods into a series of spatial relationships familiar from other sites along the eastern Mediterranean coasts. The large, colonnaded court with its flanking pools for cooling the surroundings or for outdoor paddling led into the niched, vaulted baths. From these one could walk out across the end of the stadium to the back of the stage building of the theater. Unfortunately, the wealth of statues commissioned under Trajan and Hadrian to adorn the rectangular court and its nearby shrines were reused to embellish the baths after the destructive earthquakes of A.D. 332 and 342.

> New pedestals were constructed for some of the statues, against the façade of the central *sudatorium* and elsewhere along the east stoa. Other statues, however, suffered a worse fate: they were either thrown into drains or were built into walls. The water tank of the south *sudatorium* produced a number of statues, evidently thrown in it at the time of the Arab invasions [A.D. 647 to 648]. There are a few pieces which were found in the filling of a room along the south stoa of the Palaestra, evidently thrown away when clearing the Palaestra of the débris from the earthquakes of the fourth century. It is not surprising that during this troubled life of the Gymnasium the statues which once decorated it should suffer, either in the hands of the early Christians or the Arab invaders, not to speak of the inevitable damage during the earthquakes.[11]

Despite all this rearrangement and confusion, much can be gathered about setting from the surviving statues, which for the most part have been found close to the places where they originally stood. The statues themselves reveal relationships to each other from their subjects, sizes, and choices of material—white marble from western Asia Minor in most instances, with grey black marble being used for the gods and goddesses of the Graeco-Egyptian cults and the ladies in their images. Among the Graeco-Roman copies, two sculptures stand out as such palpable Greek originals that the gymnasiarchs of the second century A.D. to late antiquity must have recognized and prized them as such. One is a Cypriote limestone kore of about 510 B.C., with carving of the highest quality in the Ionian style and with the pose and costume of the maidens from the Acropolis in Athens. The second is the head of a young goddess, perhaps Hygeia, in Pentelic marble. This work of about 340 B.C. combines the soft delicacy of the best ideal females from the wider circle of Praxiteles with a facial tradition and hair style which go back to the first quarter of the fourth century B.C. No one could possibly mistake the workmanship as Greek imperial, and the head (with the remainder of the statue?) must have been treasured at Salamis to the same degree that the Knidians cherished their Aphrodite by Praxiteles.

As might be expected, the bigger Graeco-Roman copies were of better quality than the half-life-sized or smaller figures, which could be almost crude little dedications scooped into the ruins of the palaestra, baths, or theater from nearly anywhere on the vast site. The big white marble Apollo is very impressive, partly because of his completeness. With him stood a large Athena, a similar Artemis, Asklepios in two versions, Hygeia (not the beautiful original head but an eclectic creation with diademed hair), Nemesis with all her attributes, and Hermes or a famous person (an emperor?) in heroic guise. On a slightly smaller scale came the Lysippic Herakles (of pure style close to the original), the Skopasian Meleager (an uninspired, softened copy), an aquatic nymph, and the popular group of a satyr courting a hermaphrodite. (There were, it will be recalled, no less than four replicas of this group in the four corners of a room of the Western Baths at Cherchel.)

The athletic and bathing complex at Salamis exhibited many statues of ladies in the drapery and with the attributes of divinities from Kore or Isis to mythological concepts or literary persons from the Three Fates to the poetess Corinna. The theater was the place where the cuirassed imperial benefactors, the Flavians, Trajan, and Hadrian, were honored and where, naturally, the Muses held sway. The statues at Cypriote Salamis

were many and totally predictable. Their settings, too, can be reconstructed with relative ease, as has been done in the modern "museum" of the baths.

DECAPOLIS: PHILADELPHIA

The theater just above the agora against the hillside of Amman-Philadelphia is about as far east as one can travel to judge the positioning of Greek sculpture in Roman settings (figs. 80, 81). It is dated at the height of the reign of Antoninus Pius, about A.D. 150. The two major niches of the building behind the stage held statues of Antoninus Pius and Hadrian, of which the marble, cuirassed torso has been preserved. This is one of the traditional Hadrians, carved in Athens or a nearby seaport and exported throughout the Greek imperial world. A headless statue of a draped goddess, Persephone or Pietas, was probably a portrait of Faustina II and stood in one of the upper niches with Marcus Aurelius and other members of the official family.

A spirited Antonine copy of Myron's Athena, slightly smaller in scale than the imperial statues, has been suggested as the cult image of the small temple in the center of the main upper entrance to the cavea. Single copies of Myron's Athena made attractive additions to a villa or personal library, but she seems hardly the statue for a theater temple in a city on the route from Arabia to Syria. More in keeping with the Philadelphians known tastes in mythological sculpture would be a grouping of Myron's Athena and Marsyas in the central, lower niche of the stage building. Excavations in the area above the theater, on the clifflike face of the acropolis hill, many years ago yielded the late Pergamene or Rhodian group, again an Antonine copy, of Daedalus (and Icarus?) in flight, a perfect idea in monumental marble for the shrine above or for the uppermost niche of a hillside theater in the East.[12]

FROM GERASA THROUGH PALMYRA TO ROME AND RAVENNA

The colonnaded streets and public squares or circular areas of cities in the East, long rows or serpentines of columns with arches and niched facades at the ends or on the sides, bring out a late antique phase of positioning in sculpture which carried over into the architectural mosaics of the early Middle Ages. The unfluted Corinthian columns of the straight main street at Palmyra in the second half of the second century A.D. were carved with consoles or plinths one-third of the way down

from the capital or at the top of the central drum. Statues or busts *could* be placed on these rectangular, molded plinths, and such a rhythmic arrangement was both the culmination of centuries of placing statues on pedestals in or in front of colonnades and the forerunner of church, basilican interiors like those in Rome, Ravenna, and Salonika in the fourth or fifth centuries onward, when such statues or busts on pillars or above colonnades were transformed into mosaic.

The system as applied at Palmyra and in Asia Minor was the ultimate synthesis of Greek commemoration and Roman engineering (fig. 82). As many places for statues or busts could be provided as there were columns along an avenue or around a court, and at the same time these sculptures were placed where they could be admired. They were also out of the way of people and vehicles (fig. 83).[13] If many of the plinths never received statues, as may have been the case at Palmyra, the total architectural effect was hardly less impressive than if sculptures in bronze, marble, or limestone had been added, with appropriate identifying inscriptions. When the decorative idea of sculpture in elevated locations was transformed into mosaic in late antiquity, the tradition of portrait roundels (*tondi*) in Augustan and later libraries in Rome (on the Palatine for instance) was perpetuated in the mosaics of saints, popes, and bishops in churches from Saint Paul Outside the Walls at Rome to Sant' Apollinare in Classe at Ravenna (fig. 99).

North Africa

Aside from occasional references to Hellenistic and Roman Egypt, this study has omitted the settings of statuary in the major, excavated cities of Africa from Cyrenaica westward through Tripolitania to Mauretania. What applies to Roman Salamis on Cyprus, Ephesus, Olympia, or areas of Rome itself is also relevant to Lepcis Magna or Sabratha, sometimes all the more vividly because cities of North Africa were buried in sand and less built over in mediaeval or later times. The marble standing Dioskouroi, their horses' heads beside them, positioned at the front corners of the late Antonine stage colonnade at Lepcis Magna are excellent indicators of how decorative sculpture of a religious and symbolic nature could have been placed and could survive in the cities of Roman Africa.

It is hoped that the findings in these regional samplings, primarily Italy, Greece, Asia Minor, and greater Syria, can be illustrated in future

investigations by evidences and statistics from these cities along the northern coast of Africa.[14] At Lepcis Magna, in addition to the statues still to be seen in a lower central arched niche and on the pedestals in front of the colonnade of the stage of the theater, huge marble acrolithic heads of Augustus and Tiberius (fig. 84) were found at the Temple of Roma and Augustus in the Forum Vetus, where there were also over-life-sized heads of Drusus Junior and Germanicus, indicating a major program of decoration in the five years from 14 to 19 of the Christian era. The copies of famous Greek masterpieces from that city, copies in marble with (wherever possible) overelaborated supports, included an excellent Skopasian Meleager (fig. 85), a transitional Apollo of the Omphalos type from Athens, a Diadumenos of Polykleitos, and a resting Faun of the popular series (nearly 150 copies) identified with Praxiteles and made famous by Nathaniel Hawthorne's essay on the example in the Museo Capitolino in Rome.

Even the Antinous from the frigidarium of the Hadrianic baths at Lepcis Magna was unusual, being in the guise of a Lycian Apollo-Dionysos with a most complex tripod-omphalos-cock against rock support at the left side. There was a routine but impressive Artemis Ephesia found near the circus, an Athena of fourth-century B.C. type not far from the bronze found in the Piraeus (fig. 86), and, finally, an unusual Hermes (by some late fifth- or fourth-century master) with right foot on a tortoise, caduceus in lowered left hand, and the infant Dionysos on the draped right thigh (fig. 87).[15] It would seem that the North Africans, the Tripolitanians in particular, preferred copies of a readily recognizable but highly pictorial nature, with as much extra detail as possible to turn each into a mythological essay in itself. The Athena, for example, who would normally hold the owl on her hand, here holds the olive branch in her lowered right hand, while the owl perches on her bare forearm. Such, then, was the taste for Greek sculpture in at least one city of North Africa.

Conclusion

Literary and archaeological evidence have only rarely concorded in their descriptions of statues. Ancient authors describe groups of sculptures in temples, libraries, and marketplaces. What the excavators have found has inevitably been unrecorded for various valid reasons. Often in an-

12. Fawzi el Fakharani, *AA* (1975): 377–403, especially figs. 25–27. Daedalus, work of the school of Aphrodisias(?): J. H. Iliffe, *Studies Presented to David M. Robinson* (Saint Louis, 1953), pp. 705–12. Versions appear in Greece and Italy.

13. "He planned to construct a Flaminian portico (i.e., extending along the Via Flaminia northward from the Porta del Popolo, at Rome) extending as far as the Mulvian Bridge, and having columns in rows of four or, as some say, in rows of five, so that the first row should contain pillars with columns bearing statues in front of them, while the second and third and the rest should have columns in lines of four." The emperor Gallienus (253–68): D. Magie, *Scriptores Historiae Augustae*, ed. Loeb (Cambridge, Mass., and London, 1963), vol. 3, pp. 54–55 (*The Two Gallieni* XVIII, 5).

14. John Humphrey in the Department of Classical Studies (and Classical Archaeology, The Francis W. Kelsey Museum) of the University of Michigan has initiated research seminars and special studies in the classical sculpture of North Africa. There are, of course, still cities in Asia Minor which offer fruitful fields for excavation, where sculpture should emerge in specific settings. Patara in Lycia, partly buried in sand, is one of these: see S. Haynes, *Land of the Chimaera*, pp. 90–92 (fig. 83). At the time of writing (December, 1975) hoped-for excavations at Patara seem to be a possibility in the not too distant future: G. Kenneth Sams, "Investigations at Patara in Lycia, 1974," *Archaeology* 28 (1975): 202–5. Theater at Lepcis Magna: A. Boëthius and J. B. Ward-Perkins, *Etruscan and Roman Architecture*, p. 469, pl. 243.

15. See K. Matthews and A. W. Cook, *Cities in the Sand*, pls. 72–89, views within the museum. The various articles in *Africa Italiana* during the Italian hegemony in this part of North Africa show many of these sculptures shortly after they were uncovered. The Antinous is no. 38, p. 51, pl. 29 in Ch. W. Clairmont, *Die Bildnisse des Antinous*. That North Africa kept up with the latest Roman imperial trends in decorative sculpture is evident from the Grand Baths of Septimius Severus at Hippo Regius near Bône in Algeria. There stood a "life-sized" statue in marble of the Weary Herakles of the Roman imperial type (IV) based on the Hellenistic version (II) and influenced by portraits of Commodus during his last year (192) when the cult of the Roman Hercules was identified with the emperor. The baths were dedicated under Caracalla, who, like Commodus and to a certain extent like Septimius Severus, also admired the hero. See E. Marec, *Hippone la Royale, Antique Hippo Regius*, p. 89, fig. 45; and for the types of the Lysippic Herakles which continued to be produced in the Severan period when Commodus was reinstated as the divine "brother" of Septimius Severus, see *AJA* 79 (1975): 327. Set in an elevated niche of the frigidarium of the Hadrianic baths at Lepcis Magna was also an Amphitrite based on a late fifth-century B.C. model in the taste of the original of the Aphrodite Valenti, and the baths at Leptis also exhibited, on a focal axis, a good copy of the popular fifth-century B.C. statue known as the Ares Borghese, a figure already found in

the kaisareion at Side and the semicircular colonnade of the Euripus in Hadrian's Villa at Tivoli. See K. McK. Elderkin, *From Tripoli to Marrakesh,* p. 160, pl. 6, and p. 161, pl. 7.

16. K. Lehmann, *Hesperia* 14 (1945): 266–67, n. 35; J. Nicole, *Un Catalogue d'oeuvres d'art* (Geneva, 1906). One of the statues of Herakles by Glykon of Athens (the Farnese Hercules?) is mentioned.

17. Without the careful excavation that has characterized successive French campaigns at Delphi, much less would be known about the Thessalian dedications of marble statues to Sisyphos I, Sisyphos II, Agelaos, and others, especially Agias. Eight statues stood in a row in a crowded corner northeast of the Temple of Apollo. Thanks to this care, Agias has been a key, and somewhat disturbing, statue in the early chronology of Lysippos. See E. Sjöqvist, *Lysippus,* Lectures in Memory of Louise Taft Semple, 2nd series (University of Cincinnati, 1966), pp. 13–14, figs. 3–6.

18. See E. S. Strong, *Art in Ancient Rome* (New York, 1928), vol. 2, p. 74; S. B. Platner and T. Ashby, *A Topographical Dictionary of Ancient Rome* (London, 1929), pp. 239–40, and references.

Epilogue

Sculpture in Architectural Settings on Coins

In addition to literary accounts and findings from excavations, one further source of evidence for the installation of sculpture in Greek and Roman times should be briefly considered. Coins are useful as a record not so much of individual statues, but of arrangements of statues in relation to their architectural setting. Roman coins from the central mints of the empire and the bronzes struck in Greece, Asia Minor, and Syria, the issues termed Greek imperial, give an excellent insight into the installation of Greek and Roman sculpture in classical times. There are conventions of representation which have been well documented over the past fifty years, such as widening the columns of a temple's facade to show the cult image within or even placing the principal statues of a building in front or on the structure since the edifice could not be turned inside out in a readable fasion (figs. 88*a–d*–91*a–d*). A survey of sculpture in architectural setting on Roman coins yields predictable results. Statues appear where they would be expected in temples, flanking the stairs leading to the entrance, as decorations on the roof, and in the surrounding porticoes. Herms form the posts of the precinct or courtyard wall, and, aside from what one expects in the pediments, reliefs can be seen to enrich balustrades and the facings of the podium.[1]

Coins sometimes present unusual displays of sculpture in the illustration of special buildings such as the monumental entrance of the Forum of Trajan (fig. 92*a–d*), the elaborate structures (a nymphaeum and baths) on coins of Severus Alexander (fig. 93*a, b*), and the Pons Aeilus constructed by Hadrian across the Tiber in front of his mausoleum (fig. 94*a–c*). Trophies and triumphal sculpture, including the emperor in a quadriga, enrich the top of the arched gate in Trajan's Forum; busts in *tondi* and statues in columned, pedimented niches were set between the

103

large columns and broken entablatures of the facade. Severus Alexander's buildings have sculptures on several levels, freestanding or in the niches of the central triumphal arch, including large trophies, like those of marble now set up on the balustrade of the Campidoglio (the so-called Trophies of Marius). The Pons Aelius had pairs of statues, facing each other across the roadway, on lofty columns at regular intervals from one end of the bridge to the other. These were statues of provinces and regions throughout the empire (as in relief against the podium of the Hadrianeum), or they could have been statues of the imperial family from Nerva to Antoninus Pius, Marcus Aurelius, and Lucius Verus (as in the reliefs from Ephesus). The medallions give no specific indication, but other Hadrianic monuments in Rome, in Greece or further east can give us a good idea of just what statues lined the approach to Rome's most impressive tomb.

Other than the cult images in the temples and the emperors in triumphal vehicles, few Greek or Roman statues (or types of statues) can be identified in architectural settings on Roman imperial coins. A Herakles Crowning Himself of Praxitelean type appears on the right balustrade of the Temple of Concord overlooking the Roman Forum from the Capitolium end (fig. 89*a, b*). The record of identifiable monuments in Greece is better, for Athenian imperial coins and those of towns in the Peloponnesus showed their famous works of art. These were the statues and reliefs which Nero or earlier spoilers going back to the Macedonian wars and the destruction of Corinth had not carted off to Italy. Unfortunately, the impoverished size and artistry of bronze coins from Hadrian into the third century A.D. in Greece left little room for complex architectural settings on the reverse dies rather than just the statues themselves. The record is better in Asia Minor, Syria, and (occasionally) Egyptian Alexandria where large temples, agora complexes, and even bridges (fig. 95) appear on bronzes of considerable dimensions. In most cases, however, the specific buildings are not as well known as those of Rome, and the specific statues are equally hard to identify (fig. 96). Still, the settings for statues on coins of the Greek imperial world are as predictable as those in the Latin West, that is in Rome itself. It is sad that there was little or no autonomous imperial coinage for North Africa other than Egypt.

The Roman love of specific history, of topographical recording, and personal commemoration comes out in the detailed architectural representations on imperial coins. Thus, the Flavian Amphitheater, the Colosseum, appeared both on large bronzes struck not long after the building's dedication and again under Gordianus III (238–44) when the build-

ing was repaired and enlarged (fig. 97*a,b*).[2] The sestertii in memory of Titus (79–81) show statues in the arches and shields or *tondi* on the outside of the attic. Greek coins gave little suggestion of sculptural settings. Roman imperial issues from the age of Tiberius onward (14–37) commemorated Greek and Roman sculpture placed by the dictates of Roman taste.

Conclusion

A thorough site by site survey of cities, villas, and sanctuaries throughout the Mediterranean can provide many more illustrations of Greek and Roman statues in relation to each other, but further evidence will hardly alter the general picture presented here. Large-scale importation of commercial copies remains in general the standard by which Roman decoration was measured. Shocking to the student of Greek art though it may seem, Graeco-Roman civilization was one in which architecture, especially its triumphs of engineering, was much more important than portable or, at least, movable decoration.

That the picture may not seem so grim, we can recall the masterpieces (such as the head of the goddess in marble and the late archaic kore in limestone at Salamis on Cyprus) found in contexts otherwise devoted to the copyism of the Flavian through the Severan periods. Traditional Greek sites such as Delphi or Olympia had their masterpieces, their bronze Charioteer or their Nike of Paionios, going back to the fifth century B.C. and earlier. In fairness to the great cities of Asia Minor, it must be remembered that, whatever their mythological claims, many had little Greek artistic history before the Hellenistic period. A Phrygian tomb, an Achaemenian relief, or a neo-Hittite altar could survive, but classical creativity as defined in the monuments considered here came with the Macedonian followers of Alexander the Great at the earliest. More visibly, the urge toward major public statues and reliefs came with peace and prosperity under the Roman emperors. By this time collectable masterpieces of the fifth century to Hellenistic periods had often disappeared into private collections or the temple museums of imperial Rome. Therefore, to display Polykleitos, or Alkamenes, or Lysippos, copies had to be used.

The same rules of prosperity, taste, and availability affected imperial Rome and its wealthy suburbs where imperial patrons and private owners filled their arches and garden alleys with statues of every conceivable

subject, type, and size. Archaeologists have found the occasional Greek masterpiece in these settings, particularly in the older gardens of Rome (like those of Sallust), but the overriding factor, the legacy to our time, is that Greek art was preserved through the eyes of the skilled and careful copyists.

Planners in the cities of the East, chiefly in the second century of the Roman Empire, taught the classical world how to make decorative and commemorative sculpture absolutely subservient to urban architecture. The consoles of statues and busts on the columns of arcades along main thoroughfares in Syria, Cilicia, and elsewhere made routine the effect Hadrian had tolerated in the precinct of the Olympeion at Athens when he came to see a battalion of his images, statues and busts, dedicated by the cities of the empire. We are conditioned to think of sculptures as individual works of art, or at least as parts of temples, basilicas, tombs, or villas, not to mention theaters or fountain houses. It was, however, an ultimate manifestation of Hellenistic creativity and Roman commercial expediency that mere storage warehouses, or "granaries," like those at Patara and Andriake (Myra) in Lycia, or such pedestrian ensembles as the triple arch at Patara, should have consoles for busts or busts in high relief which anticipated in their setting the ecclesiastical sculptures of the Latin West in the Middle Ages.

The arrangement of Seasons, Dioskouroi, and similar balanced figures in very high relief on Asiatic sarcophagi of the third century A.D. fixed the traditional relationships between sculptures in the transition to the late antique period. In the fourth and fifth centuries, where statues and major reliefs are lacking, paintings, mosaics, and the minor arts, carving in ivory and metalwork relief, supply a continuous tradition of Greek sculptural types in Roman settings well into the Middle Ages. The saints in front of the complex architecture in the mosaics of the dome in Hagios Georgios at Salonika are but flattened visual continuations of the Asiatic sarcophagi and, ultimately, the mural decorations of Pompeii and Herculaneum (fig. 98). The prophets in stucco relief around the windows of the Orthodox Baptistery at Ravenna, whatever they have lost of classical poses and proportions, maintain the relationship (at the middle of the fifth century) between statue, columns, pedestals or plinths, and pedimental or apsidal architecture above. A century later the saints between the windows in the presbyterium of Sant' Apollinare in Classe also at Ravenna demonstrate that the classical rhythms, the harmony between standing figure and architecture, here seen in mosaic, existed as vividly

in the age of Justinian as in the worlds of Augustus or Hadrian (fig. 99).

The circular tomb on a rectangular base, with three steps, in the left center of the ivory panel of about A.D. 400 in the Bavarian National Museum, Munich, is one of the final manifestations of Greek sculpture in a Roman imperial architectural setting (fig. 100). The form of the tomb follows that of Hadrian's Mausoleum on the bank of the Tiber and, ultimately, a number of tombs of the first century A.D. along the roads outside of Rome. The four sculptured busts in *tondi* on top of Ionic stelai-pilasters on the architraves of the arcuated colonnade have monumental three-dimensional parallels going back at least to the second century if not to the time of Augustus. In the curved niches flanking the closed portals of the square base are two statues, a man in himation and (presumably) a woman, the latter concealed by the angel seated on the rocks in the foreground. The angel is informing the women about the Ascension of Christ taking place at the upper right. Although the architecture has moved somewhat into the late antique, with the arches on columns, the tomb is intended to be traditional, and the classical rules of symmetry have been applied in arranging the busts and statues, as they were throughout the Hellenistic and earlier Roman imperial periods.[3]

NOTES

1. The study of "Architectura Numismatica" forms an extensive subculture in the scholarly world of Greek and Roman numismatics. The pioneering book was T. L. Donaldson, *Architectura Numismatica* (London, 1859; reprint ed. Chicago: Argonaut Press, 1966). Over 130 additional titles are analyzed in C. C. Vermeule, "Geography, Topography and Architecture," pt. 3, *A Bibliography of Applied Numismatics* (London, 1956). Roman Egypt has been treated exhaustively by Susan Handler, "Architecture on the Roman Coins of Alexandria," *AJA* 75 (1971): 57–74, pls. 11–12; her p. 57 (nn. 2–4) includes important additional bibliography. For Greece and Asia Minor, there are cogent observations and references in M. Jessop Price, "Greek Imperial Coins," *NC* 11 (1971): 121–34, pls. 24–26. For the eastern end of the Mediterranean, we have Bluma L. Trell, "Architectura Numismatica Orientalis. A Short Guide to the Numismatic Formulae of Roman Syrian Die-Makers," *NC* 10 (1970): 29–50, with 120 illustrations of coins and comparative works of art and architecture. Mrs. Trell's thorough methodology has appeared in a larger study on the Greek imperial world; see also "A Numismatic Commentary on the Site and Sanctuary of Pontic Neocaesarea," *AJA* 77 (1973): 230. A full range of illustrations has been collected by P. R. Franke, *Kleinasien zur Römerzeit* (Munich, 1968).

2. That the Senate took a curatorial hand in the repair and decorative installation of public buildings in Rome, especially at a time when that august body had little else to do, is evident from a speech in the *Historia Augusta* attributed to the debate on July 9, 238, at the installation of the emperors Balbinus and Pupienus. The speech certainly reflects conditions in the fourth century A.D., if not earlier. "... while the world blazes we in the Senate-house are busied with an old woman's cares. For what is the use of our discussing the restoration of temples, the embellishment of a basilica, and the Baths of Titus, or building the Amphitheatre, when Maximinus, ... , is upon us," See D. Magie, *The Scriptores Historiae Augustae,* ed. Loeb, vol. 2, pp. 450–51 (*Maximus and Balbinus* I, 3, 4).

3. W. F. Volbach and M. Hirmer, *Early Christian Art* (New York, 1961), pls. 122–27 (Hagios Georgios, Salonika), pls. 168–73 (Sant'Apollinare in Classe, Ravenna), pl. 93 (ivory panel with the Holy Sepulcher, the sleeping soldiers, the Three Marys, and the Ascension).

As late as the tenth century, in the minor arts of the eastern Roman or Byzantine imperial world as well as on the facades of Romanesque and (later) Gothic buildings, the Greek and Roman habits of arranging statues persist, in figures in niches or in statuesque figures in high relief. For example, from one among a number of such reliefs in ivory (or from metalwork and illuminated manuscripts), on a panel of the Harbaville Triptych in the Louvre, Apostles stand frontally in the lower half, arranged in pairs on bases, in the formula once reserved for Hellenistic or Roman statues in exedras, with Saint Peter (like a Zeus or a Roman emperor) on his own separate molded base in the center. In the upper half Christ is enthroned like an eastern Roman emperor, while John the Baptist and the Virgin are arranged on rectangular plinths on either side. The angels in *tondi* above, left and right, are set just in the places reserved, architecturally, for *tondi* of rulers, philosophers, statesmen, or emperors in an imperial library, like that of Augustus on the Palatine, or in a civic building like the Basilica Ulpia of Trajan's Forum, or the Bouleuterion at Ankara in Galatia with its bronze *tondo* of Trajan as an ailing, old magistrate. See J. Lassus, *The Early Christian and Byzantine World* (London, 1967), pp. 142–43, pl. 104: the panel in Paris. Other ivory panels demonstrating the same traditional principles as the Harbaville Triptych, although perhaps not so obviously, have been illustrated in J. Beckwith, *Early Christian and Byzantine Art* (Baltimore, 1970), pls. 173–75 (especially the last, a Deesis and Saints of the second quarter of the tenth century, in the Museo del Palazzo Venezia, Rome). W. Oakeshott, *Classical Inspiration in Medieval Art* (New York, 1959), gives a number of illustrations of sculpture set in the late antique fasion at the height of the Middle Ages: e.g., pl. 120 (St. Gilles, France, in the second quarter of the twelfth century).

Appendix

STATUES FOUND IN THE BATHS OF CARACALLA AT ROME

Numbers 1, 2, and 3 were found in 1540 or 1546 to 1547.

1. The Hercules Farnese, signed by Glykon of Athens. Naples, Museo Nazionale, no. 6001: Nicole, p. 32; Ruesch, *Guida,* pp. 90–92, no. 280; *Excerpt,* p. 47, no. 188.

2. The Farnese Bull, found 1546 and twice restored: Amphion, Zethos, and Dirce, the "largest piece of sculpture from Antiquity." Naples, no. 6002: Ruesch, *Guida,* pp. 80–83, no. 260; *Excerpt,* pp. 42–43, no. 167.

3. The Farnese Flora, perhaps the Aphrodite of Cos by Praxiteles, or a Hora, or even a figure of Victoria; found with the torso of the Hercules but larger. Naples, no. 6409: Ruesch, *Guida,* pp. 71–72, no. 242; *Excerpt,* p. 38, no. 149.

4. Warrior carrying a dead boy: "Atreus with the son of Thyestes" or Athamas with Learchos, Neoptolemus with Astyanax, or (mercifully) Hector with Troilus. Naples, no. 5999: Ruesch, *Guida,* pp. 72–73, no. 243; *Excerpt,* pp. 38–39, no. 150. With this (3A) belongs the fragment, a right hand holding a right foot of a child, a mirror reversal of this group (?) and thus like the mirror reversal of the Farnese Hercules found in later excavations: see L. Savignoni, *NdS* (1901): 252–53, no. 3, fig. 3.

Listed by Lanciani:

4A. The ruin of the large group of a ship with passengers approaching an island with the footprints of several human figures, reported by Flaminio Vacca in the cinquecento. "This curious piece [a large block of marble] was probably placed in the middle of the swimming-pond": R. Lanciani, *The Ruins and Excavations of Ancient Rome,* p. 539.

4B. "the so-called Vestal Tuccia" (the same as no. 16).

4C. "a colossal Pallas" (possibly the Pheidian Athena Farnese in Naples).

4D. "a Diana."

4E., 4F., 4G., 4H. "four other figures of Herakles."

4I. "a Venus."

5. "an Hermaphrodite." This is the male statue of "Bacchus Hermaphrodite" found 1556: *EA,* no. 501; Ruesch, *Guida,* p. 163, no. 530.

Also "some busts of Antoninus Pius," "pieces of an equestrian group and a statue of Caracalla." The bust or head of Antoninus Pius, colossal, Naples no. 6078, must be one of these. "Beautiful and impressive, perhaps the same as found in the time of Paul III": *Excerpt,* p. 138, no. 734.

The nineteenth century and later finds include:

6. Statue of the Herakles of Polykleitos. Rome, Museo Nazionale, no. 106164: Paribeni, *Sculture greche,* p. 37, no. 53; S. Aurigemma, *The Baths of Diocletian and the Museo Nazionale Romano,* 4th ed. (1958), pp. 96 ff., no. 254.

7. Fragment of a replica of Myron's Discobolus, from the excavations of 1901. Rome, Museo Nazionale, no. 56746: Paribeni, *Sculture greche,* p. 24, no. 22.

8. Torso, including right arm, left to just below shoulder, legs to middle of the thighs, of a good routine version of a softer variant of the Knidian Aphrodite. Rome, Museo Nazionale, no. 48133: Aurigemma, p. 166, no. 464; Helbig, *Führer,* 4th ed., vol. 3, pp. 132–33, no. 2216; Ch. Picard, *Manuel d'Archéologie Grecque,* vol. 3, pt. 2, pp. 582, 587, fig. 247.

9. Statue of Aphrodite Anadyomene, complete except for the head, with dolphin as support against her left leg. Found in the lower, service corridors of the baths. Rome, Museo Nazionale, no. 58637: *NdS* (1912): 324, fig. 12; H. Reimann, *Kerameikos,* vol. 2, p. 115, under no. 170; *MonPiot* 21 (1913): 157, fig. 2; S. Reinach, *Répertoire de la statuaire grecque et romaine,* vol. 5, p. 151, no. 4. This is a large, that is life-sized, version of the type, usually found as garden statuettes.

10. Over-life-sized head of a young god or a related personification; from an Attic original of the fourth century B.C. Found with the Aphrodite Anadyomene: *NdS* (1901): 250–52, fig. 2. Rome, Museo Nazionale, no. 11615: Aurigemma, p. 167, no. 473, p. 105, no. 277.

11. Colossal head of Asklepios, of the Melos type, with rolled fillet. Found in one of the underground galleries of the tepidarium: L. Savignoni, *NdS* (1901): 248–49, fig. 1. Published with the previous. Rome, Museo Nazionale, no. 11614:

Aurigemma, p. 168, no. 477; Helbig, *Führer*, 4th ed., vol. 3, pp. 139–40, no. 2227. Height, with neck: 0.56m. The delicacy of workmanship has been contrasted with the coldness of presentation; eyes were inlaid, and the marble was colored.

12. Torso of the Doryphoros of Polykleitos, from a niche in the semicircular exedra and peristyle at the northwest side of the calidarium. Luna marble. Rome, Museo Nazionale, no. 58638: Paribeni, *Sculture greche,* p. 37, no. 52; E. Ghisaloni, *NdS* (1912): 307, fig. 3. Height: 1.24m.

13. Upper half of the head of a herm after the Hermes Propylaios of Alkamenes, a good, dry copy. Found next to the building lettered G, like a library, on the southwest side. See *NdS* (1912): 314, figs. 4, 5.

14. Young, archaistic head from a herm. Found in the *Xistus* before the stadium on the southwest side; a good, dry copy. See *NdS* (1912): 316, figs. 6, 7.

15. Life-sized group of a warrior supporting a deceased comrade, perhaps Menelaos with the body of Patroklos. See *NdS* (1901): 253, no. 6.

16. Naples, Nuseo Nazionale, no. 5975. "Colossal statue of a young man dressed in girdled tunic and short mantle. The dress and type are those of the traditional 'Lares,' dressed as attendants at a sacrifice. It represents either a Genius, or, . . .": *Excerpt,* p. 12, no. 25. "A Genius, perhaps the personification of the Roman people": *The Archaeological Collections,* ed. Richter, 2d ed. (Naples, n.d.[circa 1935]), p. 8.

17. Naples, Museo Nazionale, no. 5978. "It is not sure whether the head is hers. The motive is derived from Pheidias but the execution is of the III Century. The type may be that of an Hora or a Kore": *Excerpt,* p. 13, no. 30. "A female statue derived from Pheidian art and believed to be Flora, Pomona, or Spring": *The Archaeological Collections,* p. 8, also colossal. Numbers 16 and 17, from the Farnese finds, were certainly intended to decorate the parts of the baths surrounding the Farnese Bull or the marble island and ship recorded by Flaminio Vacca (numbers 2 and 4A).
This survey does not take into account the large basins in various "precious" stones (green and red "basalt") or the three armchairs of red marble found in the baths. (One of the last was in a French private collection, that of a nobleman, in or near Paris in the early 1970s; it could have come to France from the cinquecento to Napoleon, or from the Palazzo Farnese at a later date.) The figural architectural sculpture is also not included, the big composite capital with the Weary Herakles being the most famous and the small Ionic Isiac capitals the most interesting.

18. Head, seemingly of a centaur and similar to the example in the Municipal Collections of Rome; the flesh surfaces were polished. The scale was large

(height: 0.33m.), and the statue must have been similar to those from Hadrian's Villa at Tivoli. Berlin Museum: *Beschreibung der antiken Skulpturen* (Berlin, 1891), p. 89, no. 206. The head in Rome is presumably the famous Conservatori "Centaur": Stuart Jones, *Sculptures of the Palazzo dei Conservatori*, pp. 128–29, no. 3, pl. 47. Speculation as to possible subject has ranged from a group of Cheiron teaching Achilles to play the kithara to an ensemble of centaurs hauling the cart of Dionysos. The Berlin head was found about 1867, was recorded in the baths by Matz and von Duhn (no. 247), and reached Berlin in 1872. It adds yet another example to the sculptures from the baths executed on a scale larger than life and in the neo-Pergamene style.

19. Head seemingly of Apollo, a Hellenistic pathetic version of a fourth-century B.C. type, of which the Giustiniani Apollo is a less distorted copy. This head found in the Baths of Caracalla and about life-sized is a most unusual interpretation of emotionalism, well in keeping with the tastes of the Severan decorators. London, British Museum: Smith, *Catalogue of Sculpture,* vol. 3, p. 16, no. 1548, pl. III; the Giustiniani Apollo (with more discussion of this head) is p. 15, no. 1547.

20. Head of the Doryphoros of Polykleitos, in fine-grained white marble. To my knowledge, no one has attempted to associate this head in print with the torso no. 12. Rome, Museo Barracco, found 1878 in the access canal of the frigidarium and termed an excellent, late Hellenistic or Augustan classicistic copy; the head would thus have been a heirloom in the Baths of Caracalla. Helbig, *Führer,* 4th ed., vol. 2, pp. 639–40, no. 1883; *NdS* (1879): 40, pl. 1, fig. 1.

21. A large marble eagle, said to have been dug up in the garden of Boccapadugli near the Baths of Caracalla in 1742, was acquired by Horace Walpole (Lord Orford) for Strawberry Hill: J. Dallaway, *Of Statuary and Sculpture,* p. 322; A. Michaelis, *Ancient Marbles in Great Britain,* p. 486. Dallaway compared the noble bird with another (said to have a modern head) bought by Charles Townley; this is presumably the example which passed with his collection to the British Museum and which appears to have been found at Monte Cagnolo: Smith, *Catalogue of Sculpture,* p. 219, no. 2135 (where the head is given merely as mended). Horace Walpole's "celebrated marble eagle" has been last recorded at Gosford House, Longniddry, in the collection of the earls of Wemyss: *AJA* 59 (1955): 141; E. Strong, *Art in Ancient Rome,* vol. 1, p. 170, fig. 206. Townley's eagle is not mentioned or listed in Gavin Hamilton's letter about Monte Cagnolo: A. H. Smith, *JHS* 21 (1901): 313–14, 319–21.

22. A colossal (twice life-sized or slightly larger) torso of Herakles, lion's skin on the left shoulder, carved in low-grade Greek marble, perhaps Proconnesian. Rome, Museo Nazionale Romano, no. 125826. It has been suggested that the statue represented Commodus, but Caracalla could have been the subject, the first identification having been based on similarity in size to the Farnese

Hercules or the Hercules in the Palazzo Pitti, from the Palatine, the latter figure an idealized Commodus. The type seems to be Myronian, that is relatively severe and vertical rather than leaning like the Lysippic figures. Commodus does appear in such guise on large bronze medallions from the mint of Rome. A statue of this size must have been placed in a major niche, perhaps as part of a focal vista with a Pheidian female (like the Athena Farnese) as the complementary figure.

These lists have benefited from discussions with Ariel Herrmann of the Museum of Fine Arts, Boston, and with Miranda Marvin of Wellesley College.

The latter has prepared a major study, "Free-Standing Sculpture from the Baths of Caracalla," which demonstrates how the relationships surveyed in these chapters, the interactions between major sculpture and monumental Roman architecture, can be studied in depth with respect to a single building constructed within (for its size) a relatively short time. She has been careful to identify the types of statuary necessary for Roman baths, the places where these statues were installed, and the surroundings, including climate, to be expected in such vast, complex areas as the halls, substructures, and surroundings—the gardens, colonnades, and exedras—of the Baths of Caracalla. She has corrected the date for the first major finds in the ruins to August, 1545.

23. Miranda Marvin's no. 4, a mirror reversal of the Farnese Hercules now not traced, may be one of the statues mentioned above under 4E to 4H. Aldrovandi reported that the head and one leg were modern. The statue was carried in the Naples Museum inventory as late as 1796. The hero's club and lion's skin rested on a bull's head, a feature found with fair frequency in Greek imperial versions of the Weary Herakles. The statue poses the suggestion that there were at least *four* colossal statues of Hercules in various passageways, vistas, or niches of the Baths of Caracalla. The manner in which the Farnese Hercules was found and reconstituted suggests that two statues might be incorporated in the figure as we see it nowadays in the Naples Museum.

24., 25. Ariel Herrmann reminds me about two large, dark, stone statues, evidently both with white marble extremities (seemingly nos. 4D and 4I here), as figures now to be seen in the Museo Nazionale, Palermo, and in the Naples Museum. These two figures projected the image of polychromed sculpture in focal areas of the baths amid all the paint, plaster, stucco, and mosaic which gave a rich overall effect to the building. Plates of the statues are republished by G. Fuchs, *RömMitt* 72 (1965): 100–115, pls. 43, 45. Their sources were clearly in Pergamene Hellenistic art.

Bibliography

Akurgal, E. *Ancient Civilisations and Ruins of Turkey*. Istanbul: Mobil Oil Türk, 1969.

Amelung, W. *Die Sculpturen des Vaticanischen Museums*. Berlin: Georg Reimer, 1903–8.

Ashby, T. "The Classical Topography of the Roman Campagna.—III (The Via Latina).—Section I." *PBSR* 4 (1907): 1–159.

———. "The Classical Topography of the Roman Campagna.—III (The Via Latina).—Section II." *PBSR* 5 (1910): 213–432.

Ashmole, B. *A Catalogue of the Ancient Marbles at Ince Blundell Hall*. Oxford: Clarendon Press, 1929.

Aurigemma, S. *The Baths of Diocletian and The Museo Nazionale Romano*. Rome: Libreria dello Stato, 1958.

———. *Velleia*. Itinerari, no. 73. Rome: Libreria dello Stato, 1940.

———. *Villa Adriana*. Rome: Libreria dello Stato, 1961.

Bean, G. E. *Turkey's Southern Shore. An Archaeological Guide*. London: Ernest Benn, 1968.

Beckwith, J. *Early Christian and Byzantine Art*. Baltimore: Penguin Books, 1970.

Bianchi Bandinelli, R.; Caputo, G.; and Vergara Caffarelli, E. *The Buried City. Excavations at Leptis Magna*. New York, Washington: Frederick A. Praeger, 1967.

Bieber, M. *The Sculpture of the Hellenistic Age*. New York: Columbia University Press, 1961.

Blake, M. E. *Roman Construction in Italy from Nerva through the Antonines*. Memoirs of the American Philosophical Society, vol. 96. Philadelphia, 1973.

Blanckenhagen, P.-H. von. *Flavische Architektur und Ihre Dekoration untersucht am Nervaforum*. Berlin: Gebr. Mann, 1940.

Blümel, C. *Katalog der Griechischen Skulpturen des Fünften und Vierten Jahrhunderts v. Chr., Katalog der Sammlung Antiker Skulpturen*, vol. 3, Staatliche Museen zu Berlin. Berlin: Verlag Hans Schoetz and Co., G.M.B.H., 1928.

Boëthius, A., and Ward-Perkins, J. B. *Etruscan and Roman Architecture*. Baltimore: Penguin Books, 1970.

Bol, P. C. *Die Skulpturen des Schiffsfundes von Antikythera*. Mitteilungen des

Deutschen Archäologischen Instituts, Athenische Abteilung, 2. Beiheft. Berlin: Gebr. Mann, 1972.

Bothmer, D. von. *Amazons in Greek Art.* Oxford: Clarendon Press, 1957.

Bowersock, G. W. *Augustus and the Greek World.* Oxford: Clarendon Press, 1965.

Brilliant, R. *The Arch of Septimius Severus in the Roman Forum.* Memoirs of the American Academy in Rome, vol. 29. Rome: American Academy, 1967.

————. *Roman Art from the Republic to Constantine.* London: Phaidon Press, 1974.

Broneer, O. "'Armed Aphrodite' on Acrocorinth and the Aphrodite of Capua." *University of California Publications in Classical Archaeology,* vol. 1, no. 2 (1930), pp. 65–84, pls. 7 f.

Brown, D. F. *Temples of Rome as Coin Types.* Numismatic Notes and Monographs, no. 90. New York: American Numismatic Society, 1940.

Brown, F. E. *Roman Architecture.* New York: George Braziller, 1961.

Browning, R. *Justinian and Theodora.* New York, Washington: Praeger Publishers, 1971.

Brueckner, A. *Der Friedhof am Eridanos, bei der Hagia Triada zu Athen.* Berlin: Georg Reimer, 1909.

Budde, L. *Die Entstehung des antiken Repräsentationsbildes.* Berlin: Walter De Gruyter, 1957.

Calza, R. *Iconografia romana imperiale, III, Da Carausio a Giuliano (287–363 d.C.).* Rome: "L'Erma" di Bretschneider, 1972.

Caputo, G. *Il Teatro di Sabratha e l'architettura teatrale Africana.* Rome: "L'Erma" di Bretschneider, 1959.

Carpenter, R. *Greek Sculpture, A Critical Review.* Chicago: University of Chicago Press, 1971.

Caskey, L. D. *Catalogue of Greek and Roman Sculpture.* Museum of Fine Arts, Boston. Boston and Cambridge, Mass.: Harvard University Press, 1925.

Chiurazzi, S. *Chiurazzi, Società Anonima, Fonderie, Ceramica, Marmeria. Napoli. Sale d'Esposizione d'Arte: Galleria Principe di Napoli.* Naples: Giuseppe Montanino, 1929.

Clairmont, Ch. W. *Die Bildnisse des Antinous. Ein Beitrag zur Porträtplastik unter Kaiser Hadrian.* Rome: Swiss Institute, 1966.

Comstock, M. B., and Vermeule, C. C. *Greek Etruscan and Roman Art. The Classical Collections of the Museum of Fine Arts.* Boston: Museum of Fine Arts, 1972.

————. *Sculpture in Stone. The Greek, Roman and Etruscan Collections of the Museum of Fine Arts.* Boston: Museum of Fine Arts, 1976.

Conticello, B.; Andreae, B.; and Bol, P. C. *Die Skulpturen von Sperlonga. AP* 14. Berlin, 1974.

Crouch, D. P. "Use of Aerial Photography at Palmyra: A Photo Essay." *Berytus* 23 (1974): 71–80, 15 pls.

Curtius, E.; Adler, F.; and Hirschfeld, G. *Die Ausgrabungen zu Olympia.* Berlin: Wasmuth, 1876–81.

Dallaway, J. *Anecdotes of the Arts in England; or Comparative Remarks on Architecture, Sculpture, and Painting.* London: Cadell and Davies, 1800.

————. *Of Statuary and Sculpture Among the Antients. With Some Account of Specimens Preserved in England.* London: J. Murray, 1816.

D'Arms, J. H. *Romans on the Bay of Naples. A Social and Cultural Study of the Villas and Their Owners from 150* B.C. *to* A.D. *400.* Cambridge, Mass.: Harvard University Press, 1970.

Dinsmoor, W. B. *The Architecture of Ancient Greece. An Account of its Historic Development.* London: B. T. Batsford, 1950.

Donaldson, T. L. *Architectura Numismatica; or, Architectural Medals of Classic Antiquity.* London: Day and Son, 1859. Reprint ed., Chicago: Argonaut Press, 1966.

Drerup, H. *Zum Ausstattungsluxus in der Römischen Architectur. Ein Formgeschichtlicher Versuch.* Münster Westf.: Aschendorffsche Verlagsbuchhandlung, 1957.

Earl, D., Carrieri, M., et al. *The Age of Augustus.* New York: Crown Publishers Inc., 1968.

Elderkin, K. McK. *From Tripoli to Marrakesh.* Springfield, Mass.: The Pond-Ekberg Company, 1944.

Felbermeyer, J. "Sperlonga, The Ship of Odysseus." *Archaeology* 24 (1971): 136–45.

Felletti Maj, B. M. *I ritratti.* Museo Nazionale Romano. Rome: Libreria dello Stato, 1953.

Franke, P. R. *Kleinasien zur Römerzeit. Griechisches Leben im Spiegel der Münzen.* Munich: C. H. Beck, 1968.

Freedberg, S. J. *Painting of the High Renaissance in Rome and Florence.* Cambridge, Mass.: Harvard University Press, 1961.

Fuchs, W., and Hirmer, M. *Die Skulptur der Griechen.* Munich: Hirmer Verlag, 1969.

Goodchild, R. *Cyrene and Apollonia. An Historical Guide.* Cyrene: Antiquities Department of Cyrenaica, United Kingdom of Libya, 1959.

Gough, M. *The Early Christians.* New York: Frederick A. Praeger, 1961.

Gsell, S. *Cherchel, Antique Iol-Caesarea.* Algiers: Service des Antiquités, 1952.

Gusman, P. *La Villa d'Hadrien près de Tivoli, Guide et description suivi d'un catalogue des oeuvres d'art.* Paris: Librairie Hachette, 1908.

Handler, S. "Architecture on the Roman Coins of Alexandria." *AJA* 75 (1971): 57–74, pls. 11–12.

Hanfmann, G. M. A. *Classical Sculpture.* London: George Rainbird. Greenwich, Conn.: New York Graphic Society, 1967.

―――. *From Croesus to Constantine: The Cities of Western Asia Minor and Their Arts in Greek and Roman Times.* Ann Arbor: University of Michigan Press, 1975.

―――. *The Season Sarcophagus in Dumbarton Oaks.* 2 vols. Cambridge, Mass.: Harvard University Press, 1951.

Harding, G. Lankester. *The Antiquities of Jordan.* New York: Frederick A. Praeger, 1967.

Haynes, S. *Land of the Chimaera. An Archaeological Excursion in the South-West of Turkey.* London: Chatto and Windus, 1974.

Helbig, W. *Führer durch die öffentlichen Sammlungen klassischer Altertümer in Rom.* 4 vols. Tübingen: E. Wasmuth, 1963–72.

Herrmann, A. Review of R. Hampe, *Sperlonga und Vergil.* In *AB* 56 (1974): 275–77.

Herrmann, H. -V. *Olympia. Heiligtum und Wettkampfstätte.* Munich: Hirmer Verlag, 1972.

Hill, I. T. *The Ancient City of Athens. Its Topography and Monuments.* Cambridge, Mass.: Harvard University Press, 1953.

Hiller von Gaetringen, F. *Thera. Untersuchungen, Vermessungen und Ausgrabungen in den Jahren 1895–1902.* Berlin: Georg Reimer, 1899–1909.

Hueber, F., and Strocka, V. M. "Die Bibliothek des Celsus. Eine Prachtfassade in Ephesos und das Problem ihrer Wiederaufrichtung." *Antike Welt* 6, no. 4 (1975): 3–14.

Huelsen, Ch. *The Roman Forum. Its History and Its Monuments.* Rome: Loescher, 1906.

Hülsen, H. von. *Römische Funde.* Göttingen, Berlin, Frankfurt: Musterschmidt-Verlag, 1960.

Inan, J., and Rosenbaum, E. *Roman and Early Byzantine Portrait Sculpture in Asia Minor.* London: British Academy, 1966.

Jidejian, N., and Chehab, Emir M. *Tyre Through the Ages.* Beirut: Dar el-Mashreq, 1969.

Johnson, F. P. *Lysippos.* Durham, N.C.: Duke University Press, 1927.

Kähler, H. *Der Römische Tempel.* Berlin: Gebr. Mann, 1970.

Karageorghis, V. *Salamis In Cyprus. Homeric, Hellenistic and Roman.* London: Thames and Hudson, 1969.

Karageorghis, V., and Vermeule, C. *Sculptures from Salamis.* Nicosia: Department of Antiquities, 1964–66.

Kekulé von Stradonitz, R. *Königliche Museen zu Berlin. Beschreibung der Antiken Skulpturen.* Berlin: W. Spemann, 1891.

Kitzinger, E. "The Hellenistic Heritage in Byzantine Art." *Dumbarton Oaks Papers* 17 (1963): 95–117, 38 figs.

Klengel, H. *The Art of Ancient Syria.* London: Thomas Yoseloff, 1972.

Lanciani, R. *Ancient Rome in the Light of Recent Discoveries.* Boston and New York: Houghton, Mifflin, 1888.

———. *New Tales of Old Rome.* Boston and New York: Houghton, Mifflin, 1901.

———. *Pagan and Christian Rome.* Boston and New York: Houghton, Mifflin, 1893.

———. *The Ruins and Excavations of Ancient Rome.* A Companion Book for Students and Travelers. Boston and New York: Houghton, Mifflin, 1897.

———. *Wanderings Through Ancient Roman Churches.* Boston and New York: Houghton, Mifflin, 1924.

Lassus, J. *The Early Christian and Byzantine World.* London: Paul Hamlyn, 1967.

Lawrence, A. W. *Classical Sculpture.* London: Jonathan Cape, 1929.

———. *Greek and Roman Sculpture.* London: Jonathan Cape, 1972.

Lippold, G. *Handbuch der Archäologie,* vol. 3, no. 1. Munich: C. H. Beck, 1950.

Lyttelton, M. *Baroque Architecture in Classical Antiquity.* London: Thames and Hudson, 1974.

Lukas, J., and Wheeler, Sir M. *Pompeii and Herculaneum.* London: Spring Books, 1966.

MacDonald, W. L. *The Architecture of the Roman Empire. An Introductory Study,* vol. 1. New Haven and London: Yale University Press, 1965.

MacMullen, R. "Some Pictures in Ammianus Marcellinus." *AB* 46 (December, 1964): 435–55, 9 figs.

Magie, D. *Scriptores Historiae Augustae.* 3 vols. Cambridge, Mass., London, and New York: Harvard University Press, 1924–63.

Maiuri, A. *Pompeii.* Novara: Istituto Geografico de Agostini, 1951.

Maiuri, B. *Museo Nazionale di Napoli.* Novara: Istituto Geografico de Agostini, 1957.

Mansel, A. M. *Die Ruinen von Side.* Berlin: Walter de Gruyter, 1963.

————. *Mansel'e Armağan. Mélanges Mansel.* Ankara: Türk Tarih Kurumu Basımevi, 1974.

Marec, E. *Hippone la Royale, Antique Hippo Regius.* Algiers: Service des Antiquités, 1954.

Matthews, K. D., Jr., and Cook, A. W. *Cities in the Sand. Leptis Magna and Sabratha in Roman Africa.* Philadelphia: University of Pennsylvania Press, 1957.

Matz, F. *Die Dionysischen Sarkophage,* vol. 1. Die Antiken Sarkophagreliefs, vol. 4, no. 1. Berlin: Gebr. Mann, 1968.

Matz, F., and Duhn, F. von. *Antike Bildwerke in Rom.* Leipzig: Breitkopf and Härtel, 1881–82.

Meiggs, R. *Roman Ostia.* Oxford: Clarendon Press, 1960.

Merker, G. S. *The Hellenistic Sculpture of Rhodes.* Studies in Mediterranean Archaeology, vol. 40. Göteborg: Paul Aström, 1973.

Michaelis, A. *Ancient Marbles in Great Britain.* Cambridge: University Press, 1882.

Morey, C. R. *Sardis V:1 Roman and Christian Sculpture. The Sarcophagus of Claudia Antonia Sabina and the Asiatic Sarcophagi.* Princeton: American Society for the Excavation of Sardis, 1924.

Mostra Augustea della Romanità Catalogo. Rome: Casa Editrice Carlo Colombo, n.d. (1937?).

Mustilli, D. *Il Museo Mussolini.* Rome: Libreria dello Stato, 1939.

Nash, E. *Pictorial Dictionary of Ancient Rome.* New York and Washington: Frederick A. Praeger, 1968.

Neuerburg, N. *Herculaneum to Malibu, A Companion to the Visit of the J. Paul Getty Museum Building.* Malibu, Calif.: J. Paul Getty Museum, 1975.

————. *L'Architettura delle fontane e dei ninfei nell'Italia antica.* Memorie dell'Accademia di Archeologia Lettere e Belle Arti di Napoli, vol. 5. Naples: Gaetano Macchiaroli, 1965.

"Numismaticus." "L'anfiteatro flavio." *Archeologia* 10, n.s. no. 2 (August, 1972): 55–57.

Oakeshott, W. *Classical Inspiration in Medieval Art.* New York: Frederick A. Praeger, 1959.

Pallottino, M. *The Meaning of Archaeology.* New York: Harry N. Abrams, 1968.

Paribeni, E. *Sculture greche del V secolo. Originali e repliche.* Museo Nazionale Romano. Rome: Libreria dello Stato, 1953.

Pellegrini, A. "Orti di Asinio Pollione." *Bullettino dell'Instituto di Corrispondenza Archeologia per l'anno 1867* (Rome, 1867): 109–19.

Platner, S. B., and Ashby, T. *A Topographical Dictionary of Ancient Rome.* Oxford: University Press, and London: Humphrey Milford, 1929.

Pollitt, J. J. *The Art of Greece. 1400–31* B.C. *Sources and Documents.* Englewood Cliffs, N.J.: Prentice-Hall, 1965.

——. *The Art of Rome. c. 753* B.C.*–337*A.D. *Sources and Documents.* Englewood Cliffs, N.J.: Prentice-Hall, 1966.

Poulsen, F. *Catalogue of Ancient Sculpture in the Ny Carlsberg Glyptotek.* Copenhagen: Ny Carlsberg Foundation, 1951.

Price, M. Jessop. "Greek Imperial Coins. Some Recent Acquisitions by the British Museum." *NC* 11 (1971): 121–34, pls. 24–26.

Price, M. Jessop, and Trell, Bluma L. *Coins and Their Cities, Architecture on the Ancient Coins of Greece, Rome, and Palestine.* Detroit: Wayne State University Press, 1977.

Reinach, S. *Répertoire de la statuaire grecque et romaine.* Paris: Ernest Leroux, 1897–1931.

——. *Répertoire de Peintures Grecques et Romaines.* Paris: Ernest Leroux, 1922.

Richter, G. M. A. *Catalogue of Greek Sculptures.* Metropolitan Museum of Art, New York. Cambridge, Mass.: Harvard University Press, 1954.

Rickman, G. *Roman Granaries and Stone Buildings.* Cambridge: University Press, 1971.

Ridgway, B. S. "The Setting of Greek Sculpture." *Hesperia* 40, no. 3 (July–September, 1971): 336–56.

Robinson, D. M. "Roman Sculptures from Colonia Caesarea (Pisidian Antioch)." *AB* 9 (1926): 5–69.

Ruesch, A. *Guida illustrata del Museo Nazionale di Napoli.* Naples: Richter, 1920. (Also published in a shortened, English-language edition, *Excerpt from Guida illustrata del Museo Nazionale di Napoli.*)

Schmidt, Erika E. *Die Kopien der Erechtheionkoren. AP* 13. Berlin: Gebr. Mann Verlag, Berlin, 1973.

Smith, A. H. *A Catalogue of Sculpture in the Department of Greek and Roman Antiquities, British Museum.* London: Trustees of The British Museum, 1892–1904.

——. *Catalogue of the Celebrated Collection of Ancient Marbles: The Property of The Marquess of Lansdowne.* London: Christie, 1930.

——. "Gavin Hamilton's Letters to Townley." *JHS* 21 (1901): 306–21.

Squarciapino, M. Floriani. *Sculture del Foro Severiano di Leptis Magna.* Monografie di Archeologia Libica, no. 10. Rome: "L'Erma" di Bretschneider, 1974.

Strong, E. S. *Art in Ancient Rome.* New York: C. Scribner's Sons, 1928.

Stuart Jones, H., et al. *A Catalogue of the Sculptures in the Municipal Collections of Rome. The Sculptures of the Museo Capitolino.* Oxford: Clarendon Press, 1912.

——. *A Catalogue of the Sculptures in the Municipal Collections of Rome. The Sculptures of the Palazzo dei Conservatori.* Oxford: Clarendon Press, 1926.

Thompson, H. A. *The Athenian Agora. A Guide to the Excavation and Museum.* Athens: American School of Classical Studies, 1962. Third edition, 1976.

————. "The Odeion in the Athenian Agora." *Hesperia* 19 (1950): 31—141, pls. 16—80.

Toynbee, J. M. C. *The Hadrianic School. A Chapter in the History of Greek Art.* Cambridge: University Press, 1934.

Travlos, J. *Pictorial Dictionary of Ancient Athens.* New York and Washington: Praeger Publishers, 1971.

Trell, B. L. "Architectura Numismatica Orientalis. A Short Guide to the Numismatic Formulae of Roman Syrian Die-Makers." *NC* 10 (1970): 29–50, 120 figs.

————. "Architecture on Ancient Coins." *Archaeology* 29 (1976): 6–13.

————. *Architecture on Ancient Coins. Contemporary Impressions of Greek and Roman Buildings.* London: British Museum, 1976.

Vermeule, C. *The Goddess Roma in the Art of the Roman Empire.* Cambridge, Mass.: Cosmos Press. London: Spink and Son, 1974.

————. "Graeco-Roman Statues: Purpose and Setting–I,–II: Literary and Archaeological Evidence for the Display and Grouping of Graeco-Roman Sculpture." *The Burlington Magazine* 110, no. 787 (October, 1968): 545–58; no. 788 (November, 1968): 607–13.

————. "Greek Funerary Animals, 450–300 B.C." *AJA* 76 (1972): 49–59, pls. 11–14.

————. "Greek Sculpture and Roman Taste." *Boston Museum Bulletin* 65 (1967): 175–192.

————. *Roman Imperial Art in Greece and Asia Minor.* Cambridge, Mass.: Harvard University Press, 1968.

————. "The Weary Herakles of Lysippos." *AJA* 79 (1975): 323–32, pls. 51–55.

Volbach, W. F., and Hirmer, M. *Early Christian Art. The Late Roman and Byzantine Empires from the Third to the Seventh Centuries.* New York: Harry N. Abrams, 1961.

Ward-Perkins, J. B. "The Art of the Severan Age in the Light of Tripolitanian Discoveries." *Proceedings of the British Academy* 37 (1951–52): 269–304.

Wataghin Cantino, G. *La Domus Augustana. Personalità e problemi dell'architettura flavia.* Turin, G. Giappichelli, 1966.

Wiegartz, H. *Kleinasiatische Säulensarkophage.* Istanbuler Forschungen, vol. 26. Berlin: Gebr. Mann, 1965.

Willemsen, F. *Die Löwenkopf-Wasserspeier vom Dach des Zeustempels.* Olympische Forschungen, vol. 4. Berlin: Walter de Gruyter, 1959.

Winnefeld, H. *Die Villa des Hadrian bei Tivoli.* Berlin: G. Reimer, 1895.

Wood, R., and Wheeler, Sir M. *Roman Africa in Colour.* London: Thames and Hudson, 1966.

Zanker, P. *Forum Romanum. Die Neugestaltung durch Augustus.* Tübingen: Ernst Wasmuth, 1972.

Index

Plates

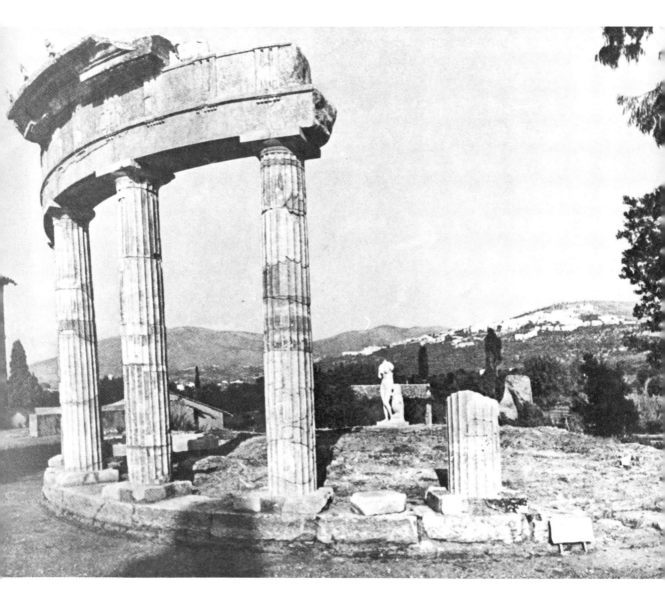

Fig. 1. Supposed temple of the Aphrodite of Knidos, Hadrian's recreation in his Villa at Tivoli. (*From S. Aurigemma*, Villa Adriana, *pl.II.*)

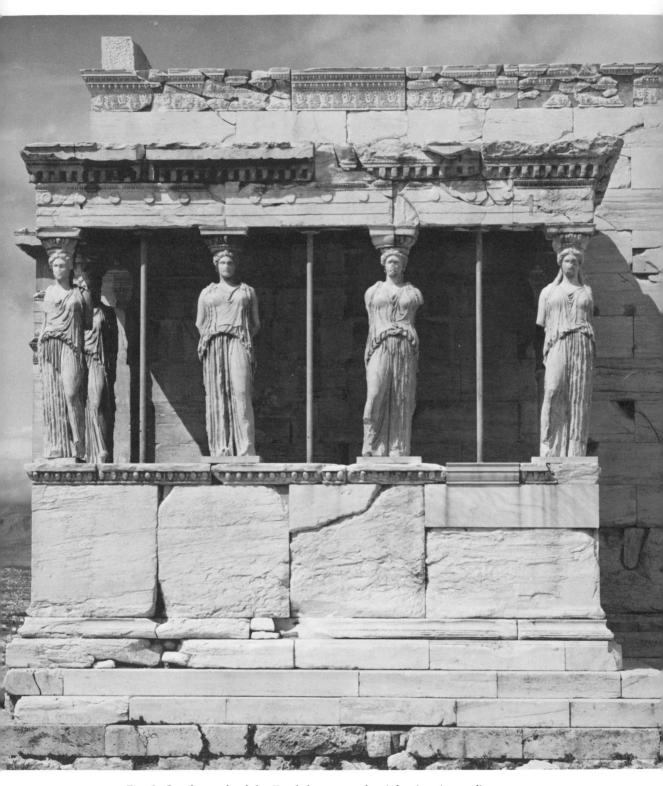

Fig. 2. South porch of the Erechtheum on the Athenian Acropolis, the Caryatids. (*Courtesy D. A. Harissiadis, Athens.*)

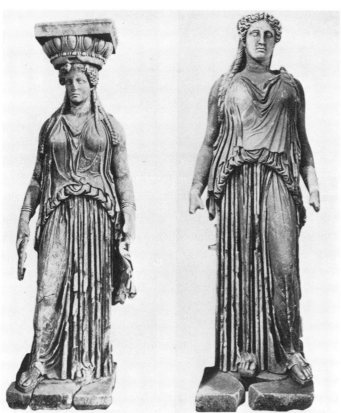

Fig. 3. *Above:* Reconstruction of the Caryatid order from the flanking colonnades of the Forum of Augustus in Rome. (*From A. Boëthius and J. B. Ward-Perkins,* Etruscan and Roman Architecture, *fig. 108.*)

Fig. 4. Caryatids (or decorative figures) from the Euripus of Hadrian's Villa at Tivoli. (*From Aurigemma,* Villa Adriana, *figs. 97, 98.*)

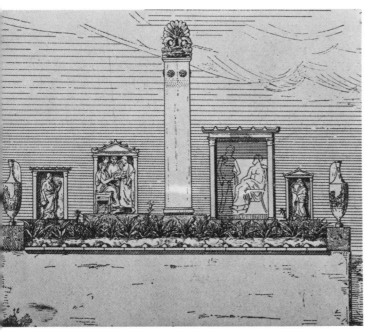

Fig. 5. Reconstruction of a family plot with sculptures. Fourth century B.C. Athens, Kerameikos Cemetery. (*From A. Brueckner*, Friedhof am Eridanos, *fig. 43.*)

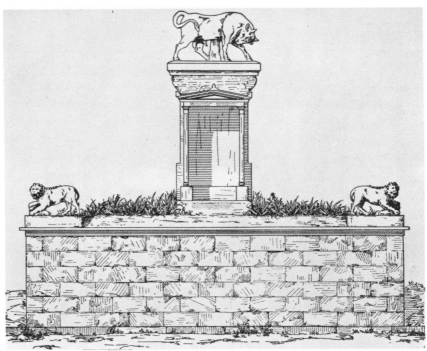

a

Fig. 6*a, b*. Monument of Dionysios (*a*). Flanking lion, from left side of similar monument (*b*). Fourth century B.C. Athens, Kerameikos Cemetery. (*From Brueckner, fig. 49.*)

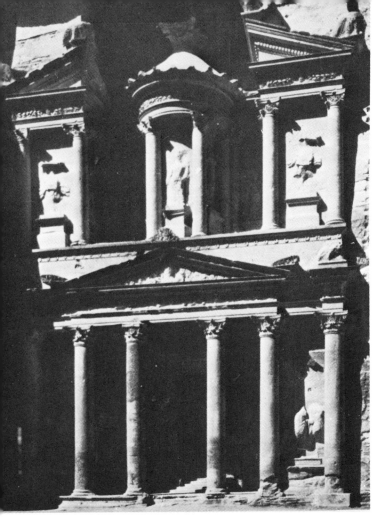

Fig. 7. The "Khasne," rock-cut tomb of the early Roman imperial period at Petra, with statues on pedestals represented in high relief. (*From M. Lyttelton*, Baroque Architecture in Classical Antiquity, *pl.1.*)

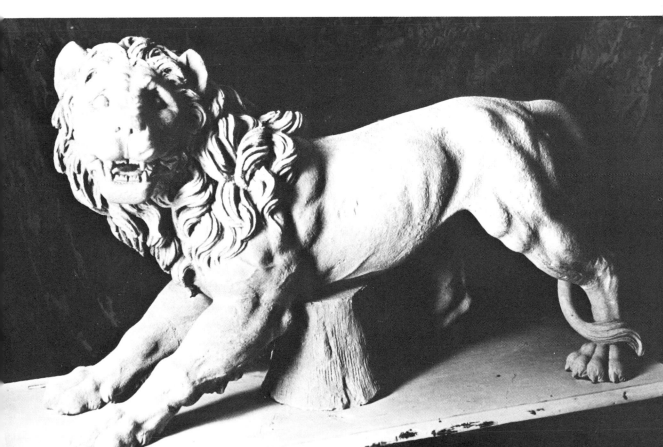

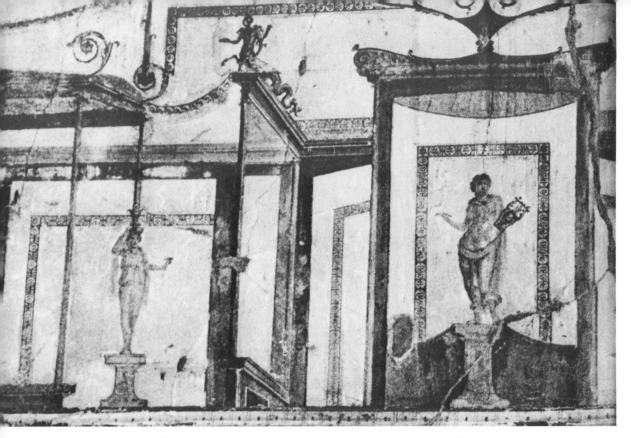

Fig. 8. *Above:* Vaulted tablinum of a house next to the College of the Priests of Augustus at Herculaneum. Time of the emperors Nero or Vespasian, about A.D. 65 to 80. (*From J. Lukas and Sir M. Wheeler,* Pompeii and Herculaneum, *pp. 138–39.*)

Fig. 9. Miniature nymphaeum with the reclining Nile and niches for spouts or statuettes. Roman imperial period. Formerly Cobham Hall (Kent) and later London, Spink and Son. (*Courtesy late Earl of Darnley.*)

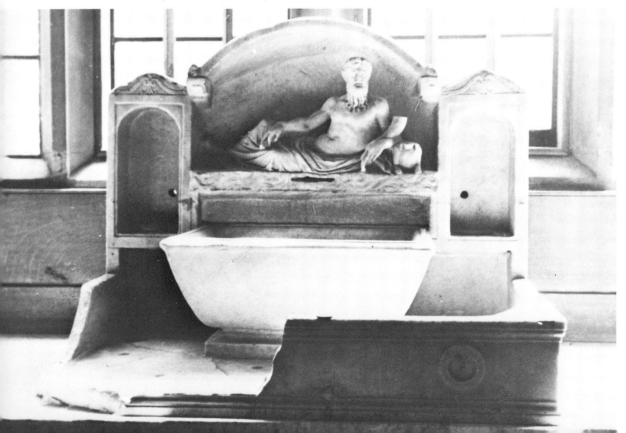

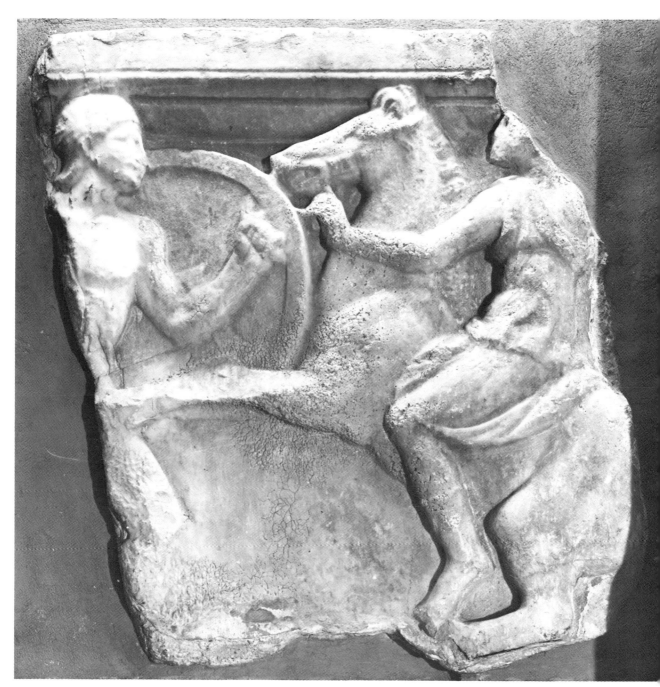

Fig. 10. Greek and Amazon in combat. Graeco-Roman relief from the waters around Piraeus harbor. Formerly Bloomfield Hills (Michigan), Cranbrook School and later New York, Parke-Bernet Galleries. (*Courtesy Sotheby, Parke-Bernet.*)

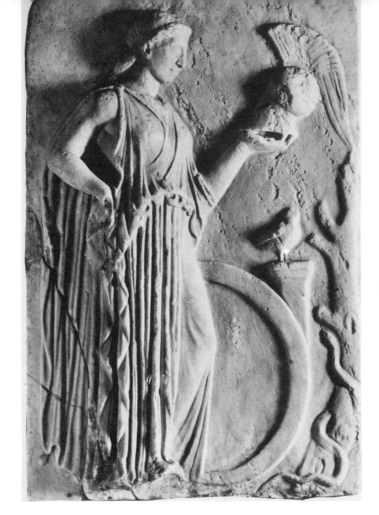

Fig. 11. Athena of Pheidian type, flying her owl and holding her helmet. Graeco-Roman relief. Copenhagen, Ny Carlsberg Glyptotek, from London, Lansdowne House. (*Courtesy Ny Carlsberg Glyptotek.*)

Fig. 12. Graeco-Roman relief showing the visit of Dionysos to a poet's house, reliefs and sculpture about. London, British Museum. (*Courtesy Trustees of The British Museum.*)

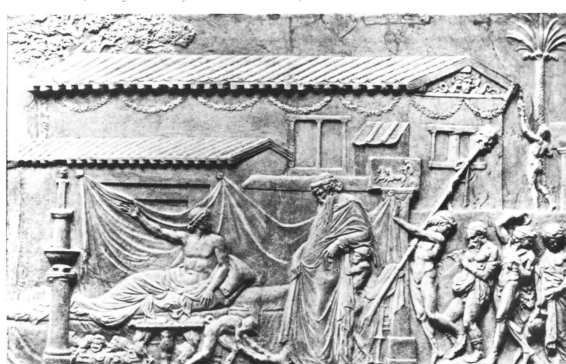

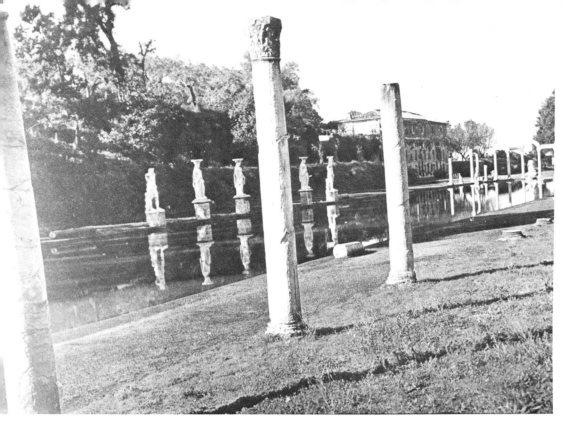

Fig. 13. View across the Euripus of Hadrian's Villa at Tivoli, the "Caryatids" and Sileni displayed beside the canal. (*From Aurigemma, Villa Adriana, pl. VI.*)

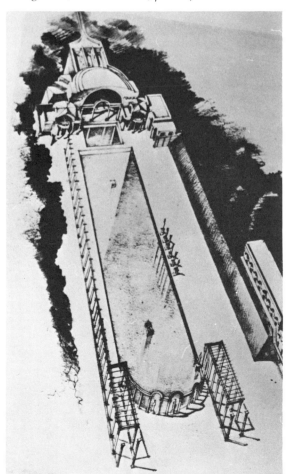

Fig. 14. Reconstructed view of the Canopus and Euripus of Hadrian's Villa at Tivoli. After B. Apollonj-Ghetti, 1956. (*From Aurigemma, Villa Adriana, fig. 94.*)

Fig. 16. Terminal figure of a female. Formerly London, Lansdowne House, from Hadrian's Villa at Tivoli. (*Courtesy Spink and Son, London.*)

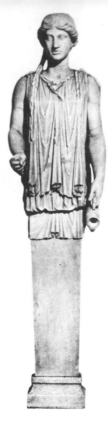

Fig. 15. Plan of the statues by Polykleitos, Kresilas, Pheidias, and Alkamenes as found at the colonnaded end of the Euripus in Hadrian's Villa at Tivoli. (*From Aurigemma,* Villa Adriana, *fig. 110. Courtesy Gabinetto Fotografico Nazionale E, 37881.*)

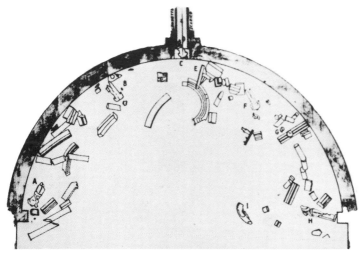

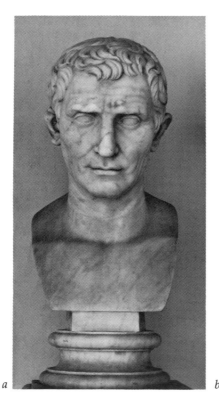

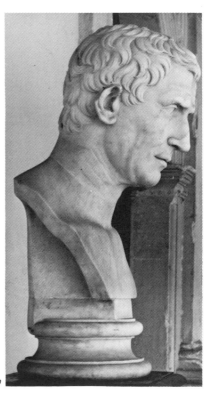

a *b*

Fig. 17*a, b.* Hadrianic copy of a prominent official to the latter part of the Roman Republic, from Hadrian's Villa at Tivoli. Knole (Kent). (*Courtesy the Sackville Family.*)

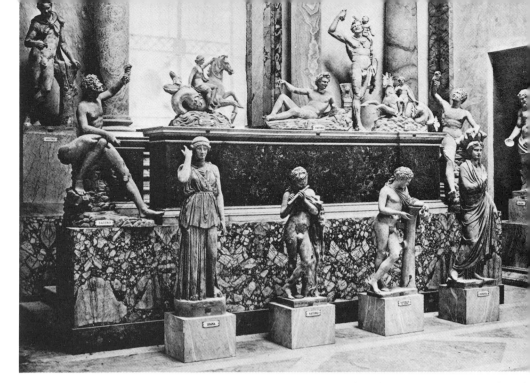

Fig. 18. Satyrs and Nereids. Graeco-Roman decorative copies of Hellenistic statues. Vatican, Braccio Nuovo. (*From W. Amelung*, Sculpturen des Vaticanischen Museums, *vol. 1, pl. 5.*)

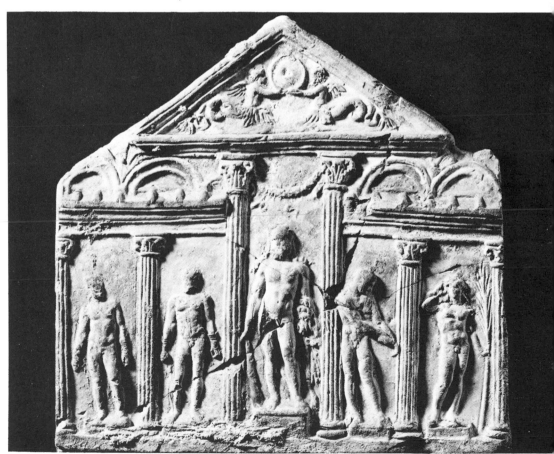

Fig. 19. Facade of a gymnasium. Roman imperial architectural terracotta. Boston, Museum of Fine Arts. (*Courtesy Museum of Fine Arts, Boston.*)

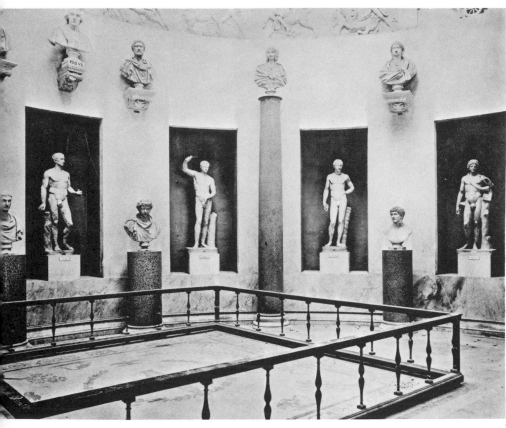

a

Fig. 20a, b. Athletes from the Villa of Quintilius Varus. Graeco-Roman
decorative copies of fifth-century B.C. and later statues. Vatican,
Braccio Nuovo. (*From Amelung, vol. 1, pls. 16, 17.*)

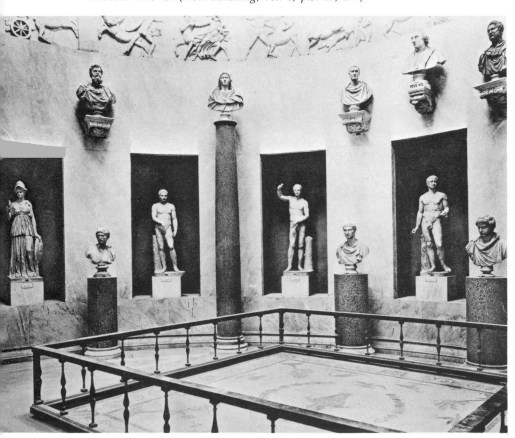

b

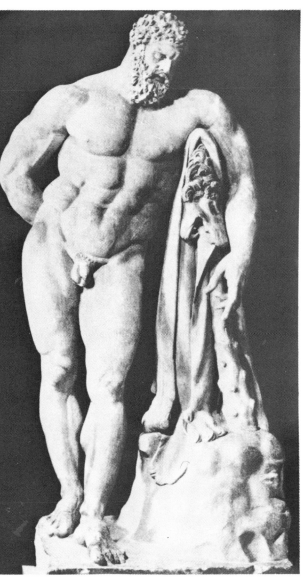

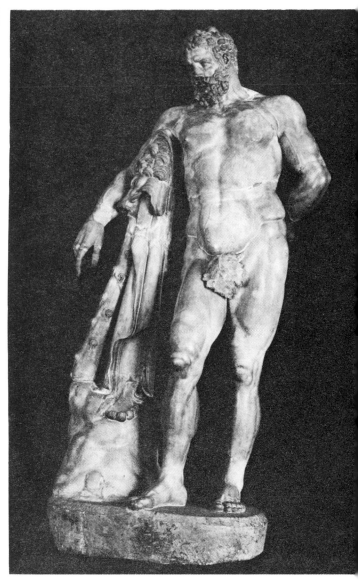

Fig. 21. The Farnese Hercules, Graeco-Roman creation after a Hellenistic version of the Weary Herakles by Lysippos. Naples, Museo Nazionale. (*Courtesy Museum of Fine Arts, Boston.*)

Fig. 22. The Weary Herakles after Lysippos, reversed version. Graeco-Roman times. London, recorded in Art Market. (*Courtesy Spink and Son, London.*)

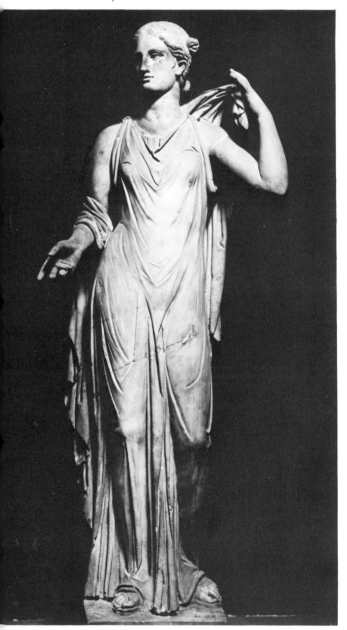

Fig. 23. So-called Venus Genetrix with position of the body and arms reversed from the normal Graeco-Roman copies. Rome, Villa Torlonia-Albani. (*From EA, no. 3251.*)

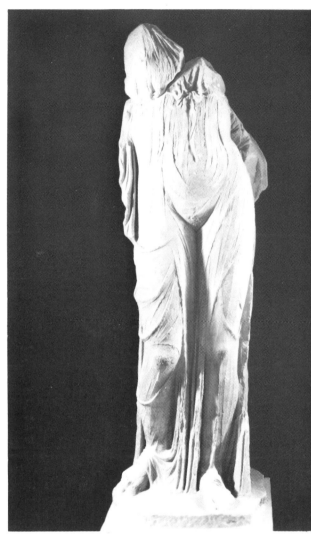

Fig. 24. Venus Genetrix, a copy with body and arms in the canonical positions. Argos Museum. (*Courtesy The Argos Museum.*)

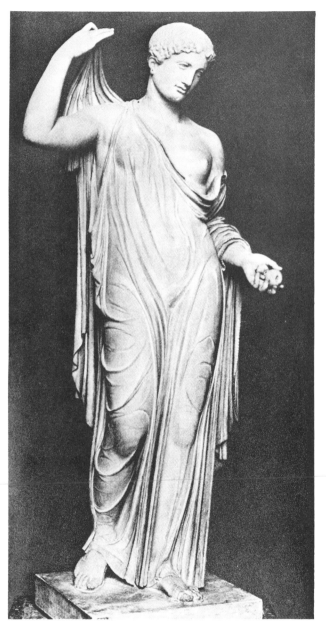

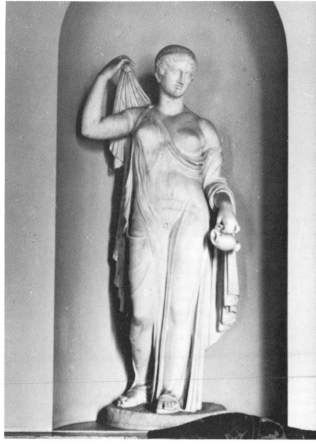

Fig. 26. Venus Genetrix, Graeco-Roman copy. Holkham Hall (Norfolk). (*Courtesy Earl of Leicester.*)

Fig. 25. Venus Genetrix, the most famous Graeco-Roman copy. Paris, Musée du Louvre. (*Courtesy Museum of Fine Arts, Boston.*)

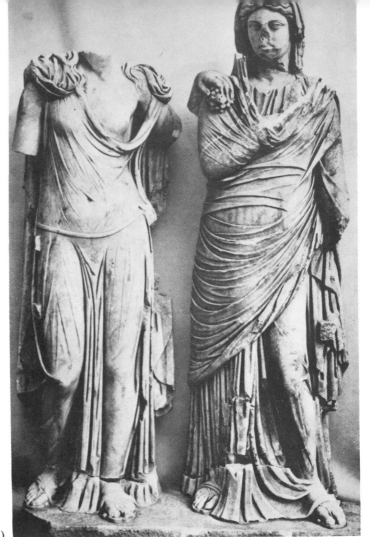

Fig. 27. Women from Perge, one arrayed as the so-called Venus Genetrix. Time of Emperor Hadrian. Antalya Museum. (*From* Mélanges Mansel, *vol. 3, pl. 206.*)

Fig. 28. Odeon of Agrippa, the building as reconstructed during the Antonine period. Athens, Agora. (*Courtesy Agora Excavations.*)

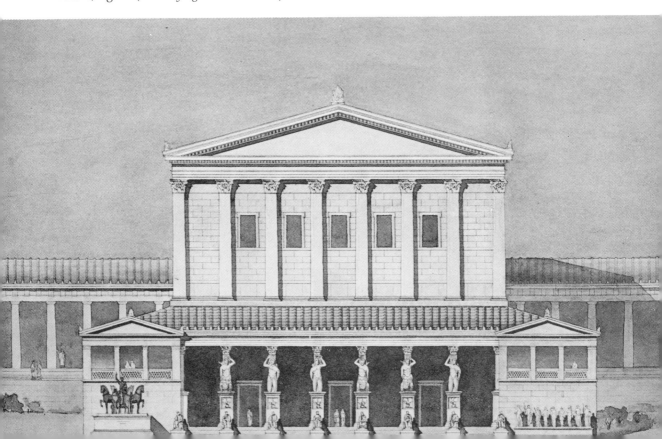

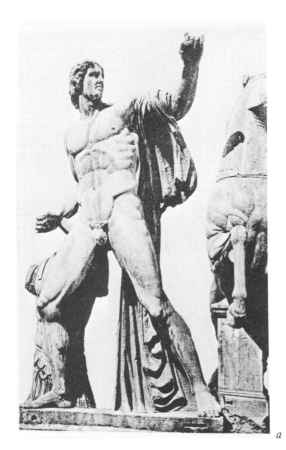 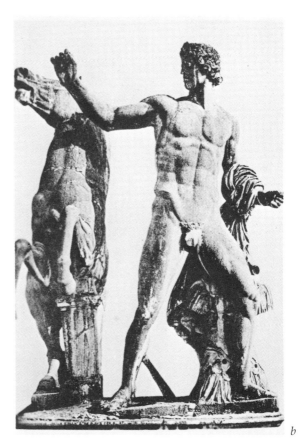

a

b

Fig. 29a, b. The so-called Horse Tamers of Monte Cavallo. Graeco-Roman adaptations after
a group or groups of the fifth century B.C. (*From* Hesperia *19* [*1950*] *pl. 77b.*)

Fig. 30. The Horse Tamers as seen in the sixteenth century. Oil painting by Marten van
Heemskerck, 1546. (*Fot. 6653.*)

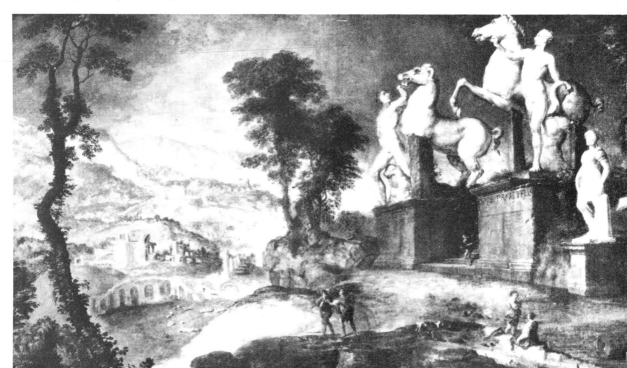

Fig. 31. Discobolus after Naukydes, a small-scale reversal. Museum of Fine Arts, Boston. Bequest of Benjamin Rowland, Jr. (*Courtesy Museum of Fine Arts, Boston.*)

Fig. 32. Discobolus after Naukydes. Full-sized Graeco-Roman copy. Vatican Museums. (*From F. P. Johnson, Lysippos, pl. 2.*)

Fig. 33. Poseidon, the Lateran type. Graeco-Roman copy of a fourth-century B.C. original, probably by Lysippos. Vatican Museums. (*From Johnson, pl. 24.*)

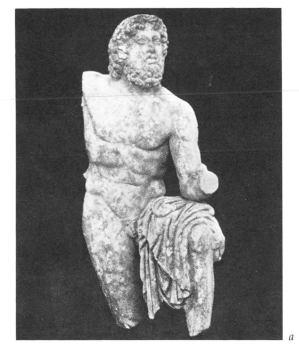

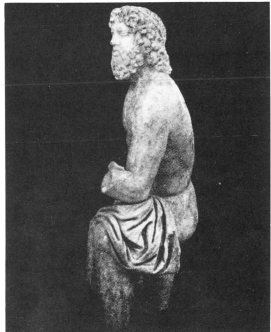

a

b

Fig. 34*a, b*. Poseidon, a reduced-scale reversal of the Lateran type. Graeco-Roman copy. Crete, Heraklion Museum. (*From Johnson, pl. 25.*)

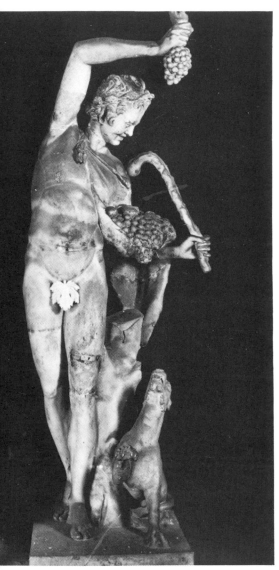

Fig. 35. Statue of the Hellenistic type known as the Satyr in the Orchard. Graeco-Roman copy. Rome, Villa Torlonia-Albani. (*From EA, no. 3559.*)

Fig. 36. Satyr, of the same general type as fig. 35. Graeco-Roman copy. Cherchel Museum. (*From S. Gsell,* Cherchel, *no. 104, plate.*)

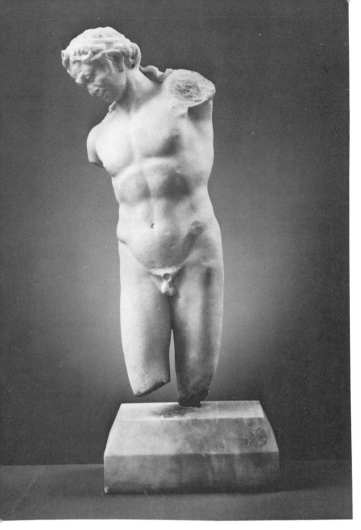

Fig. 37. Satyr, reduced-scale reversal of the types shown in figs. 35 and 36. Graeco-Roman copy. Madison (Wisconsin), University of Wisconsin, Elvehjem Art Center. (*Photo by the author.*)

Fig. 38. *Below:* Sarcophagus with Seasons personified. Later Roman imperial period. Rome, Palazzo dei Conservatori. (*From H. Stuart Jones,* The Sculptures of the Palazzo dei Conservatori, *pl. 17.*)

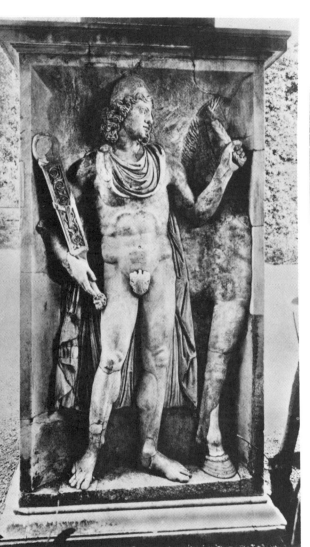

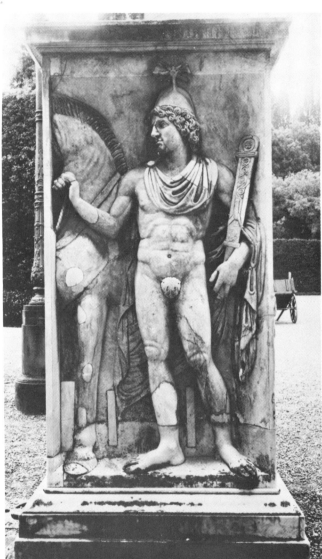

Fig. 41. Base from a triumphal arch. Roman imperial period. Florence, Boboli Gardens, from Rome. (*From* EA, *no. 3415.*)

Fig. 42. Base from a triumphal arch. Roman imperial period. Paired with fig. 41. (*From* EA, *no. 3411.*)

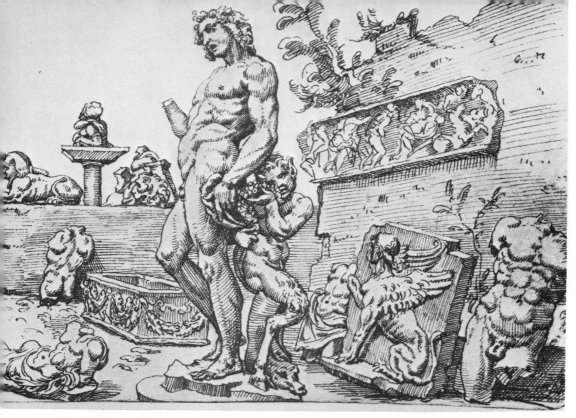

Fig. 43. View of the courtyard of the Casa Galli, Rome, in the 1540s. Drawing by Marten van Heemskerck. Michelangelo's Bacchus is in the foreground. Berlin, Cabinet of Prints. (*Courtesy Museum of Fine Arts, Boston.*)

Fig. 44. Hemicycle with niches (for thin statues, reliefs, bookracks) in the library of Hadrian's Villa at Tivoli. (*From Aurigemma, fig. 39. Courtesy Anderson, 609.*)

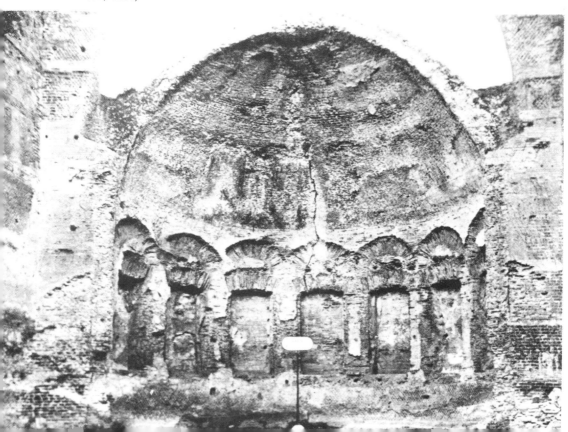

Fig. 45. Interior of Lansdowne House, London, as it appeared in the 1920s.
(*From* EA, *no. 3048.*)

Fig. 48. Rodolfo Lanciani's plan of the Lamian Gardens, with indication of where sculptures were found. (*From R. Lanciani,* New Tales of Old Rome, *p. 219.*)

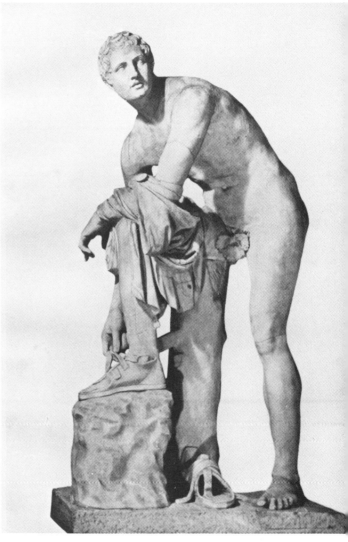

Fig. 47. Hermes tying his sandal, Graeco-Roman copy of a statue in the tradition of Lysippos. Copenhagen, Ny Carlsberg Glyptotek, no. 273a. Formerly London, Lansdowne House, from Hadrian's Villa at Tivoli. (*Courtesy Spink and Son, London.*)

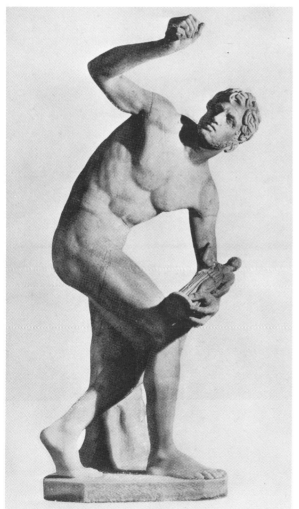

Fig. 46. Discobolus of Myron, Graeco-Roman copy restored as Diomedes stealing the Palladium. Formerly London, Lansdowne House and Bowood (Wiltshire). (*Courtesy Marquess of Lansdowne.*)

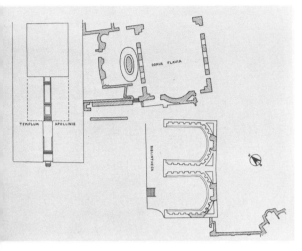

Fig. 49. Plan of the library and the Temple of Apollo, southwest of the Domus Flavia. (*From E. Nash*, Pictorial Dictionary of Ancient Rome, *fig. 231.*)

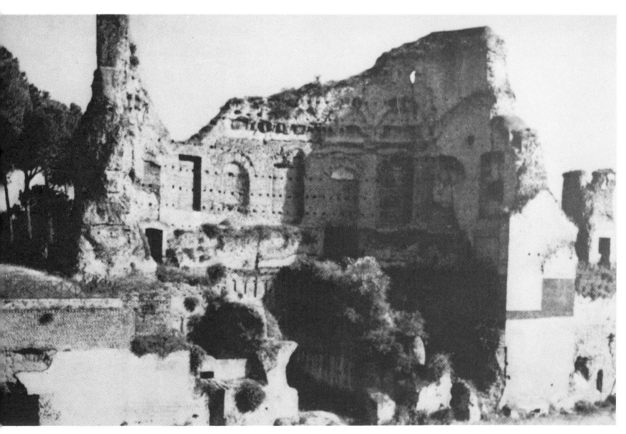

Fig. 50. The exedra of the ''Hippodromus Palatii,'' the so-called Stadium of Domitian. Rome, Palatine Hill. (*Fot 337.*)

a

Fig. 52a, b. Herakles wrestling
the Nemean Lion. Fragment
of a small statue in dark stone
from the so-called Stadium of
Domitian. Cambridge (Mass.),
Collection of the late Sir
Charles Nuffler. (*Courtesy
Museum of Fine Arts, Boston.*)

b

Fig. 53. Fragments of colossal statues and other antiquities, chiefly architectural elements, from Domitian's Domus Augustana or Flavia on the Palatine. Rome, Palazzo Farnese. (*Photo by the author.*)

Fig. 54. The Forum of Augustus, northwest exedra with niches for statues. (*Fot 457.*)

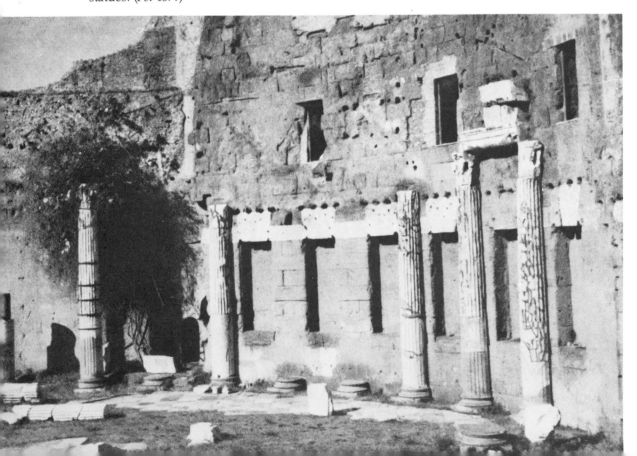

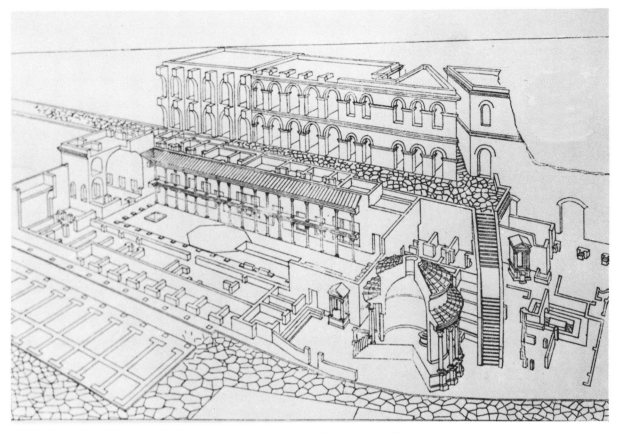

Fig. 55. The Temple of Vesta and the House of the Vestals.
(*From Ch. Huelsen,* Das Forum Romanum, *fig. 84.*)

Fig. 56. Statues of the Virgines Vestales Maximae, reerected on the north
side of the peristyle. (*Fot 104.*)

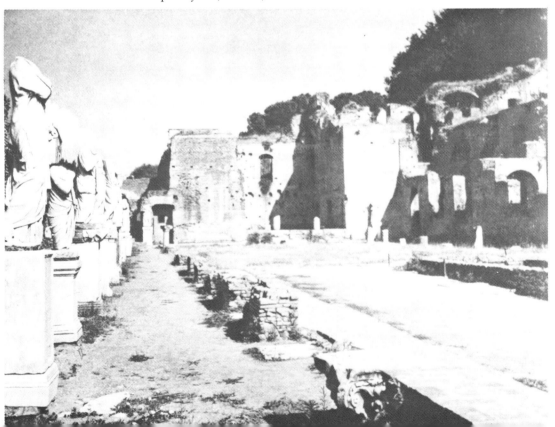

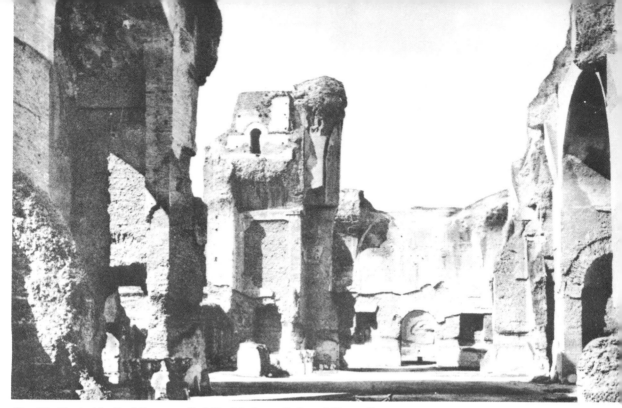

Fig. 57. Central hall of the so-called Tepidarium, Baths of Caracalla.
(*Courtesy Brogi, 3405.*)

Fig. 58*a, b*. The Farnese Bull, Graeco-Roman adaptation of a late Hellenistic
creation. Naples, Museo Nazionale, from the Baths of Caracalla.
(*Courtesy Hirmer Verlag, Munich.*)

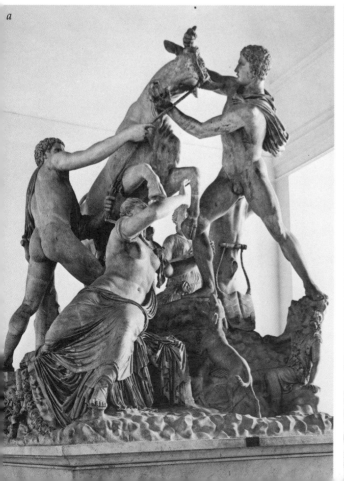

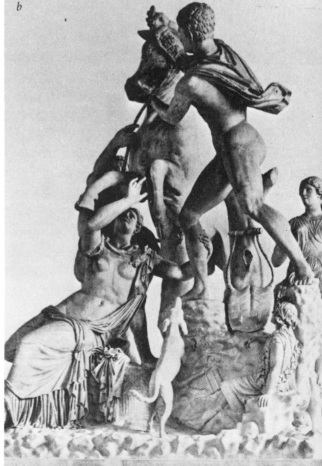

Fig. 59. Chapel to Tyche with images. Roman imperial period. Rome, near San Martino ai Monti. Engraving by L. Ronci. (*From* Bullettino Comunale 13 [*1885*], *pl. III.*)

Fig. 60. Chapel to Tyche, side view. Rome, near San Martino ai Monti. Engraving by L. Ronci. (*From* Bullettino Comunale 13 [*1885*], *pl. IV.*)

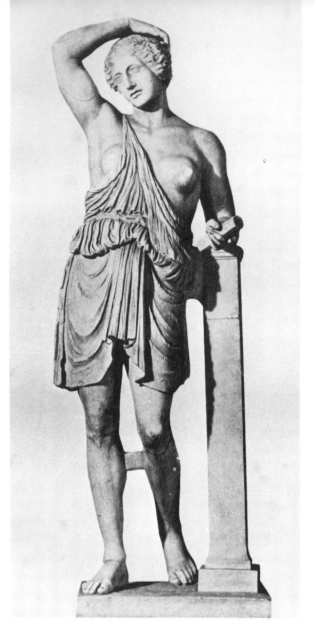

Fig. 61. Marcus Aurelius Caesar (140–61)
as a Dioskouros or similar hero. Formerly
London, Lansdowne House and Bowood
(Wiltshire), from Tor Columbaro.
(*Courtesy Marquess of Lansdowne.*)

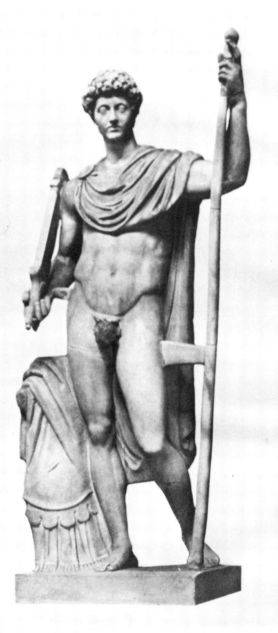

Fig. 62. Wounded Amazon, Graeco-
Roman copy of a statue attributed to Poly-
kleitos or Kresilas. New York, The Metro-
politan Museum of Art. Gift of John D.
Rockefeller. Formerly London, Lans-
downe House, from Tor Columbaro.
(*Courtesy Spink and Son, London.*)

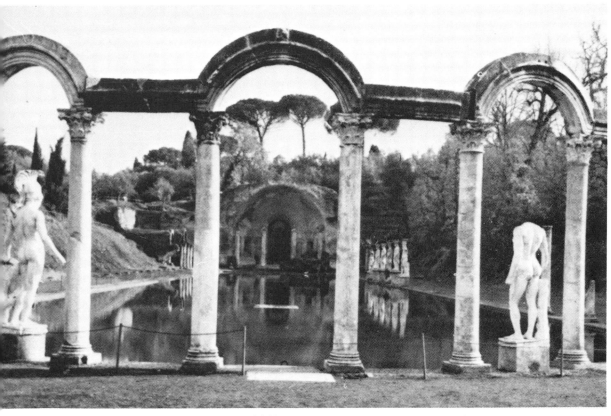

Fig. 63. Graeco-Roman copies of fifth-century B.C. statues as set up in the Euripus of Hadrian's Villa at Tivoli. (*From Boëthius and Ward-Perkins, fig. 136.*)

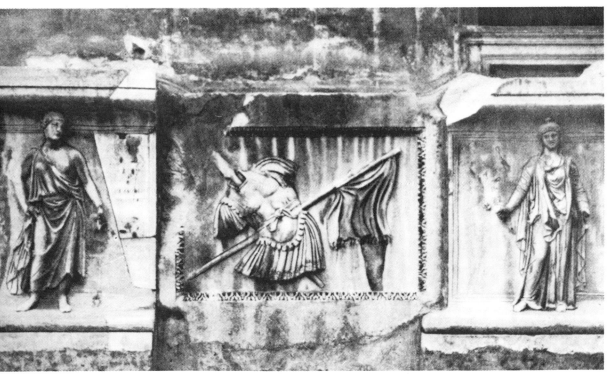

Fig. 64. Part of the marble balustrade of the Hadrianeum in Rome, with provinces identified as Vindelicia and Dacia. (*Fot 947.*)

Fig. 65*a–c.* Coins representing the port of Claudius at Ostia. (*a*) Engraving of sestertius of Nero. (*From T. L. Donaldson,* Architectura Numismatica, *no. 89.*) (*b,c*) Sestertius of Nero. (*Courtesy Museum of Fine Arts, Boston.*)

Fig. 66*a, b.* Coins representing the port of Trajan at Ostia. (*a*) Engraving of sestertius of Trajan. (*From Donaldson, no. 90.*) (*b*) Sestertius of Trajan. (*Courtesy Museum of Fine Arts, Boston.*)

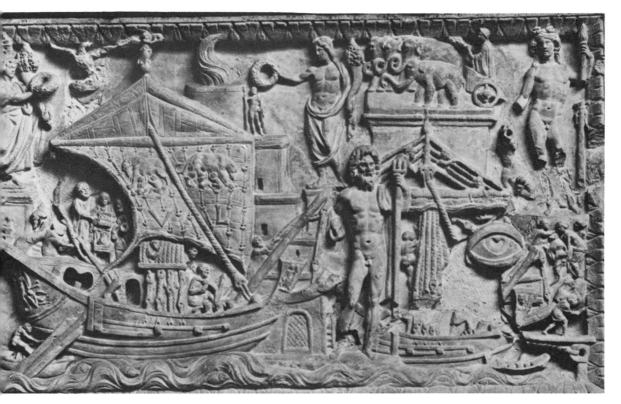

Fig. 67. Relief showing ships and statues in the harbor complex at Ostia. Rome, Torlonia Collection. (*Courtesy German Archaeological Institute, Rome.*)

Fig. 68. Plan of the Forum and Basilica at Velleia. (*From S. Aurigemma,* Velleia, *end paper.*)

Fig. 69. Julio-Claudian statues from the Basilica at Velleia. Parma, Museo Nazionale. (*From Aurigemma*, Velleia, *p. 43.*)

Fig. 70. The Metroon at Olympia showing the locations of imperial statues. (*From* Olympia, *vol. 3, fig. 291.*)

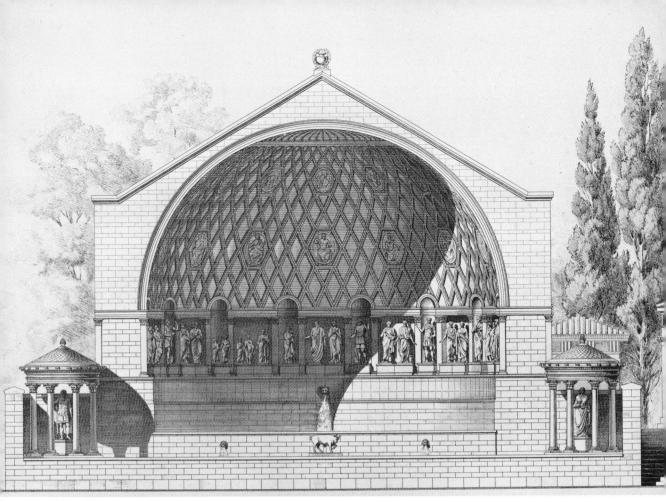

Fig. 71. Nymphaeum of Herodes Atticus, reconstruction with statues.
Olympia. (*From* Olympia, *vol. 3, fig. 294.*)

Fig. 72. Plan of the nymphaeum of Herodes Atticus. (*From* Olympia, *vol. 3,*
fig. 298.)

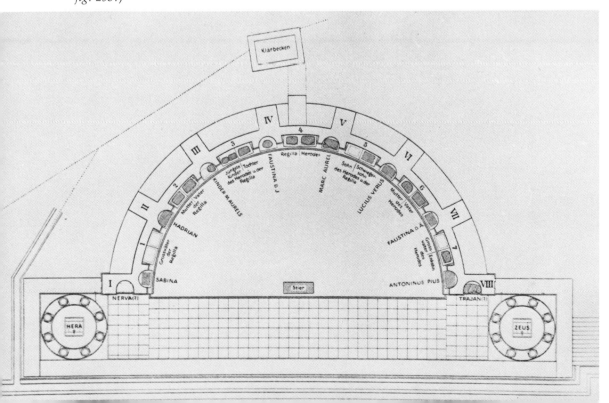

Fig. 73. Temple of the Olympian Zeus and the precinct wall, Athens. Restored plan. A.D. 124 to 132. (*From J. Travlos,* Pictorial Dictionary of Ancient Athens, *fig. 324.*)

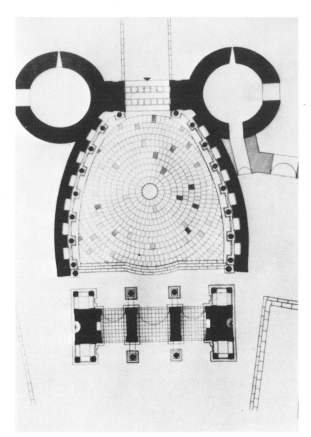

Fig. 74. Plan of the gate and forecourt at Perge. (*From* AA, *1956, fig. 53.*)

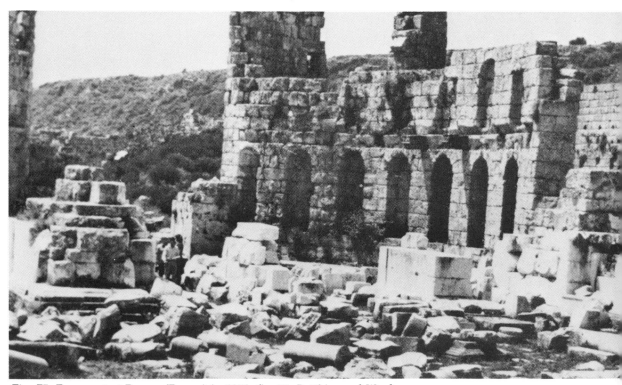

Fig. 75. Forecourt at Perge. (*From* AA, *1956, fig. 55; Boëthius and Ward-Perkins, fig. 212.*)

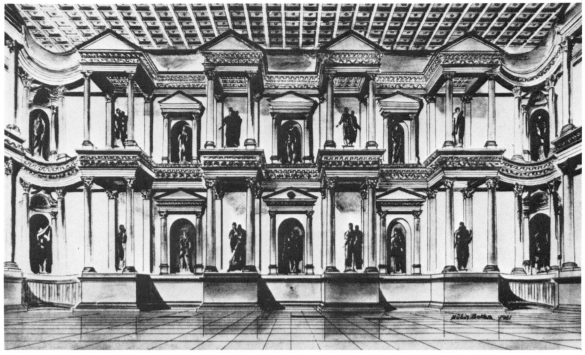

Fig. 77. Artist's rendering of the interior of the praetorium or kaisareion at Side. (*From A. M. Mansel,* Die Ruinen von Side, *fig. 90.*)

Fig. 78. *Above:* Plan of the praetorium or kaisareion at Side. (*From Mansel, fig. 85.*)

Fig. 76. Dioskouros from Perge, Hadrianic copy of a late Hellenistic type. (*From* AA, *1956, fig. 58.*)

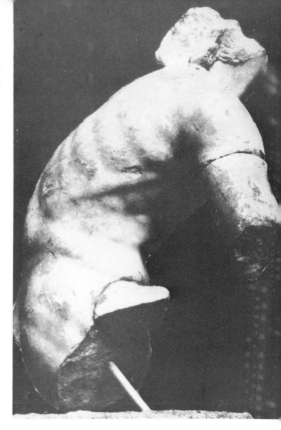

Fig. 79. Statue from the upper interior of the kaisareion at Side. Graeco-Roman copy of a fourth-century B.C. or Hellenistic type, after Lysippos. (*From Mansel, fig. 91.*)

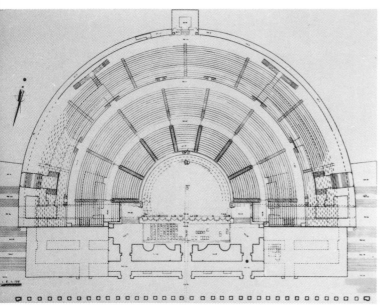

Fig. 80. Plan of the theater at Amman-Philadelphia. (*From* AA, *1975, p. 380.*)

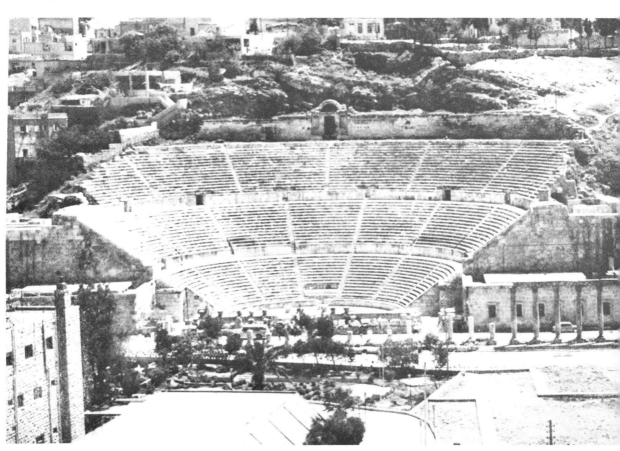

Fig. 81. View of the theater at Amman-Philadelphia. (*From* AA, *1975, p.379.*)

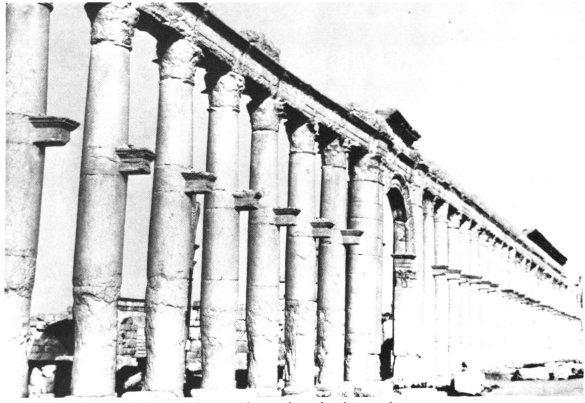

Fig. 82. The colonnaded street at Palmyra with consoles or brackets on the columns for statues or busts. View toward the tetrapylon. (*From H. Klengel, The Art of Ancient Syria, p. 144.*)

Fig. 83. The Roman triumphal gate at Patara in Lycia. (*Courtesy S. Haynes, Land of the Chimaera, p. 91.*)

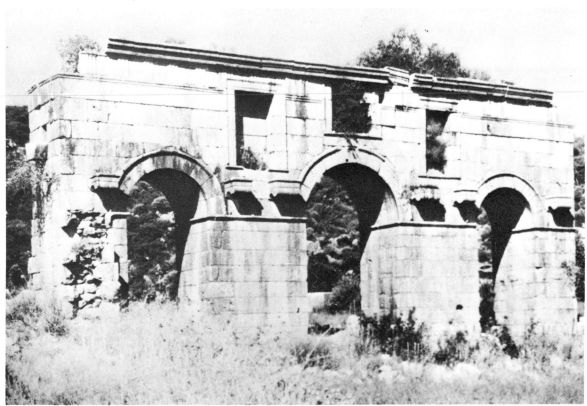

Fig. 84. Tiberius from the Temple of Roma
and Augustus at Lepcis Magna. (*From
K. D. Matthews, Jr., and A. W. Cook,
Cities in the Sand, pl. 87.*)

Fig. 85. Meleager after Skopas, Graeco-
Roman copy from Lepcis Magna. (*From
Matthews and Cook, pl. 77.*)

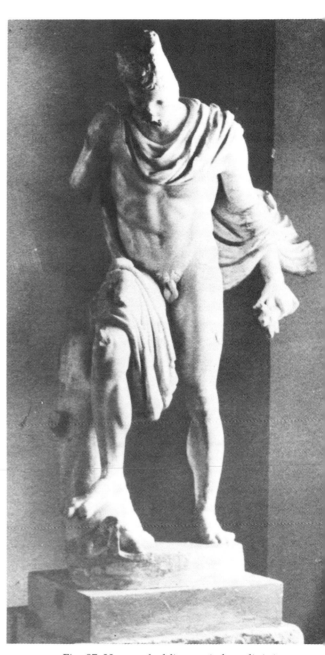

Fig. 86. Athena, Graeco-Roman copy after a bronze statue of the fourth century B.C., from Lepcis Magna. (*From Matthews and Cook, pl. 79.*)

Fig. 87. Hermes holding an infant divinity (Dionysos at the sea?) and his kerykeion, right foot on a turtle. Graeco-Roman copy after a bronze statue of the late fifth or fourth century B.C., from Lepcis Magna. (*From Matthews and Cook, pl. 80.*)

a

c

b

d

Fig. 88*a–d.* Temple of Antoninus Pius and Faustina the Elder, Rome. (*a*) Engraving. (*From T. L. Donaldson,* Architectura Numismatica, *no. 4.*) (*b, c*) Coins. (*d*) The site of the temple. (*Courtesy Museum of Fine Arts, Boston.*)

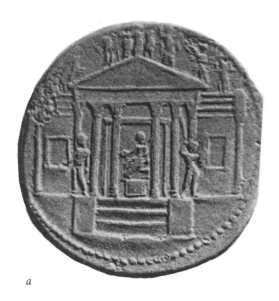

a

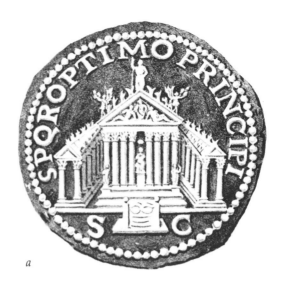

a

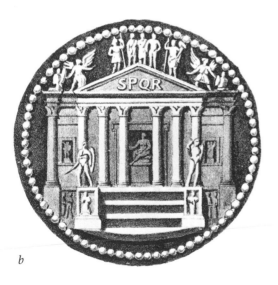

b

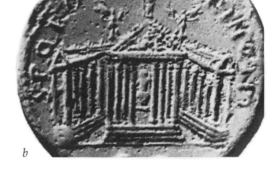

b

Fig. 90a–c. Temple of Trajan, perhaps
Jupiter Capitolinus, Rome. (a) Engraving.
(From Donaldson, no. 7.) (b, c) Coins.

Fig. 89a, b. Coins representing the temple
of Concord, Rome. (a) Sestertius of Tiberius
(b) Engraving. (From Donaldson, no. 5.)

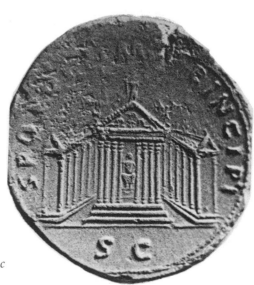

c

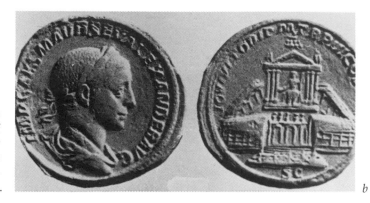

Fig. 91a–d. Temple of Jupiter, identified as Ultor ("the Avenger"), Rome. (a) Plan of the temple. (b) Front and back view of a sestertius of Severus Alexander. (c) Engraving of coin representing the temple. (From Donaldson, no. 8.) (d) The site.

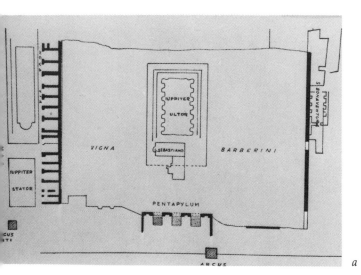

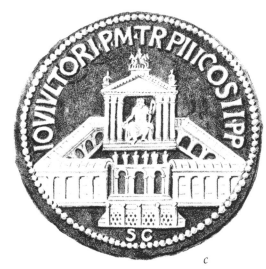

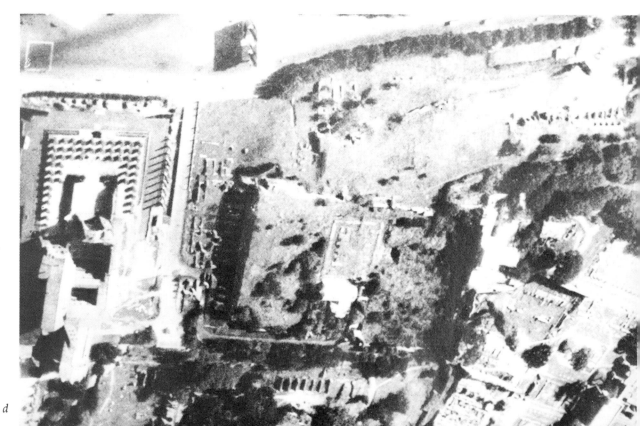

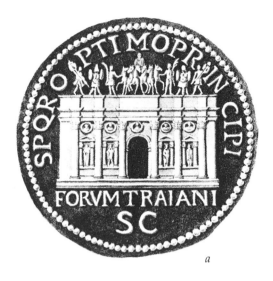

a

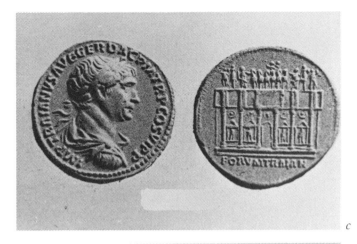

c

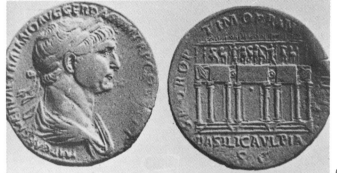

d

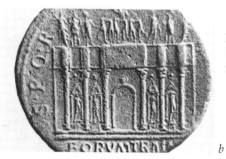

b

Fig. 92*a–d*. Coins representing the Forum of Trajan, Rome. (*a*) Engraving. (*From Donaldson, no. 67.*) (*b–d*) Coins, including front and back views.

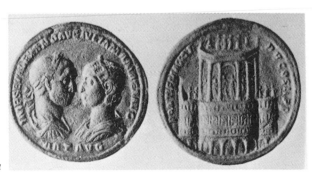

a

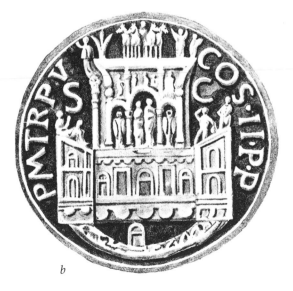

b

Fig. 93*a, b*. Coins representing the nymphaeum of Severus Alexander, Rome. (*a*) Front and back view of medallion (*b*) Engraving. (*From Donaldson, no. 73.*)

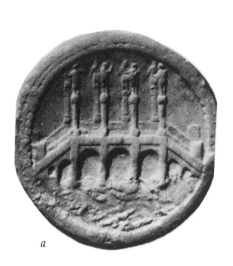

a

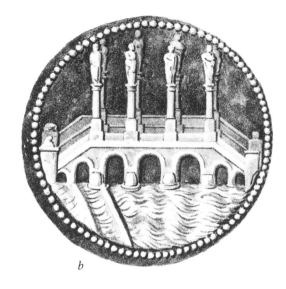

b

c

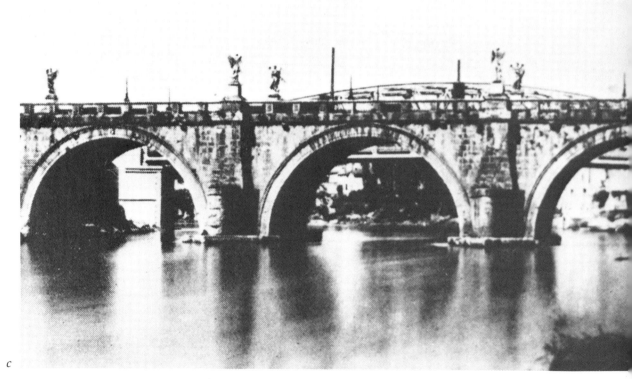

Fig. 94*a*–*c*. Hadrian's Bridge across the Tiber, at his
mausoleum, Rome. (*a*) Medallion. (*b*) Engraving. (*From
Donaldson, no. 64.*) (*c*) The bridge.

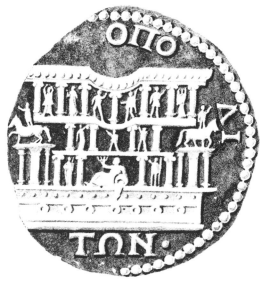

Fig. 95. Engraving of coin struck under Gallienus, showing the bridge at Antioch-on-the-Maeander. (*From Donaldson, no. 65.*)

Fig. 96. Engraving of coin struck under Septimius Severus, representing the nymphaeum at Hadrianopolis in Thrace. (*From Donaldson, no. 77.*)

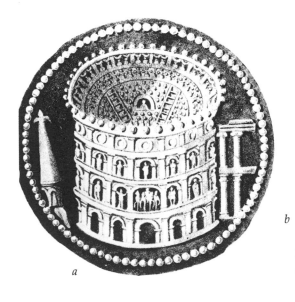

a

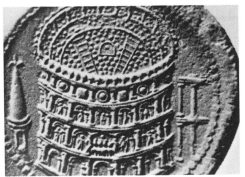

b

Fig. 97*a*, *b*. Coins representing the Flavian Amphitheater in Rome (the "Colosseum"). (*a*) Engraving. (*From Donaldson, no. 79.*) (*b*) Sestertius of Titus.

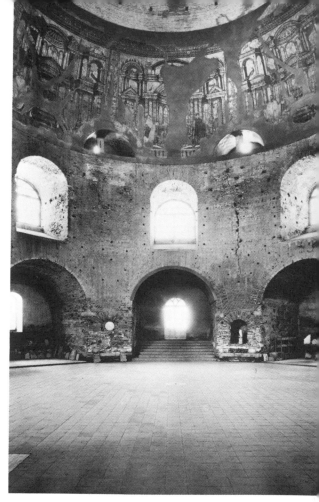

Fig. 98. Interior of Hagios Georgios in Salonika. Early and late fourth century A.D. (*From W. F. Volbach, Early Christian Art, pl. 122.*)

Fig. 100. Late Graeco-Roman tomb with statues and *tondo* busts. Ivory panel of circa A.D. 400 in Munich, Bavarian National Museum. (*From Volbach, pl. 93.*)

Fig. 99. Interior of Sant' Apollinare in Classe, Ravenna. Circa A.D. 549. (*From Volbach, pl. 173.*)